HISTORIC PHOTOS OF
ARLINGTON COUNTY

TEXT AND CAPTIONS BY MATTHEW GILMORE

TURNER
PUBLISHING COMPANY
NASHVILLE, TENNESSEE PADUCAH, KENTUCKY

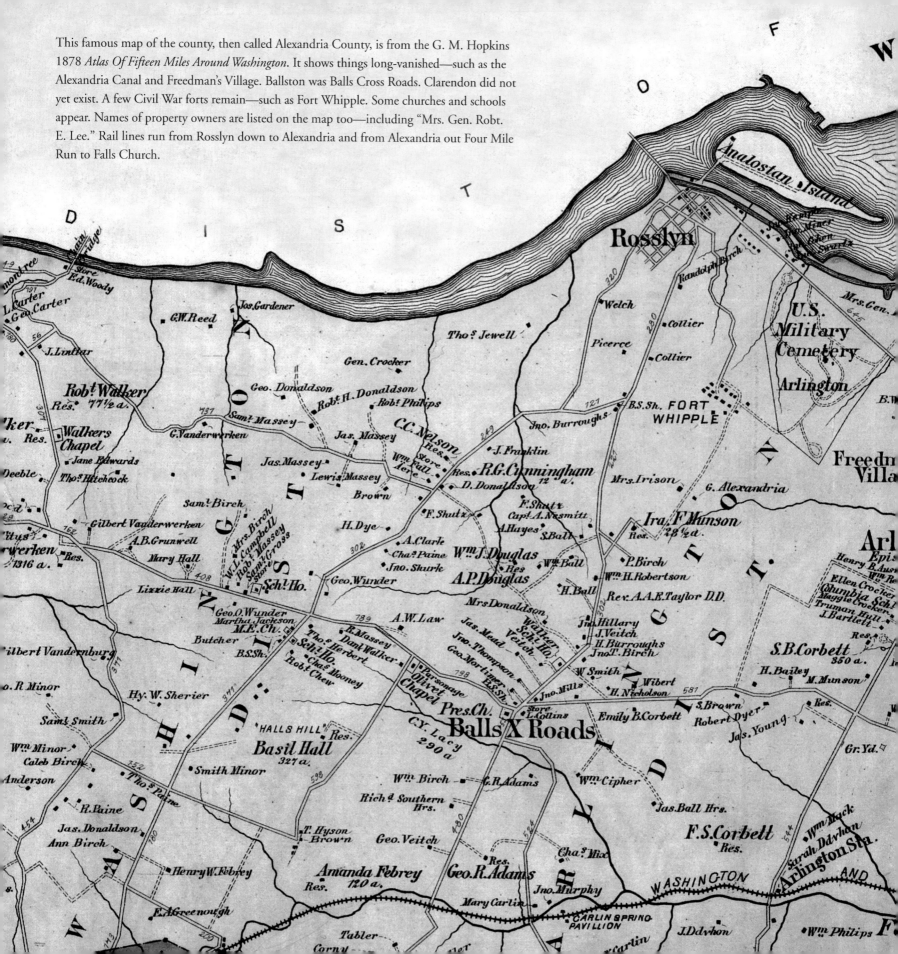

This famous map of the county, then called Alexandria County, is from the G. M. Hopkins 1878 *Atlas Of Fifteen Miles Around Washington*. It shows things long-vanished—such as the Alexandria Canal and Freedman's Village. Ballston was Balls Cross Roads. Clarendon did not yet exist. A few Civil War forts remain—such as Fort Whipple. Some churches and schools appear. Names of property owners are listed on the map too—including "Mrs. Gen. Robt. E. Lee." Rail lines run from Rosslyn down to Alexandria and from Alexandria out Four Mile Run to Falls Church.

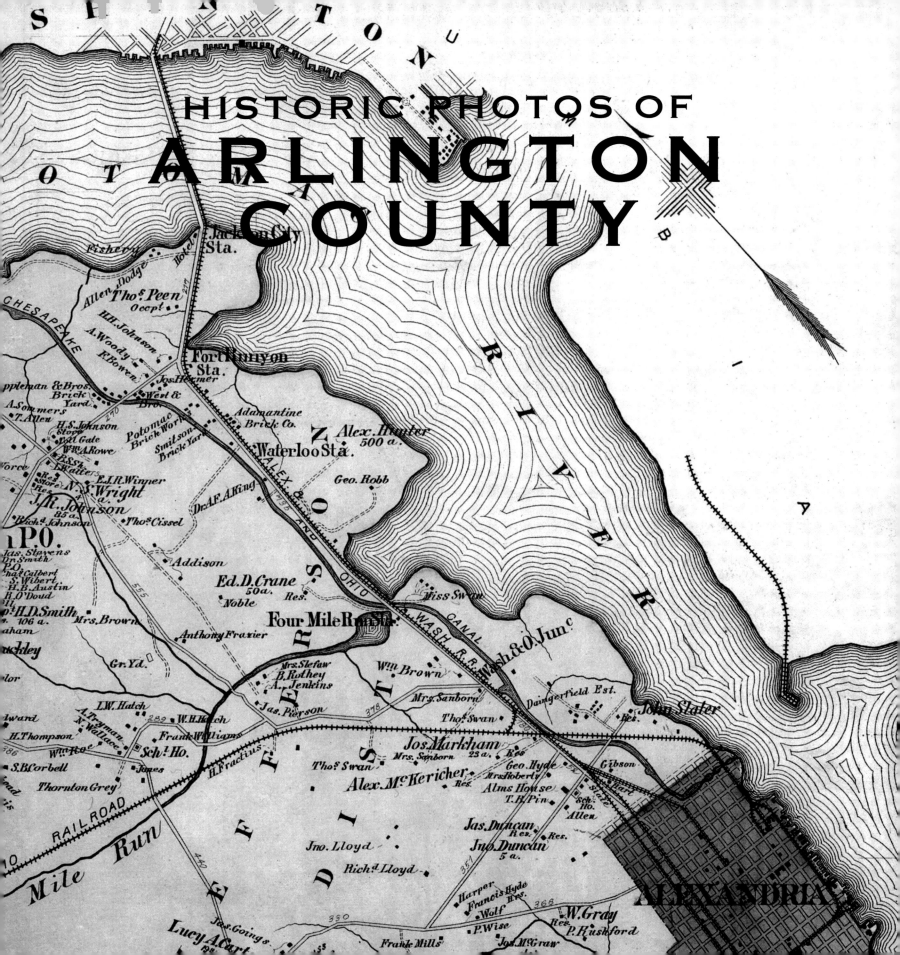

HISTORIC PHOTOS OF
ARLINGTON
COUNTY

Turner Publishing Company

200 4th Avenue North • Suite 950 412 Broadway • P.O. Box 3101
Nashville, Tennessee 37219 Paducah, Kentucky 42002-3101
(615) 255-2665 (270) 443-0121

www.turnerpublishing.com

Historic Photos of Arlington County

Library of Congress Control Number: 2007929608

ISBN-13: 978-1-59652-396-8

Printed in the United States of America

07 08 09 10 11 12 13 14—0 9 8 7 6 5 4 3 2 1

CONTENTS

ACKNOWLEDGMENTS .. VII

PREFACE ... VIII

A PLACE FOR SOLDIERS
(1861–1899) .. 1

DEVELOPING A NEW IDENTITY
(1900–1930) ... 29

FROM WASHINGTON'S BACKYARD TO SUBURBAN HEARTLAND
(1931–1975) ... 105

NOTES ON THE PHOTOGRAPHS .. 200

Arlington first began studying widening Fairfax Drive in 1945. The work of widening it from North Glebe Road to Clarendon Circle was completed in 1949. This additional thoroughfare for the county grew in importance with the location of two Metro stops along its course in the 1970s. This photograph was taken October 19, 1949.

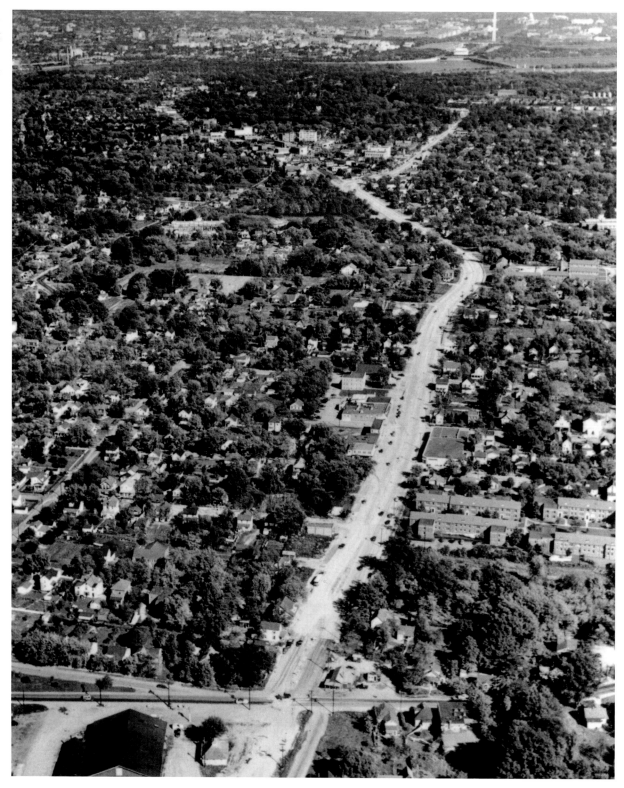

Acknowledgments

This volume, *Historic Photos of Arlington County,* is the result of the cooperation and efforts of many individuals, organizations, and corporations. It is with great thanks that we acknowledge the valuable contribution of the following for their generous support:

Alexandria Public Library
Local History/Special Collections

Virginia Room
Arlington County Public Library

The Washingtoniana Division
DC Public Library

Library of Congress

I would like to thank Heather Crocetto, Judith Knudsen, Bonnie Baldwin, and John Stanton at Arlington County Public Library's Virginia Room for their yeoman service and invaluable help; Rita Holtz and Julie Ballin-Patton of the Alexandria Public Library Local History/Special Collections; Karl Van Newkirk, at the Arlington Historical Society; Faye Haskins at the Washingtoniana Division, D.C. Public Library; and Ed Redmond at the Library of Congress.

Donald Alexander Hawkins again provided valuable advice and insight, as did historian extraordinaire Sara Collins; Michael Harrison and Zachary Schrag made insightful suggestions. And thanks to the indefatigable Gerald Swick.

—Matthew Gilmore

PREFACE

Historic images of Arlington are a bit more fugitive and widely scattered than those of its neighbor, Washington, D.C. This book brings together about 200 images from the collections of the Arlington County Public Library, the Library of Congress, the Local History/Special Collections branch of Alexandria Public Library, and the Washingtoniana Division of the D.C. Public Library.

The varieties of institutional collections tapped indicate an important aspect of the photographic documentary record of Arlington County, which has often been viewed from the periphery, from the perspective of its neighbors: Rosslyn in the north of Arlington is adjacent to Georgetown, D.C.; at the western edge of the county is Falls Church. To the south is Alexandria City and to the east the Potomac and the city of Washington. The county has often been defined by its nearness to these neighbors—by what it is *not*—ever since its cession from Fairfax County in 1791. Even then, its name was Alexandria County, not Arlington County.

It became part of the new District of Columbia, the nation's new capital—the one-third portion not derived from Maryland. The new city of Washington was located across the river in the former Maryland portion, and that would become the seat of government. Alexandria City lay at the southernmost end of Arlington (then Alexandria County). With no federal facilities to be located in Arlington, the residents ultimately requested retrocession to Virginia and rejoined the Old Dominion in 1846. With the Civil War, Arlington took on a vital importance in the defenses of the capital. Quickly overrun by Union troops, it was never seriously contested by the Confederacy. Its visual centerpiece—General Robert E. Lee's home, Arlington House—became a potent symbol, along with the many Union dead buried in the Arlington Cemetery.

In 1870, the city of Alexandria separated from the county. The county would be renamed Arlington in 1920. Not part of the nation's capital, now also exclusive of Alexandria city—what was Arlington? Slowly, then with increasing rapidity, it began to serve as the capital's backyard (though facing toward its front—the Mall and Capitol). It became the capital's

suburb, in effect replacing those areas adjacent to the old city of Washington which had become now more built up. The expansion of rail access and streetcars across the Potomac spurred development. Small-town life sprang up across the county, with the schools, fire stations, and small businesses becoming centers of activity.

Arlington played host to those vices men fall prey to, particularly gambling and alcohol. In 1836, the Arlington end of Long Bridge was developed as "Jackson City," named for then-President Andrew Jackson. It did not prosper but lived on as a low-rent district. The county became a place to play (for its neighbors, particularly), to conduct experiments in flying and agriculture. Finally, in the twentieth century, it became a place to locate those federal facilities which just wouldn't fit into the District—the National Airport and the War Department Offices (the Pentagon).

In addition, Arlington saw the typical development of suburban tract homes (many for government employees working in Washington, D.C.), war housing, and small-scale retail. Postwar Arlington continued to see a population boom, leveling off in the 1960s. The county struggled through and led Virginia's efforts to desegregate public education.

Transportation in and through the county was always a prime concern. Commuter rail disappeared, replaced by buses and traffic snarls, only to have rail service reappear as Metro rail, accompanied by elaborate interstates. As the images in the book close, Arlington has become even more tied into the greater suburban Washington, a suburban home to Washingtonians, but conscious of a proud, small-town Virginia heritage.

The goal of this work is to bring together photographs—some familiar and some rarely seen—for a broader audience who will not have seen the whole kaleidoscope of aspects of Arlington: the early rural days, the small Southern towns, the growth of federal government facilities, and the national institutions.

With the exception of cropping where necessary and touching up imperfections caused by time, no other changes to these photographs have been made. The focus and clarity of some images is limited to the technology of the day and the skill of the photographer.

We encourage readers to see Arlington in a new light as they visit, shop, or pass simply through—to reflect on Arlington's heritage and place in the greater national capital region.

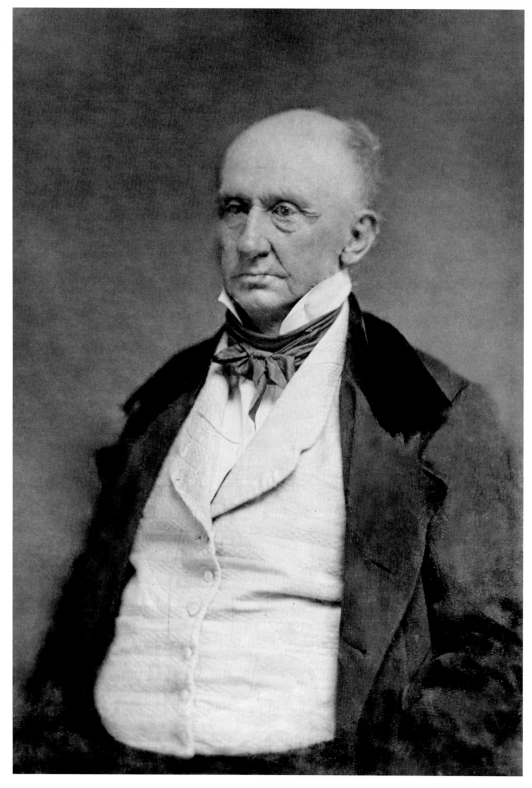

George Washington Parke Custis in a portrait taken by Mathew Brady in the 1840s. Custis was the grandson of Martha Custis Washington, wife of President George Washington, and was brought up by the couple after the early death of his father. Custis built his mansion, originally called Mount Washington in tribute to his step-grandfather, when his attempt to purchase Mount Vernon was rebuffed. He married Mary Fitzhugh Lee and renamed the house Arlington House (after a Custis estate in Maryland) in 1804. The center portion of the house, with its landmark oversize Tuscan columns, was finished in 1817. Custis was a literary man—essayist, orator, playwright, and unsuccessful politician—described in his obituary as "that old man eloquent." He died in 1857. His daughter Mary Ann Randolph Custis married Robert E. Lee, who would win world renown as a Confederate commander in the Civil War.

A Place for Soldiers

(1861–1899)

Arlington County began its existence as the result of the deal made in 1790 to construct a capital for the nation on the banks of the Potomac, in return for federal assumption of state debt. This deal was completed in 1791 when President George Washington chose the location for the capital at the confluence of the Potomac and the Eastern Branch, just upriver from his hometown, Alexandria. In fact, Alexandria would be included in the new District of Columbia, along with thirty-odd square miles on the Virginia shore of the Potomac. That area became the Alexandria County portion of the District of Columbia, and from this descended what is now Arlington County, its borders formed in 1870. No public buildings were to be located in the county, which led residents to rejoin the Old Dominion in 1846. The location of the old far-west cornerstone of the District of Columbia was now several miles deep inside Virginia.

The county remained rural, with the town of Alexandria at the southernmost end housing most of the population and economic activity. The major landmark of the county was a splendid house begun in 1802 to honor the recently deceased President Washington. Originally naming it Mount Washington, George Washington Parke Custis, the adopted grandson of the President, built the house. Its distinctive, massive, Doric columns were visible from miles around, including across the river in Washington City.

The Potomac was spanned by construction of Long Bridge in 1804. An unsuccessful attempt was made in 1836 to create a counterpart to Washington City at the west end of Long Bridge on the Virginia shore. Called Jackson City, after then-President Andrew Jackson who presided at its dedication, the town simply failed to take off. After the Civil War, it became a small corner of disreputable activities, such as gambling, outside of District jurisdiction. The Aqueduct Bridge from Georgetown joined the new Alexandria Canal to the Chesapeake and Ohio Canal in 1834, another link across the Potomac.

The United States split in civil war in 1861, and the danger to Washington City was immediately apparent, particularly after the First Battle of Bull Run at Manassas, Virginia, on July 21, 1861. Even though Maryland remained in the Union, hostile Virginia territory lay just across the river. The Federal government promptly took control of what was then still

1

called Alexandria County and the town of Alexandria. An arc of fortifications was constructed across the high ground of the county to protect the capital. A Confederate army assailed the Washington defenses north of the river in 1864, but the Virginia fortifications never faced a serious test. Federal troops occupied Arlington House, an irresistible target as the home of the enemy's most famous general, Robert E. Lee, who had married G. W. P. Custis' daughter, Mary Ann Randolph Custis in 1831. In 1864, Private William Christman became the first soldier buried on the estate, the cemetery at Washington's Soldier's Home being filled up. Arlington National Cemetery became the nation's stake-in-the-ground in the county—there would now be always a national interest and investment, which had been lacking when the county was actually part of the national capital. The cemetery, capped by the ever-so-visible Custis-Lee mansion became a tourist attraction and focal point. Another part of the estate was developed into Freedman's Village, a community home to freed slaves and their families for the next twenty years.

In 1870, Alexandria City and Alexandria County were separated, an act permitted by the new constitution which readmitted Virginia to the Union. Yet, still the division was not distinct—the courthouse for Alexandria County remained in Alexandria city until 1898. The courthouse became another landmark, sitting on the highest point in the county, facing into the Virginia hinterland. Rosslyn lay to the east of the courthouse, where Aqueduct Bridge crossed over to Georgetown. It was one of the primary entry points into the county, which remained essentially rural until the beginning of the twentieth century.

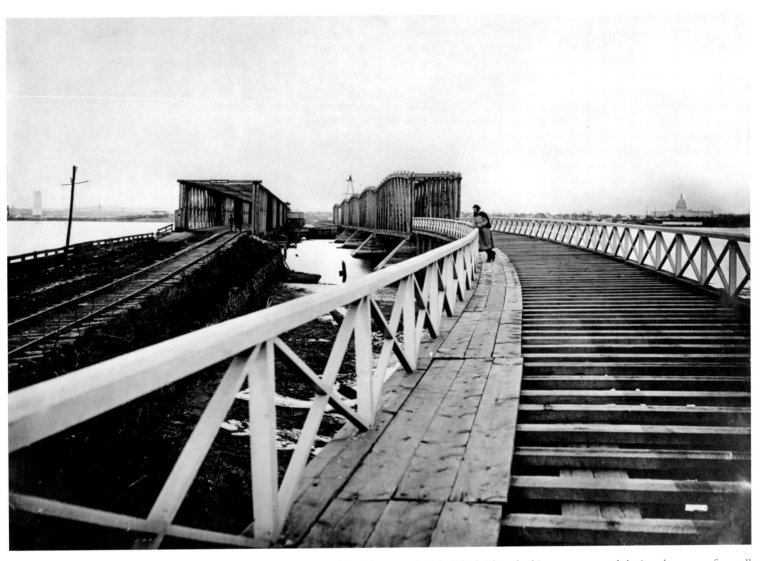

View of Long Bridge from the Virginia side. The bridge planking was removed during the war to forestall infiltrators and raids. Only a small walkway was left on which to walk—clearly visible in this image. Long Bridge was the main connection between Alexandria County and the City of Washington. The first bridge at this site was built in 1809; it was repeatedly damaged and rebuilt. The parallel bridge was constructed in 1863—shortly before this photograph would have been taken. They were removed and replaced with the Highway Bridge which opened in 1906. The Alexandria end of the bridge had the failed development named Jackson City.

In 1791 the boundaries of the new federal capital were laid out; forty boundary stones marking the ten-mile square District of Columbia. This stone stood at the far west corner of the original district, marking the division between Fairfax County, Virginia, and Alexandria County, D.C. After the 1846 retrocession of Alexandria County, the stone marked the boundary between Falls Church, Fairfax, and Alexandria counties. Curiously, the stone is too small; surveyors in 1791 confused the West Cornerstone and the Southeast #3 stones, the three-foot-tall cornerstone and two-foot-tall intermediate stone being swapped.

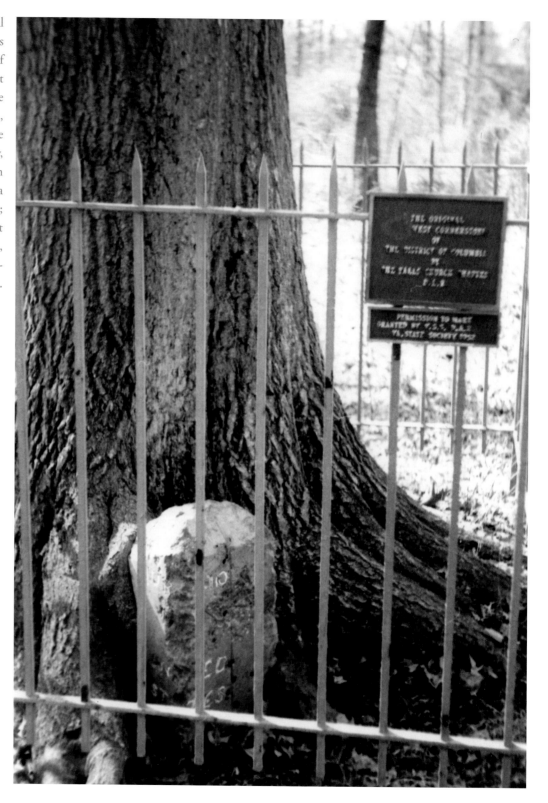

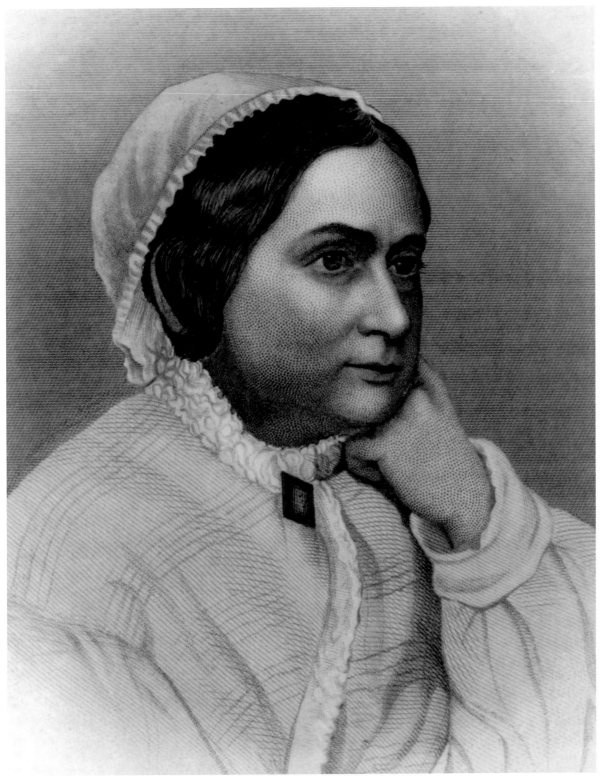

Mary Custis Lee, daughter of George Washington Parke Custis, inherited Arlington House at his death in 1857. They had seven children: George Washington Custis; William H. Fitzhugh ("Rooney"); Robert Edward, Jr.; Mary; Agnes; Anne; and Mildred. With the start of the war, she left Arlington, which was promptly occupied by Union troops. The government maneuvered a tax foreclosure seizure of the property. She died in 1873, having seen her old home just once following the war. Ultimately, the Supreme Court overturned that action, but her eldest son settled with the government for $150,000 compensation. The house had become uninhabitable, surrounded by the military cemetery. This image was made December 18, 1858.

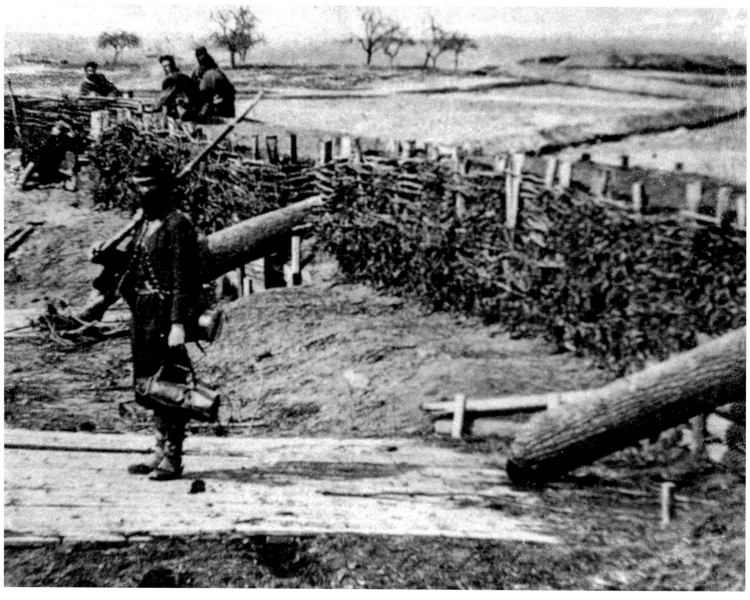

So-called "Quaker guns" at Munson's Hill—logs shaped and painted to look like artillery. Munson's Hill was the major redoubt for Union forces in Northern Virginia. Confederate forces were kept out of the county, so the war there passed fairly without incident.

This octagonal house, converted to a hospital, was part of an architectural fad for eight-sided houses; another was the Glebe House. This was located a mile outside Alexandria on the pike to Leesburg. General Henry Warner Slocum, impressed by the nursing and managerial skill of Maine-native Amy Morris Bradley in Dr. Brickett's regimental hospital, whisked her away to run the hospital for the entire brigade. He took this, the Octagon House, and Powell house for his hospital and installed Bradley as lady superintendent. She and her nurses created a homey atmosphere. Together, the buildings could house seventy-five patients, but in March of 1862, the rebels evacuated Centreville; the hospital was broken up and the brigade ordered south to Centreville. This image is from about 1861.

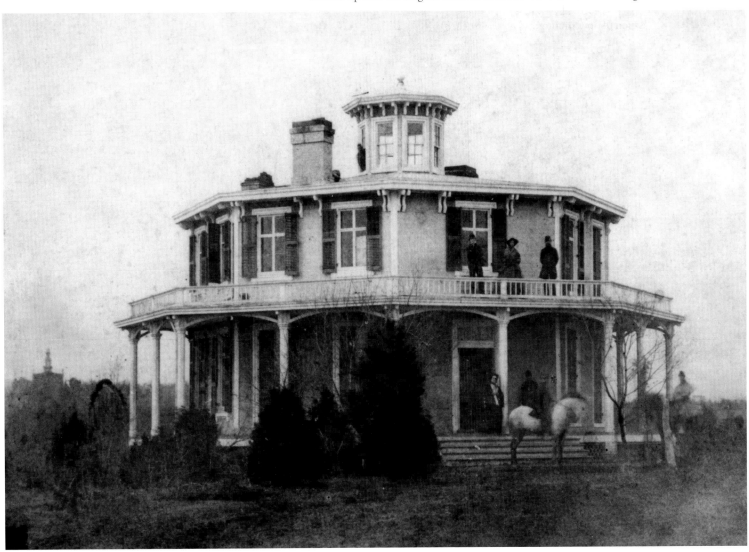

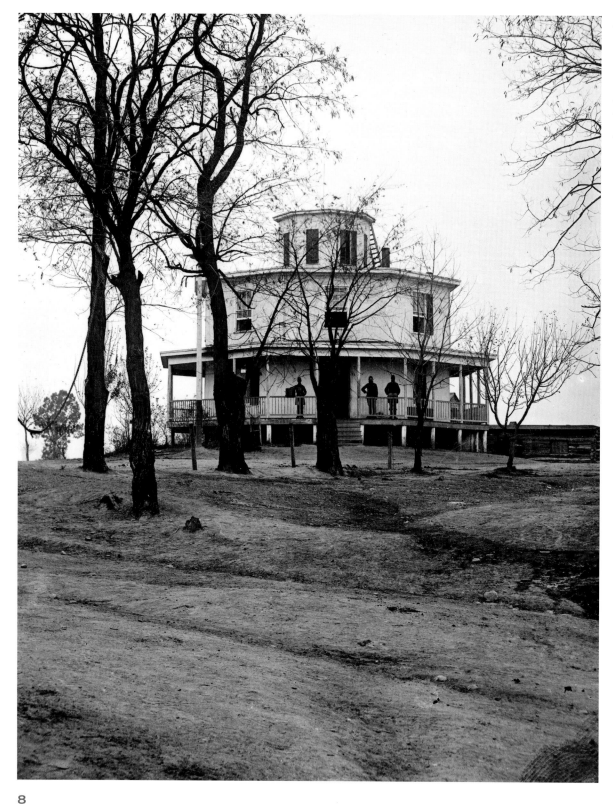

An 1861 Civil War image of another octagonal house, the headquarters of General Irwin McDowell, near Arlington House. McDowell would later headquarter at Arlington House.

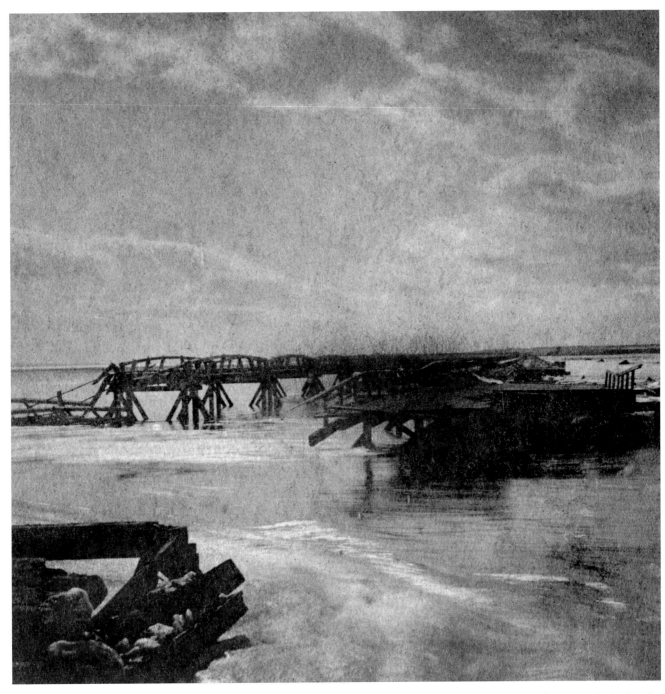

A striking image of Long Bridge damaged by ice in February 1863, before the second bridge was built. The long, low-slung, wooden bridge was severely damaged by ice and floods many times, but plans to replace it with something more robust failed until the turn of the century and the McMillan Commission.

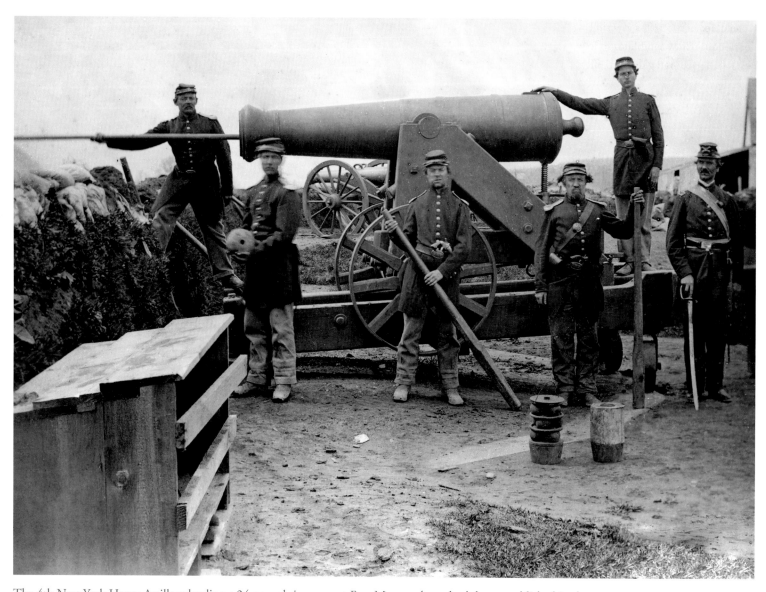

The 4th New York Heavy Artillery loading a 24-pound siege gun at Fort Marcy; a letter back home published in the newspaper ran, "Thinking you might wish to hear a little news from the "4th Heavy," I take the liberty of addressing you. Our fort is on an eminence, about half way between the Chain Bridge and Washington; mounts forty guns of various sizes and calibre, ranging from 10-pounder Parrott guns to 8-inch Columbiads, and from 24-pounder Coehorn to 10-inch mortars. It is the strongest fort on the line, with one exception—Fort Lyon, near Alexandria—and with Fort Marcy, a smaller fort about a half mile to the right, and near the bank of the Potomac, has been called the key to Washington." The regiment served in the defenses of Washington until it was sent to the front in 1864. Their experiences were published in a history titled *Heavy Guns and Light* in 1890.

Andrew Russell's photograph of the stables at Arlington House, used for the horses of visiting officers. The architecture of the stables echoed that of the main house, according to the 1934 restoration report: "The fine old stable, across the ravine among the trees to the west, in architectural style and materials, and with classic portico similar to the house." It burned about 1914. The picture dates from a series Russell took in June 1864.

Built in May 1861, Fort Haggerty protected the Aqueduct Bridge, as an auxiliary to Fort Corcoran. With the start of the war, the bridge was converted from canal use to foot traffic. Planks were laid to support a double-track wagon road. This was a very important river crossing—the only one between Chain Bridge miles to the north and Long Bridge to the south. Fort Haggerty was named after Col. James Haggerty, 69th New York State Militia who died from wounds received at Bull Run. The 69th New York State Militia provided one of the detachments garrisoning the fort.

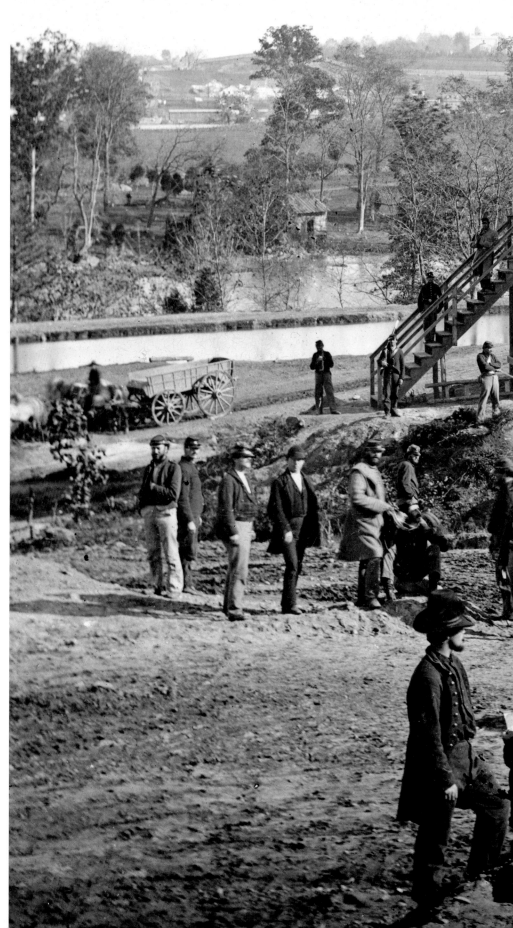

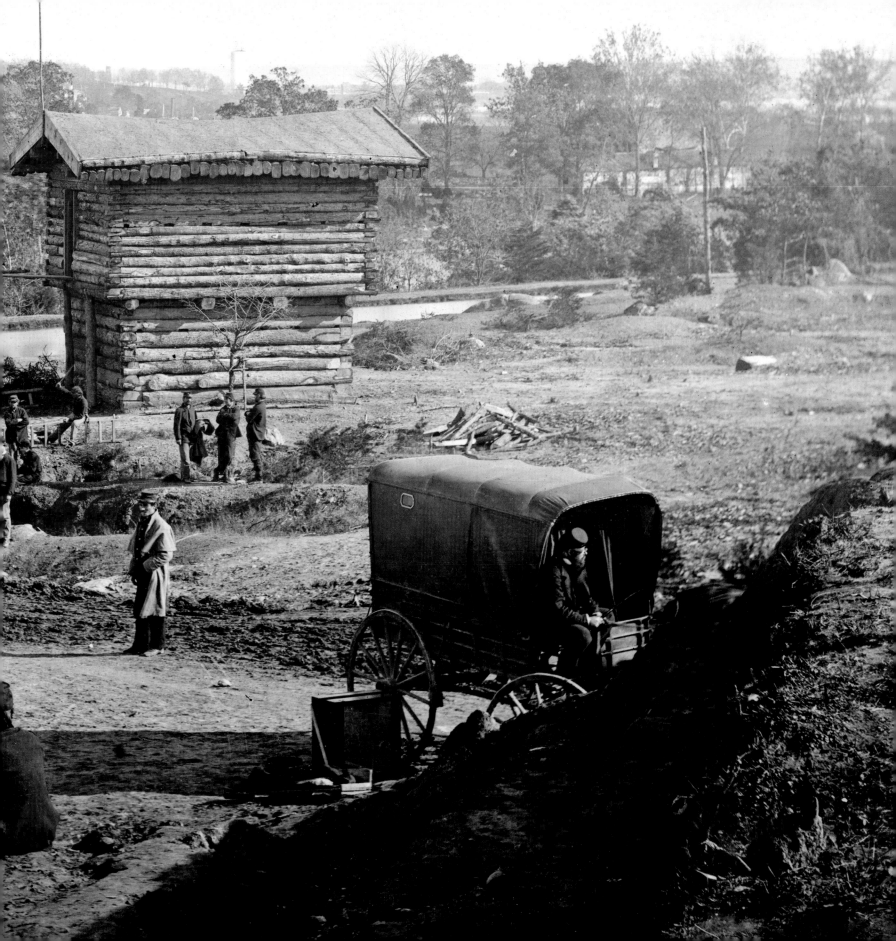

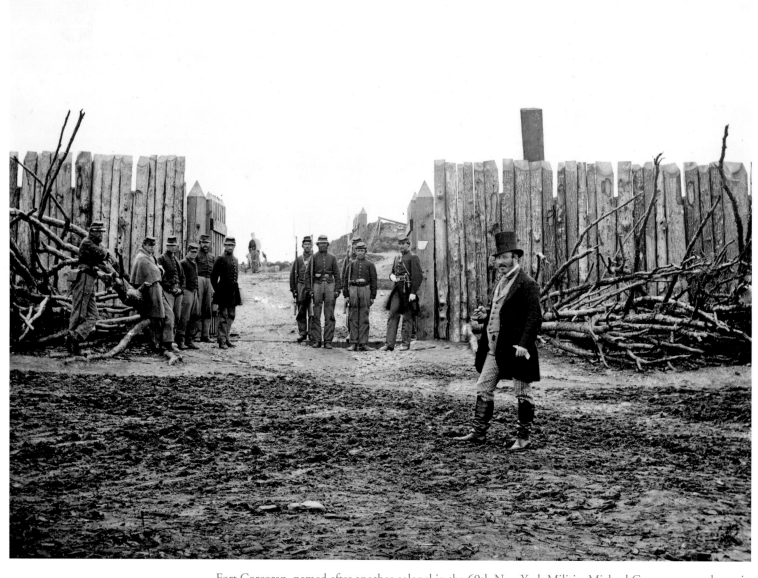

Fort Corcoran, named after another colonel in the 69th New York Militia, Michael Corcoran, was the main protection for Aqueduct Bridge. President Abraham Lincoln visited the fort several times. It was located near N. Quinn Street, between Key Boulevard and 18th Street.

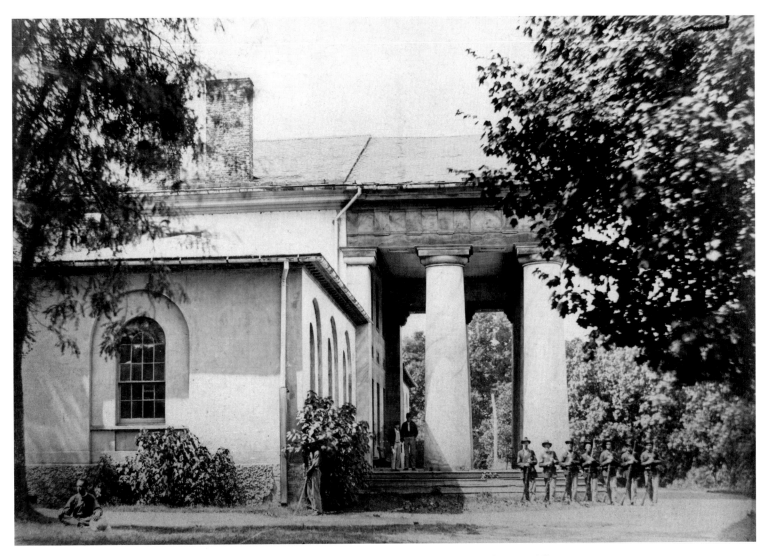

Arlington House portico from the south. Many soldiers and visitors had their picture taken on the steps. The house was a kind of talisman for Union troops, being the home of the enemy general Robert E. Lee and having been built as a memorial to President Washington. It was the major Virginia landmark one saw looking to the south and west from Washington. Here, in June 1864, soldiers and others posed in front on the steps, along with the groundskeeper.

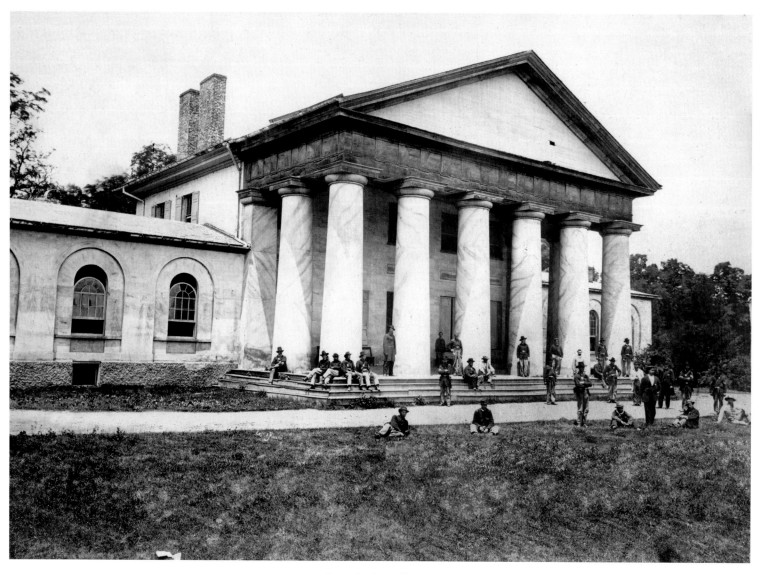

In 1864, Russell's camera captured a whole crowd of men relaxing on the portico and grounds of Arlington House. This was a very popular spot for group photographs because it was the home of the Confederate commander Robert E. Lee.

Fort Whipple lay almost due south of Fort Corcoran, on land now part of Fort Myer. It has been called "one of the finest field fortifications constructed in the Defenses of Washington" and included emplacements for forty-three guns. Fort Whipple was named after Maj. Gen. Amiel W. Whipple, who died in 1863 from wounds suffered at Chancellorsville. This June 1865 photograph shows black crepe above the door, probably a symbol of mourning for President Abraham Lincoln, who had been assassinated two months earlier.

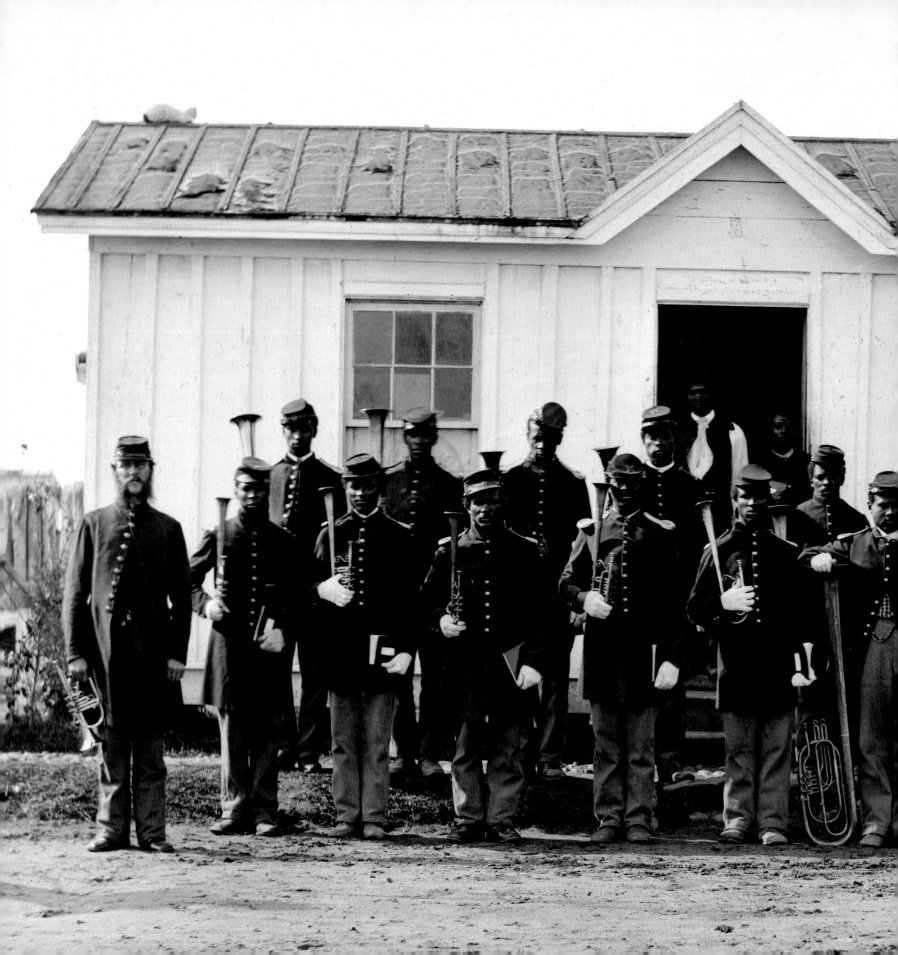

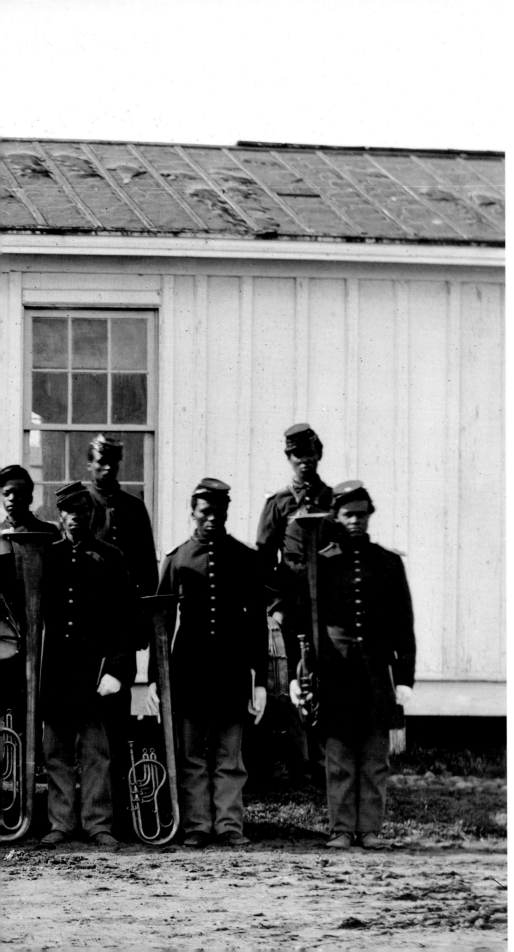

The band of the 107th U.S. Colored Infantry proudly stand at attention with their instruments at Fort Corcoran, November 1865. All those brass instruments must have made an impressive sound. The 107th was organized in Louisville, Kentucky. It saw action throughout the North Carolina campaign and was mustered out November 1866.

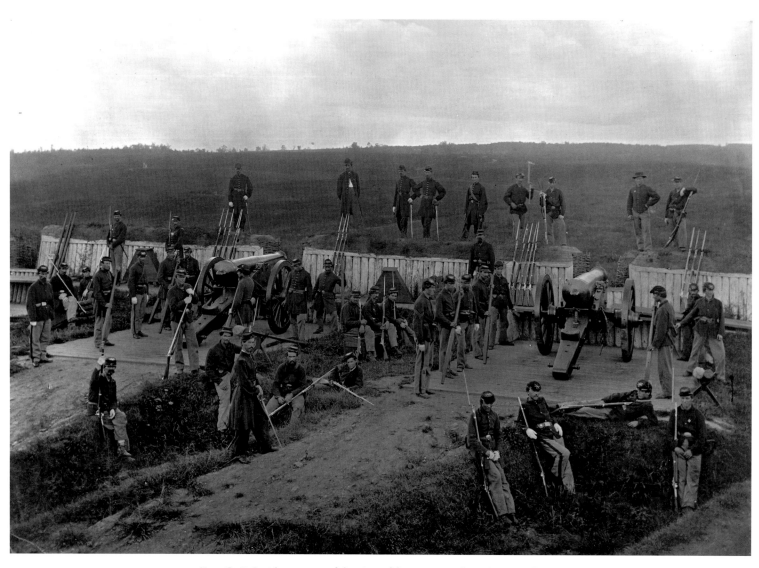

Fort C. F. Smith was one of the ring of forts surrounding the city of Washington. Here, Company F of the 2nd New York Infantry mans the battle works for a publicity photograph. Charles Fergsuon Smith, after whom the fort was named, was a Union general who was successful at the Battle of Fort Donelson in February 1862 but soon thereafter died of an injury and dysentery.

Home of Mary Carlin, in what is now Glencarlyn. This log house at 5512 North Carlin Springs Road was built about 1800 by William Carlin and is one of the earliest buildings still standing in Arlington. William Carlin had been a tailor in Alexandria whose clientele included George Washington. His granddaughter, Mary Alexander Carlin, taught in the Arlington schools, was born in this house, and lived here until her death in 1905. This undated image shows the house before later additions.

An image of the quaint-looking wellhouse at Arlington House. This was a part of the complex of outbuildings which supported life in the big house.

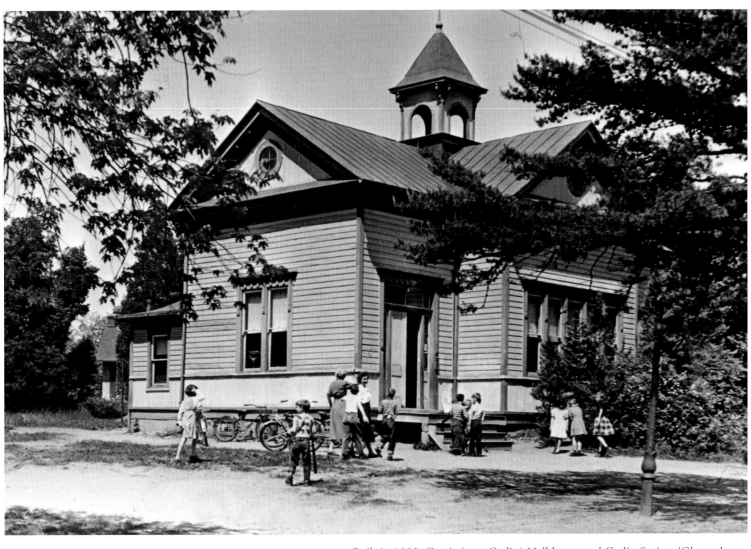

Built in 1892, Curtis (now Carlin) Hall has served Carlin Springs/Glencarlyn at various times as a community center, church, school, library, and nursery school.

Chain Bridge was the other connection of Northern Virginia to the District of Columbia and Maryland. As with Long Bridge, the river often destroyed the bridge—this was the seventh Chain Bridge, built between 1872 and 1874. It was more robust than its predecessors and lasted until 1936. Remarkably, the piers date back to the sixth bridge from the 1850s. It was 1,350 feet long, 20 feet wide, and 26 feet high, with 15-inch rolled iron floor beams.

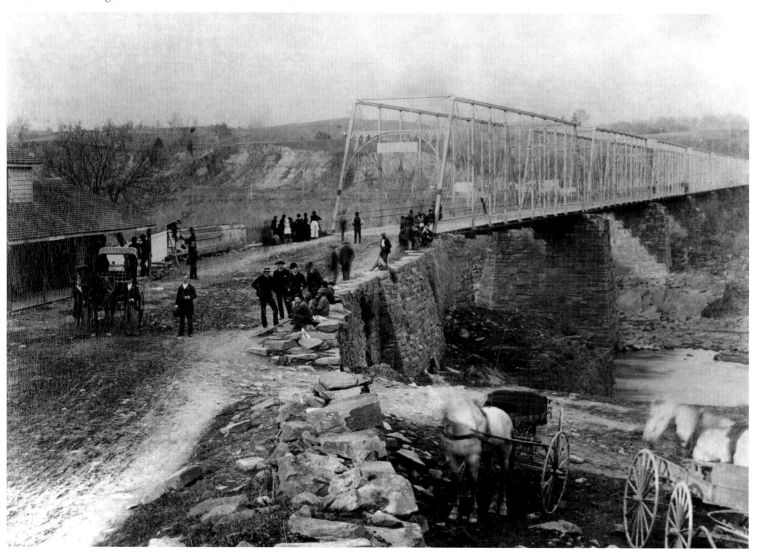

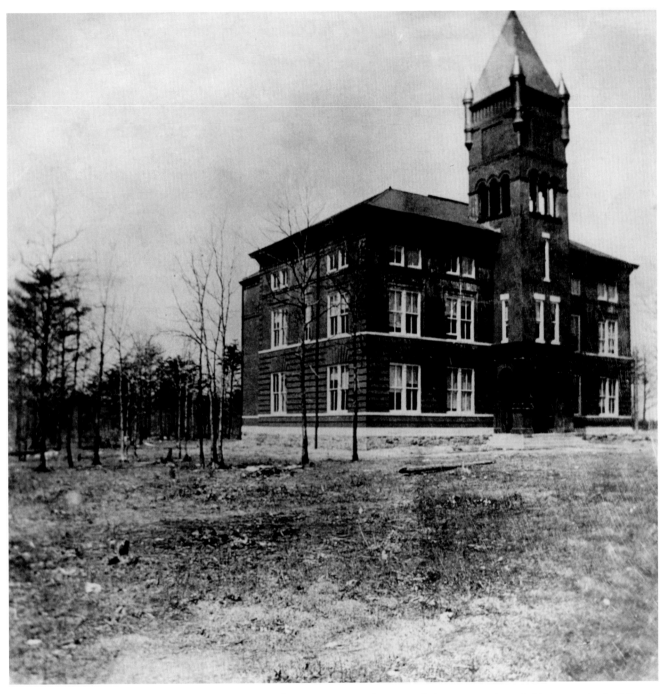

Alexandria County did not have its own courthouse until the construction of this impressive building in 1898, shown here shortly after construction. Besides the courtroom there were a jail, meeting rooms, and offices. Albert Goenner was the architect of this and other important structures in Arlington.

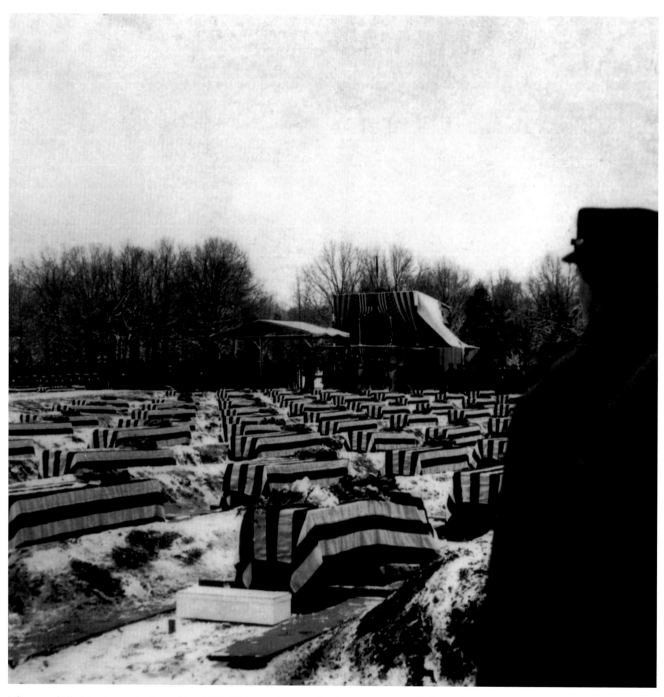

The men killed in the explosion of the USS *Maine* in Havana Harbor were originally buried in Cuba. A year later the bodies of 151 of the 253 killed were reinterred at Arlington Cemetery, December 28, 1899. President William McKinley and members of his cabinet attended.

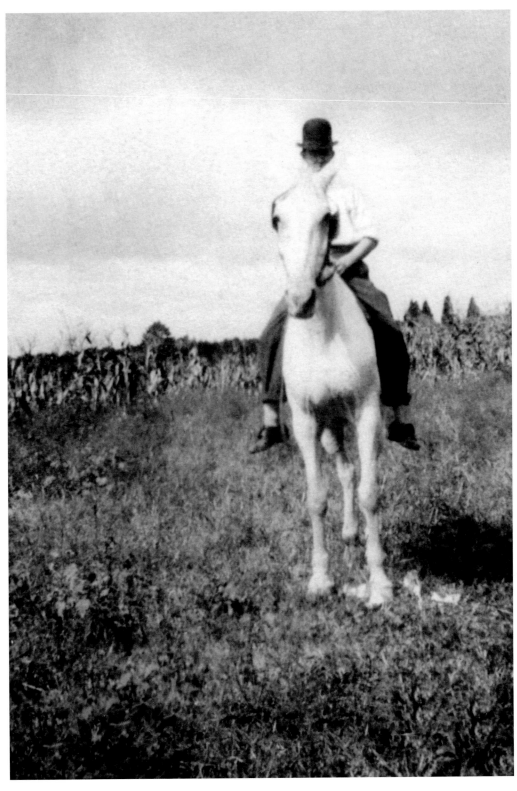

Al Thompson on the horse "Bash." Bash had been owned by one of Mosby's Rangers, "Ned" Thompson (later justice of the peace). The place where they are standing is now the site of Clarendon Baptist Church in downtown Clarendon. In 1899, it was farmland; William Ball's cornfield is in the background.

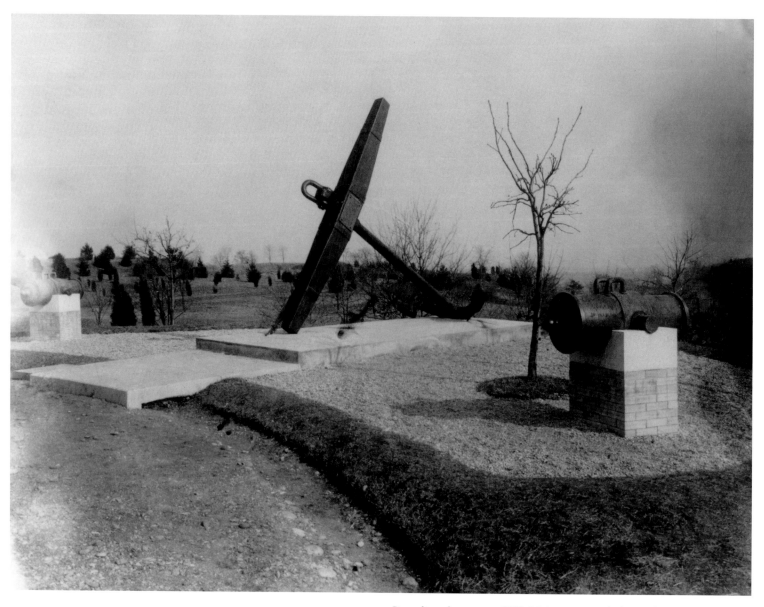

Preceding the current USS *Maine* memorial, this replica anchor, flanked by cannon, was installed in 1899 to commemorate the men killed when the ship exploded in Havana Harbor. On February 15, the anniversary of the disaster, "Maine Day" would be celebrated by placing floral arrangements on the anchor.

DEVELOPING A NEW IDENTITY

(1900–1930)

Starting in the 1900s, trolley lines were developed through the county, spurring residential development. One ran westward along the northern portion of the county, another southward on the eastern edge, and a third ran northwesterly at the western edge. A map from 1910 shows much of the county mostly farmland with residential development clustered along the rail corridors which bisected the county. Those parts of the county which were developed, such as Rosslyn and Jackson City, presented a difficult challenge. Crandal Mackey was narrowly elected Commonwealth's Attorney for the county on a good-government ticket, campaigning to clean up vice in those areas. His campaign was partially successful.

At the same time, the federal government was making its presence increasingly felt and seen. Fort Myer, established in the Civil War, was built up at the turn of the century. It was the site of Orville Wright's early aviation experiments. International communications were established with the construction of the landmark three radio towers in 1910. Congress established Arlington experimental farm in 1900, carving off a 400-acre section from the Arlington estate to serve as the Department of Agriculture's research facility.

The county shrank a bit early in the century—in 1915 and again in 1929—when Alexandria City annexed several square miles of the southern portion, despite fierce resistance. The state legislature passed legislations that prevented further depredations. Territory lost included the two county high schools. A new high school, Washington-Lee, opened in 1925, despite opposition from numerous residents employed in the District of Columbia, where they sent their children to school.

In 1920, Alexandria County was renamed Arlington County, affirming its distinct identity, separate from that of Alexandria City, but the struggle for identity faced new opposition: disagreements over whether villages should incorporate individually or if the entire county should incorporate as a city. Fears of fragmentation stopped the smaller incorporation efforts, and fears of higher taxes defeated plans to incorporate the entire county. Another sporadic, feebler impulse was for reunion with the District of Columbia, an idea generally more popular in Washington than Arlington, but advocated by some in the county.

At the center of the county, the village of Clarendon developed into the commercial core and shopping district—a short streetcar ride out from Rosslyn past the looming courthouse.

In 1900, Congress had set aside a portion of Arlington Cemetery for the burial of Confederate soldiers. The United Daughters of the Confederacy petitioned to erect a memorial to these soldiers, and the Secretary of War, William Howard Taft, agreed in 1906. The cornerstone was laid in 1912, in a ceremony which included Grand Army of the Republic commander-in-chief James A. Tanner (who had lost both legs at the Second Battle of Bull Run) and William Jennings Bryan.

Located at the junction of the railroad and Columbia Pike, Oscar Haring's general store was the first store in Barcroft and one of the first buildings in the area. Folks waiting for the train would shelter here by the stove in bad weather. Oscar's son Eddie started the little local *Barcroft News* newspaper. According to its masthead, the first *Barcroft News* was written, edited, and published in 1903 by O. Edward Haring, the son of Oscar Haring, who ran a general store at Columbia Pike and Four Mile Run (where the Barcroft Shopping Center is a hundred years later). Eddie Haring was then eighteen years old. He was "a very bright, likeable fellow and the hero of all the neighborhood belles and the ring leader in all the sports and social events as well," according to Louise Payne's recollection in her article on Barcroft.

More recently, we have been told that the actual writer and printer of the paper was Sydney Marye, an uncle of Eddie Haring, who also lived in the neighborhood with his family. Marye's daughter, Adaline Marye Robertson, lived in Barcroft until the late 1990s and, although she was just a babe at the time, she remembers it was a family joke that Sydney insisted on crediting the paper to Haring. (Adaline was mentioned in the 1903 *Barcroft News* as "the baby at the Maryes," and she is still being honorably mentioned in the present day *Barcroft News*!)

The four pages of the paper were only 4 inches wide by 5.75 inches long. The little newspaper served a community of 20 houses, and the masthead proclaimed that it was published in "Barcroft, Va."

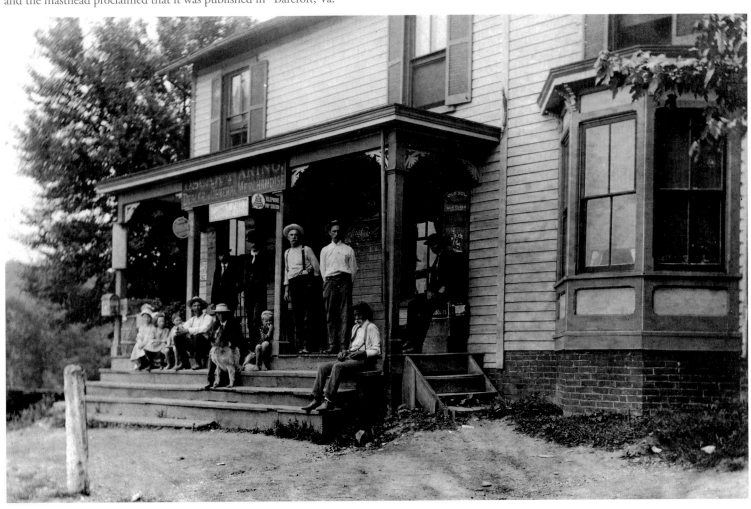

A 1903 picture of Charles Knoxville's Sunday Bar. Knoxville's bar on North Moore Street in Rosslyn epitomized the gambling, drinking, and houses of prostitution that Crandal Mackey planned to shut down when he ran for Commonwealth Attorney. Knoxville had run-ins with the law, having been fined five dollars for assault in 1895 and served ninety days in jail in 1896 for selling liquor without a license. This picture was taken during Mackey's campaign.

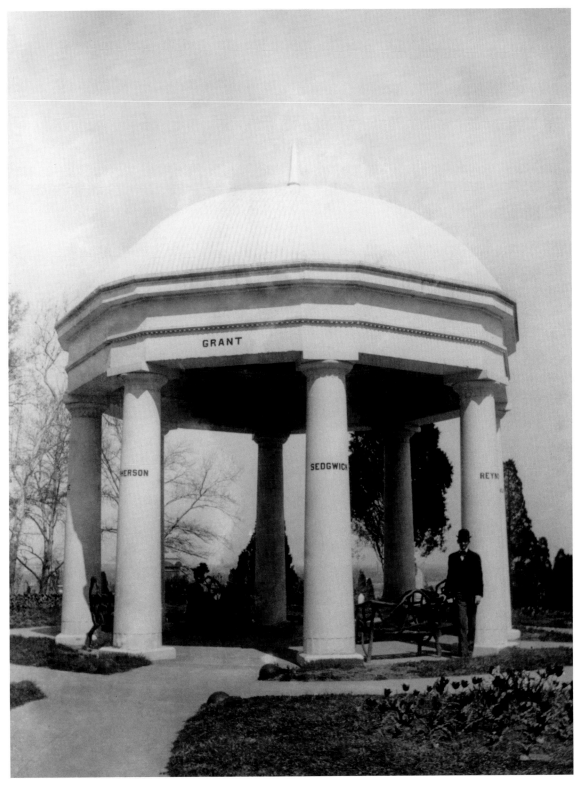

Temple of Fame at the Arlington mansion, circa 1903. It bore the names of Washington, Lincoln, Grant, and Farragut and eight Union generals--Thomas, Meade, Sedgwick, McPherson, Reynolds, Garfield, Humphreys, Mansfield. Hack drivers, tour guides of the day, told credulous tourists that those generals were buried under each column. The adjacent flower bed had the number of unknown soldiers buried in the cemetery spelled out in plantings. Despite being a noted and popular landmark, it was torn down when the Lee rose garden was recreated in 1966.

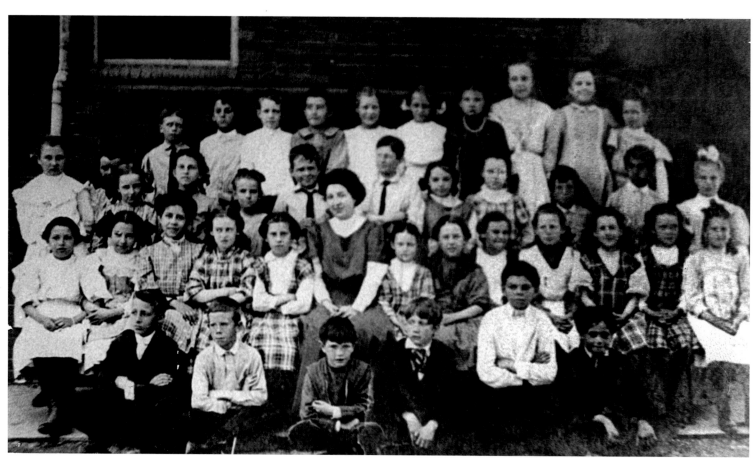

A fourth grade class at Ballston School around 1904. The county was as yet very thinly settled; schools were just beginning to proliferate.

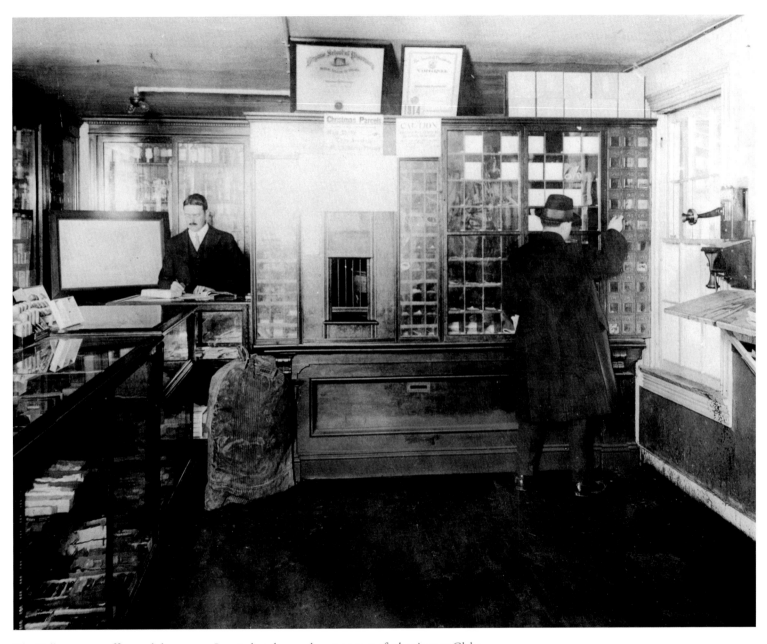

The Ballston post office and drug store. Located at the southwest corner of what is now Glebe Road and Wilson Boulevard, it was run by Dr. W. C. Wellburn, the long-time county coroner. His wife, Mary King Wellburn, was the postmistress. He had the first cement sidewalk in the county, a notable convenience for customers, allowing them to avoid some of the normal muddiness of the unpaved streets.

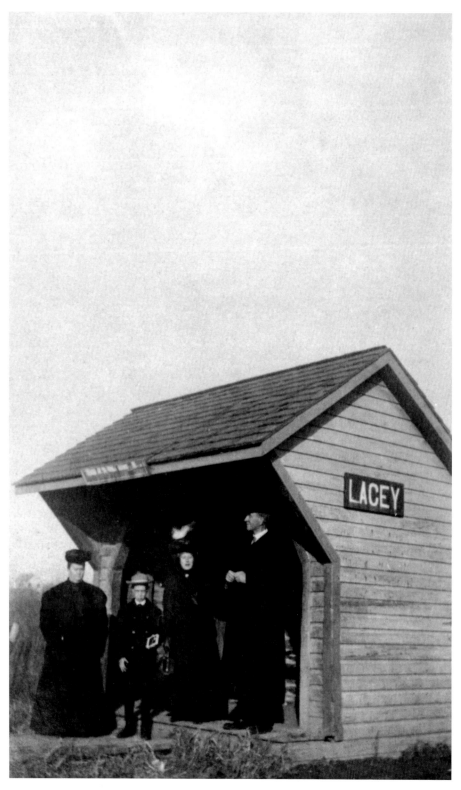

Despite its diminutive size, this was an important trolley stop when this photo was taken around 1906. Named after the adjacent Lacey family farm, the location is now the site of a Holiday Inn. Pictured are Carl Porter, his cousin Ana Johnson, her mother, and Porter's uncle Carl Elof Swenson. The Johnsons were visiting from Long Island.

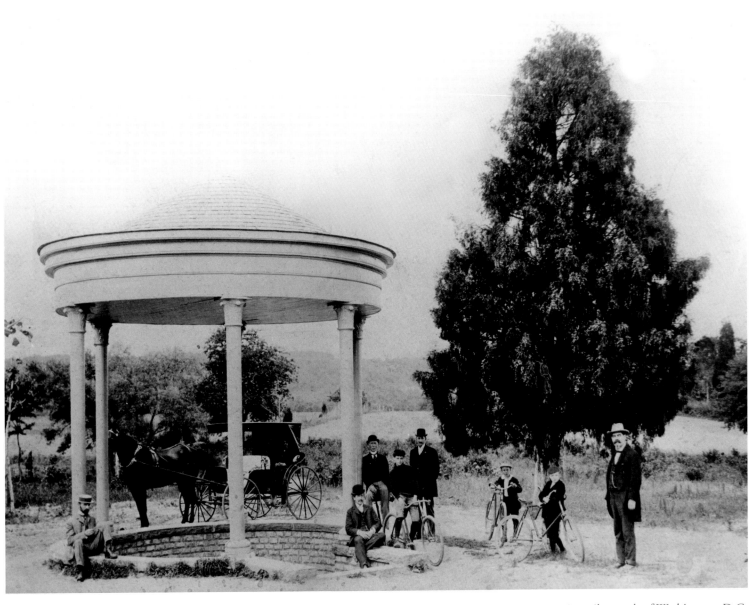

Pictured is the gazebo at the Hume Spring, on Mt. Vernon Avenue, 5.8 miles south of Washington, D.C; Frank Hume is standing furthest right. Nearby were Hume School and Hume Station. Hume Springs takes its name from Confederate veteran Frank Hume. Hume ran a grocery and liquor business in Washington, D.C., eventually becoming the largest wholesale grocer in the city. He died in 1906.

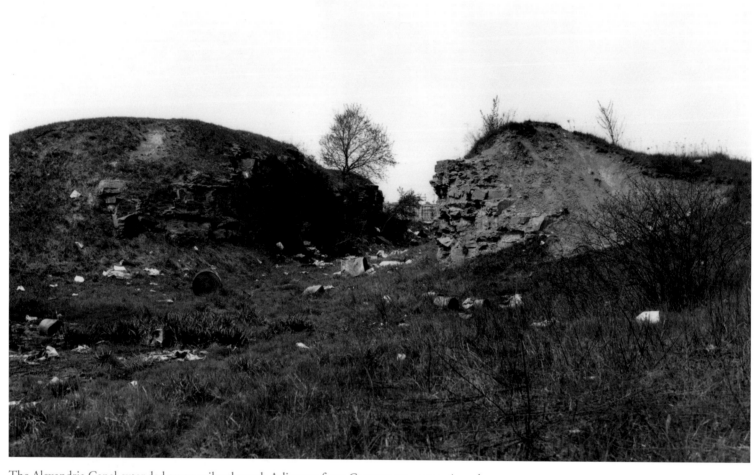

The Alexandria Canal extended seven miles through Arlington from Georgetown, across Aqueduct Bridge south to Alexandria. First authorized in 1812, the canal was not constructed and brought into operation until 1843. Through its connection with the Chesapeake and Ohio Canal, the Alexandria Canal brought flour then coal to Alexandria. Competition from railroads led to its decline and final closure in 1888. Extremely few images exist of the canal or its remains. Here are the ruins of one of the canal locks around 1900.

Aqueduct Bridge, viewed from the steps made famous in the movie *The Exorcist,* next to the Capital Traction car barn. This bleak, snowy winter view shows a bit of pedestrian traffic and the trolleys on the bridge around 1900. The rural nature of the county is evident in he view beyond. To the far right across the Potomac is the Arlington Brewery (in 1920 it would become the Cherry Smash bottling plant).

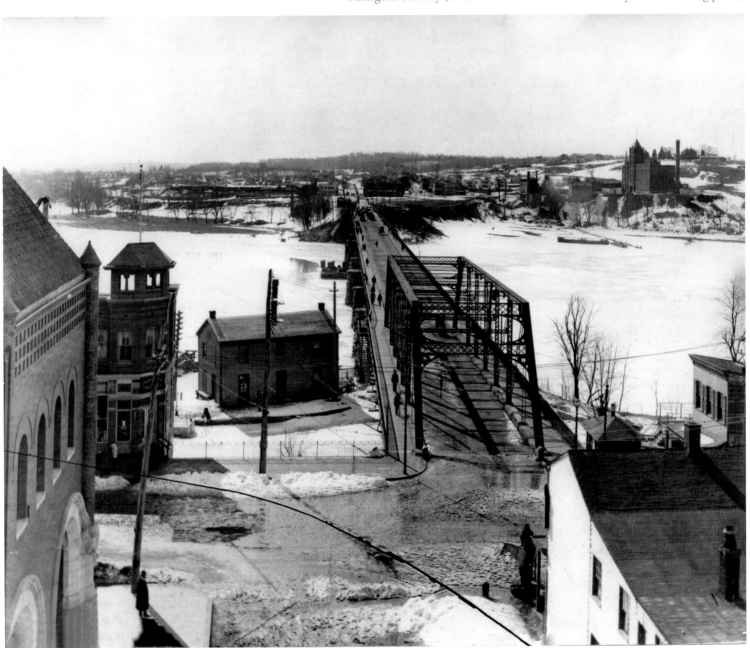

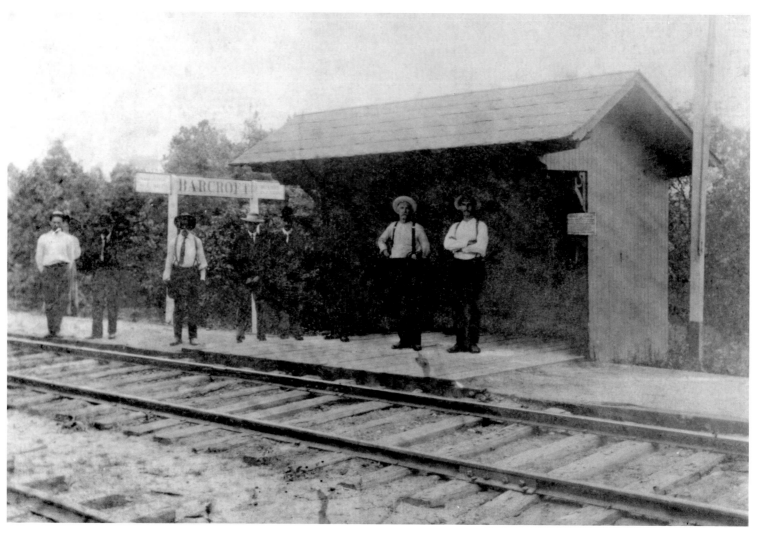

The Barcroft station about 1910, located at Columbia Pike. From here you could travel to Alexandria or Washington or west to Bluemont.

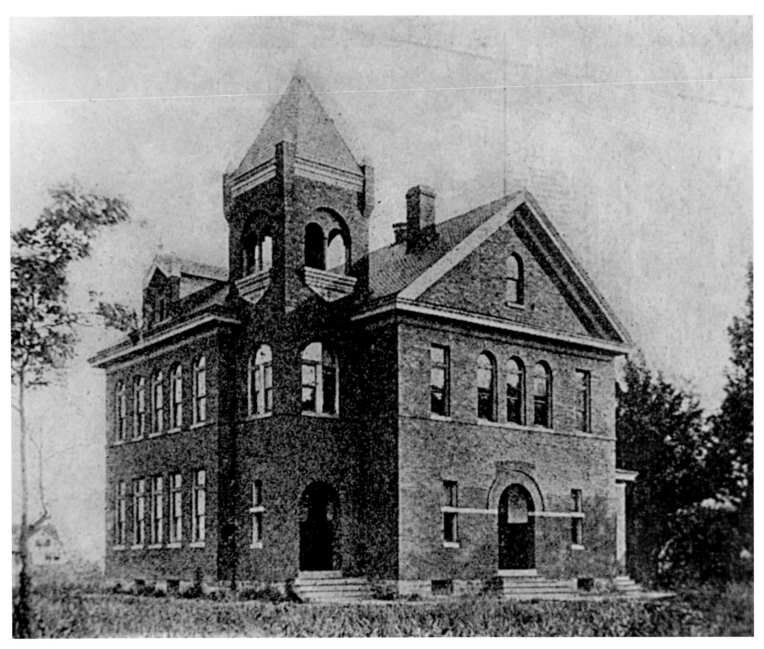

The Columbia School, built in 1905, was designed by Albert Goenner,
architect of the county courthouse. Columbia was one of the first schools
in the county.

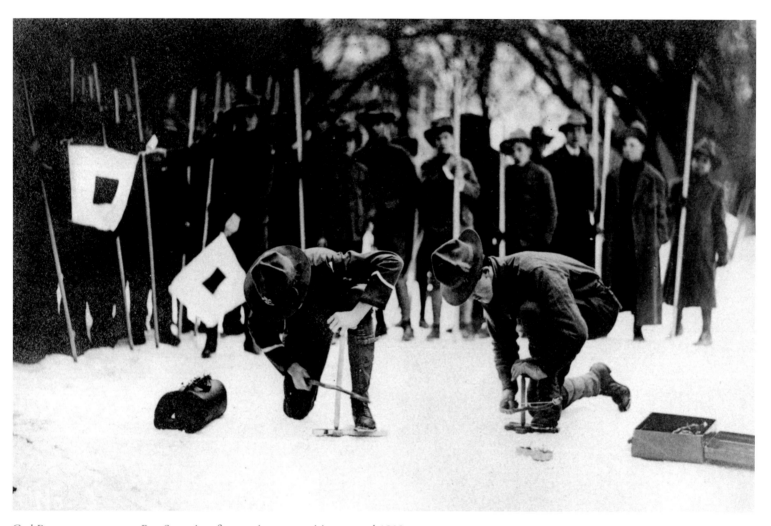

Carl Porter competes as a Boy Scout in a fire-starting competition around 1910.
This was Boy Scout Troop #1. Scouting began in Arlington in 1907.

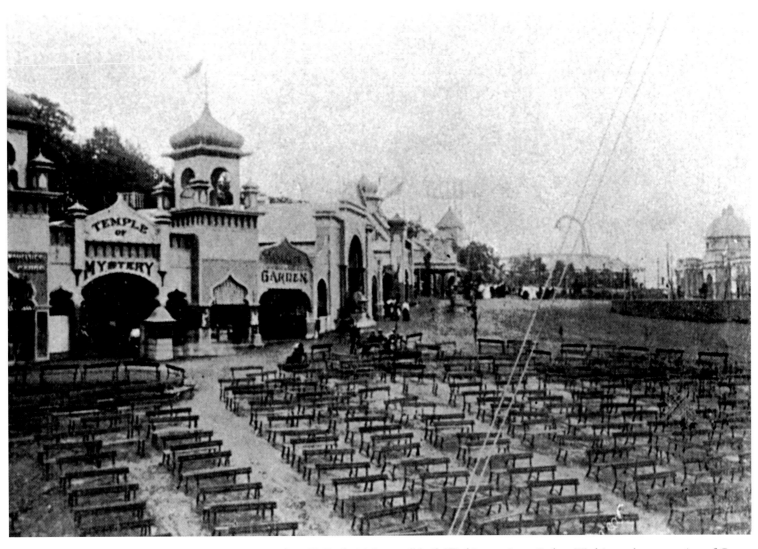

Pittsburgh's Frederick Ingersoll built Washington Luna Park as Washington's own version of Coney Island in 1906. It was near the site of the nineteenth-century failed town Jackson City at the end of Long Bridge. It featured vaudeville, bands, picnicking areas, and sports fields. It cost $500,000 to build and featured newfangled electric illumination—50,000 lights. Opening May 28, 1906, it only lasted nine seasons; a fire destroyed the famed rollercoaster in 1915.

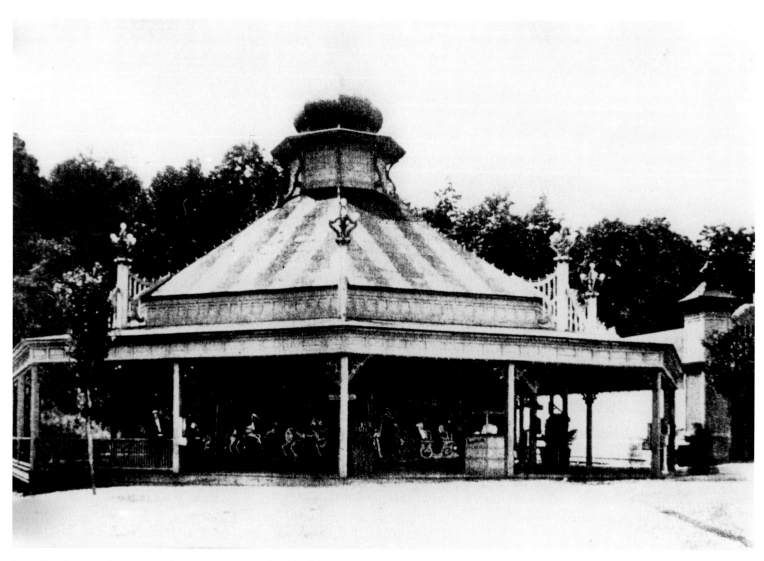

Luna Park's carousel was a popular attraction. Luna Park in Arlington was
one of many developed by Ingersoll scattered across the country.

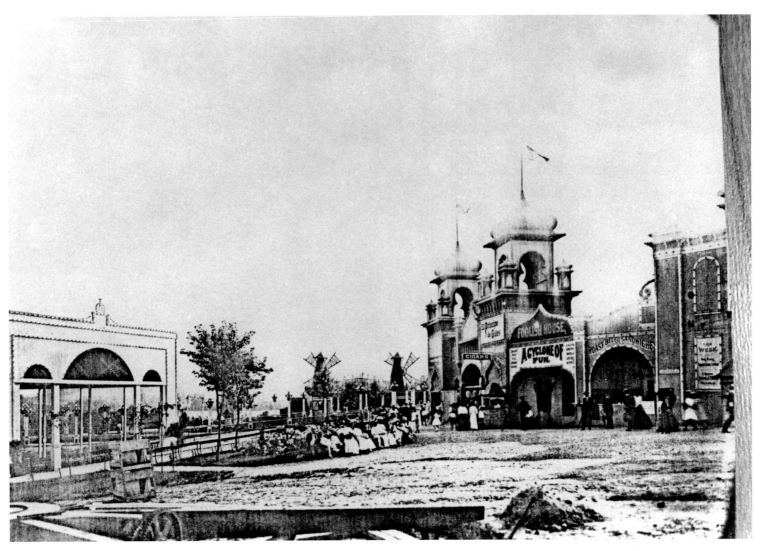

Newspaper coverage described Luna Park as the "fairy city" rising across the Potomac from Washington. These are some of the buildings which inspired that description, including two (!) windmills and "Foolish House," subtitled "a cyclone of fun." Luna Park closed in 1915. There were only a few amusement parks in the Washington area: Glen Echo opened in the 1890s and lasted till the 1960s; the District's Suburban Gardens would serve a black population after 1921 until 1940; and Marshall Hall was a steamboat ride away at Indian Point, only closing in 1982.

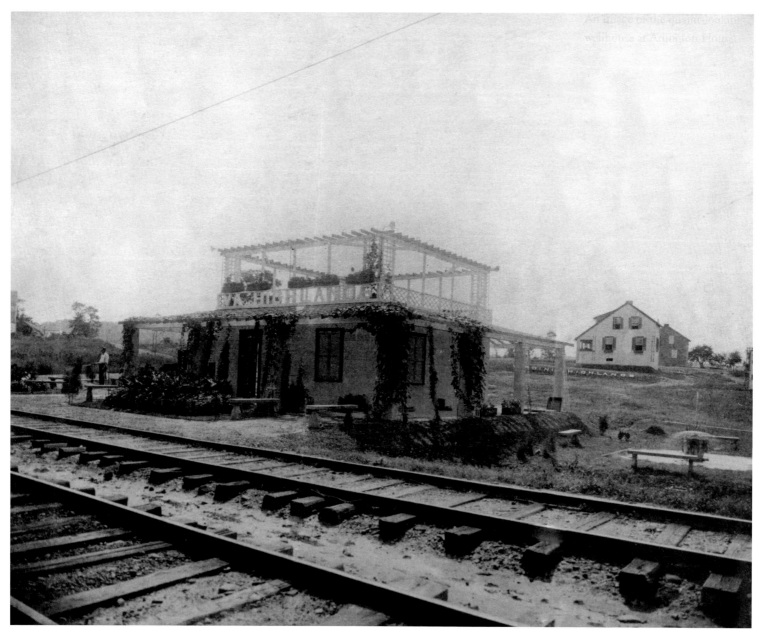

A trolley station located at what is now 23rd and Eads streets presents a rather suburban aspect, festooned with overgrowing vines, September 1, 1910. While the station name is spelled out in two-foot-high letters on the station roof, also barely visible is the subdivision name "Virginia Highlands" spelled out a slope behind the station. Virginia Highlands in 1910 was experimenting with poured concrete houses, reportedly the first practical demonstration of the technique. The resulting houses were whitewashed and landscaped to make the ideal "garden suburb."

Rosslyn Station in 1910 shows a crowded urban/suburban commuter transfer station. Looming in the distance across the Potomac is the Georgetown car barn.

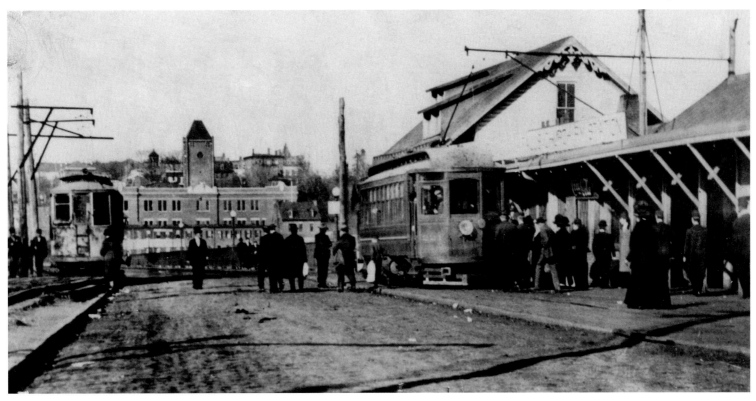

Around 1910, four young ladies of the Lee clan posed on the porch roof of Menokin, the summer home of Cassius M. Lee, one of the far-flung Lee family. One may be Marguerite DuPont Lee who summered here before her husband's early death in 1912. Menokin was advertised for sale in 1919. Cassius Lee was a cousin of Robert E. Lee. It was here in 1870 the general could talk informally of the past with his cousin, recounting battles, missed opportunities, and alternatives, according to Cazenove Lee, Cassius's son. "Only my father and two of his boys were present. I can remember his telling my father of meeting Mr. Leary, their old teacher at the Alexandria Academy, during his late visit to the South, which recalled many incidents of their school life."

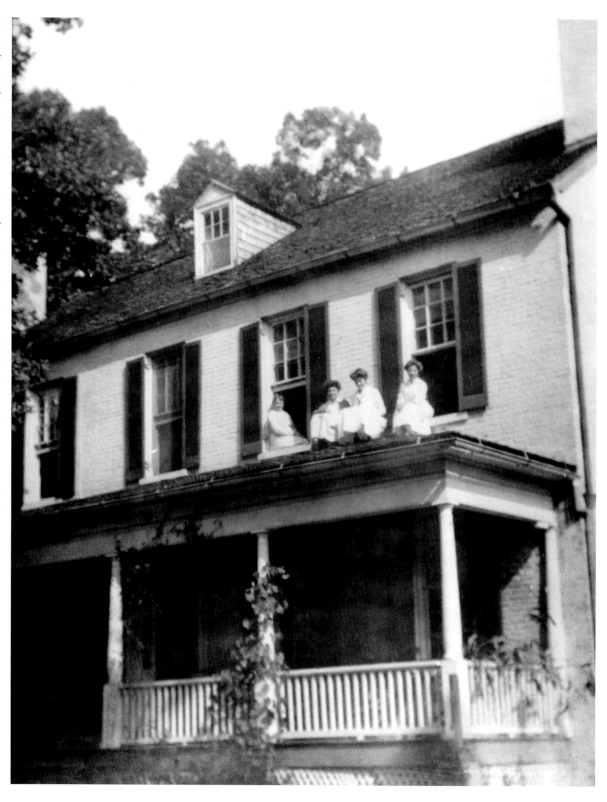

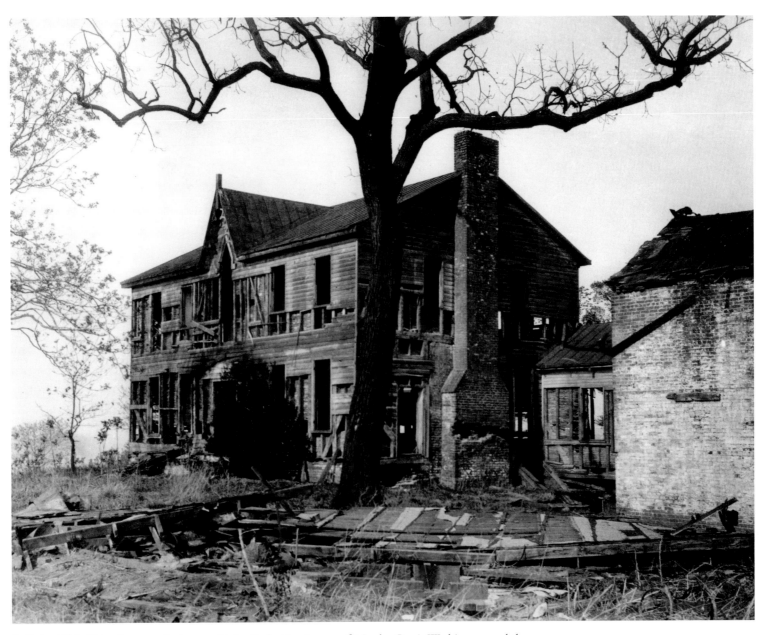

Built in 1695, Abingdon was the home of John Parke Custis, son of Martha Custis Washington and the birthplace of Nellie Custis and George Washington Parke Custis. On their father's death just six months later, George Washington brought the children into his family at Mount Vernon. The estate passed out of family hands, and the house ultimately went into sad decline, as shown in this photo from around 1910. The decrepit structure, on the verge of preservation, burnt to the ground in 1930. The remains, threatened with destruction in the face of expansion of National Airport seventy years later, met with a furor, resulting in their rescue.

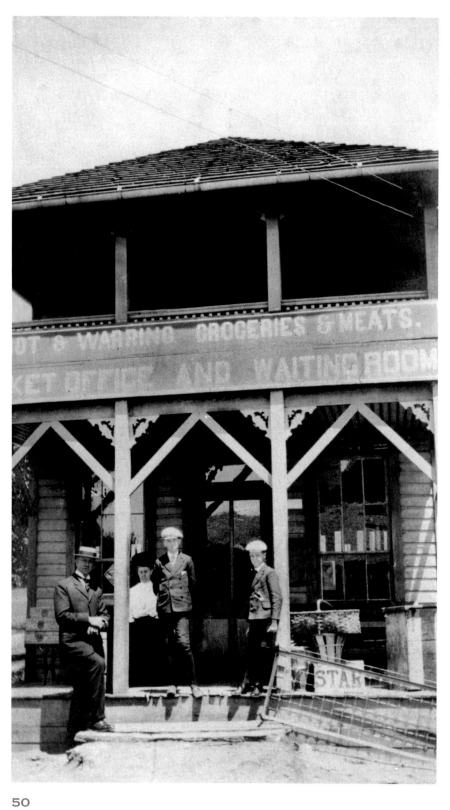

The Ballston station looks like that found in any small town across America. Smoot and Warring offered the chance to buy your groceries while you waited or upon your return.

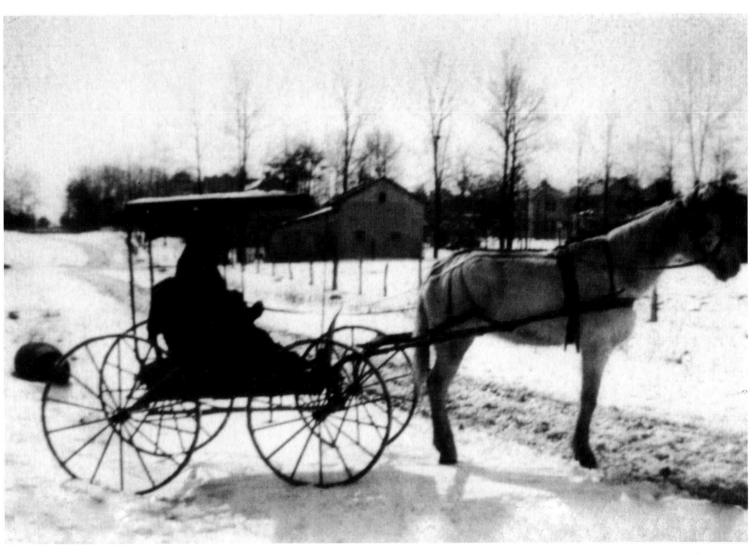

In 1911, Lt. Edward Francis "Squire Ned" Thompson posed in his buggy in the snow, at what is now the 2800 block of Wilson Boulevard. Squire Ned had been a member of Mosby's Rangers, then after the war eventually became justice of the peace. The stable in the distance belonged to George H. Rucker, whose real estate firm helped develop much of Arlington, including Ashton Heights, Lee Heights, Cherrydale, Tara-Leeway Heights, Woodlawn Village, Country Club Hills, Parkington (now Ballston), and the Westover Shopping Center.

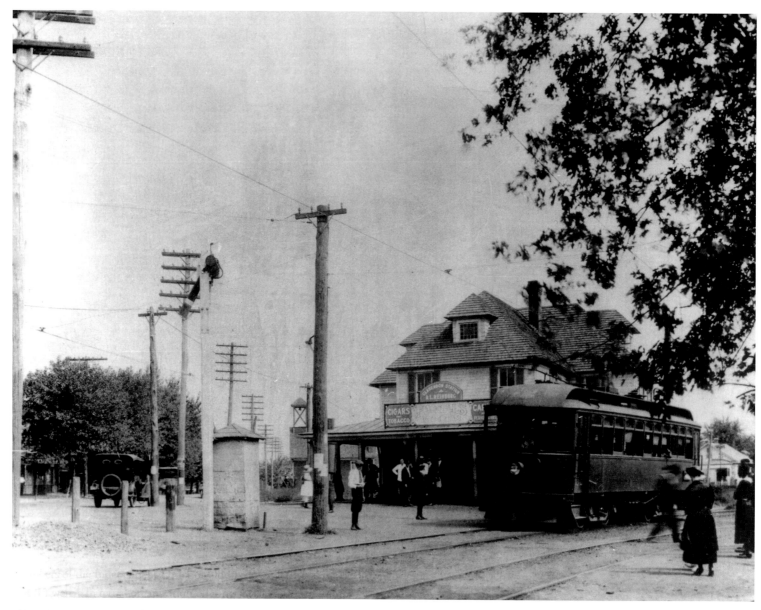

Clarendon Circle pictured here is dominated by the trolley. The circle marked the commercial center of the county well into the twentieth century.

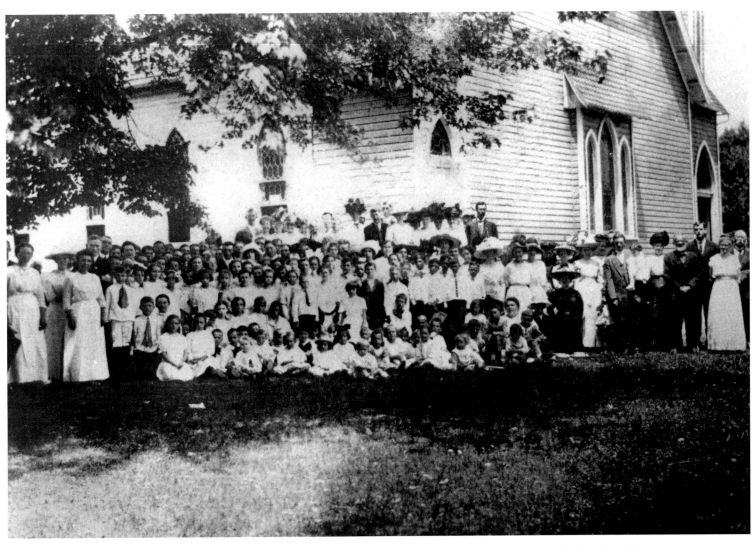

A very impressive crowd at the Mount Olivet Methodist Church in 1912; note everyone is dressed for the summer weather. Mount Olivet is the oldest church site in continuous use in the county. In 1899, Pastor James W. Norris denounced the immorality of Rosslyn and Jackson City—a cause taken up by Crandal Mackey. Sue Landon Vaughan, regarded as one of the founders of Decoration Day, is buried in the church graveyard.

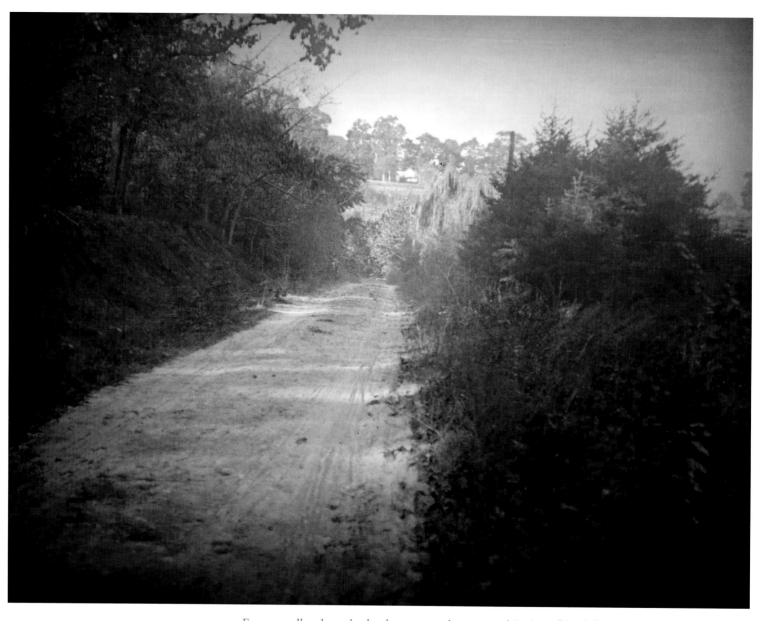

Even as trolleys brought development to the county, this view of Rock Spring Road in 1912 shows the persistence of intensely rural features. The road now runs through housing and along the neatly manicured 70-par Washington Golf and Country Club.

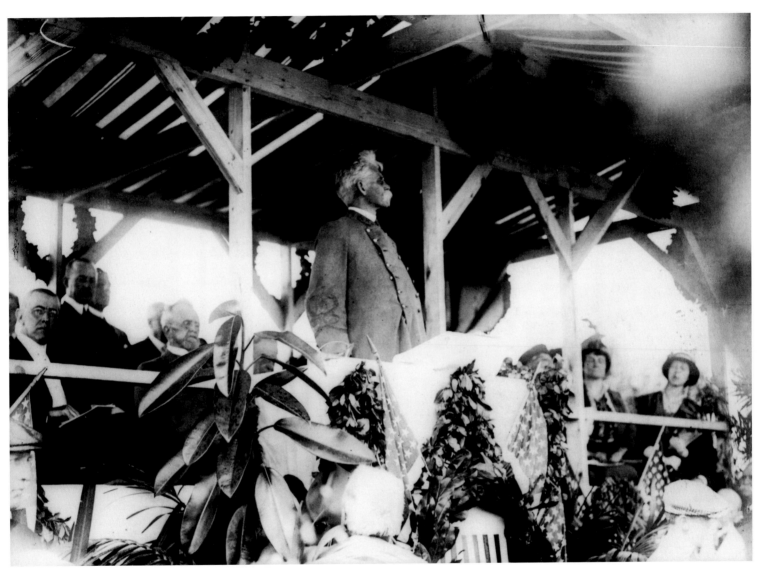

General Bennet H. Young addresses the crowd assembled for the unveiling of the Confederate war dead memorial at
Arlington Cemetery, June 4, 1914. Young was commander of the United Confederate Veterans. President Woodrow Wilson
is visible to the left. Moses Ezekiel designed the monument, which the United Daughters of the Confederacy paid for and
still maintain. Bitter feelings after the war finally had ebbed enough by 1900 for a spot to be officially designated for burial
of Confederate dead at Arlington, and installation of the memorial was an attempt at further reconciliation.

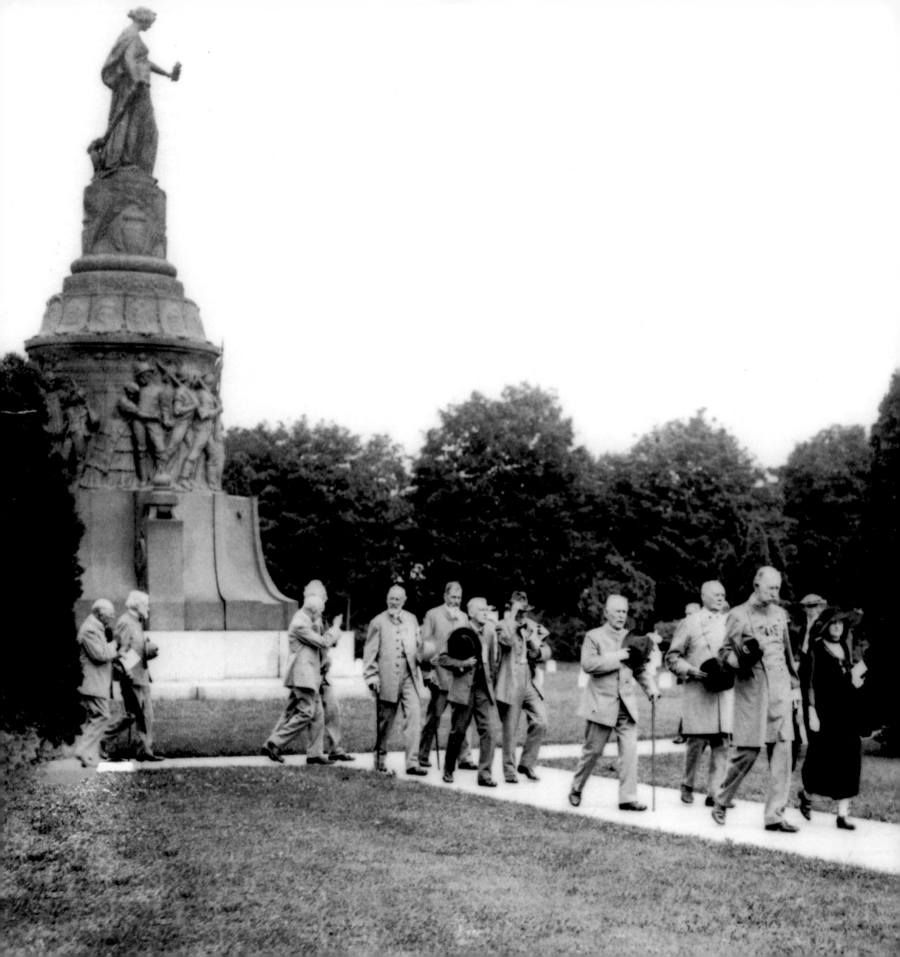

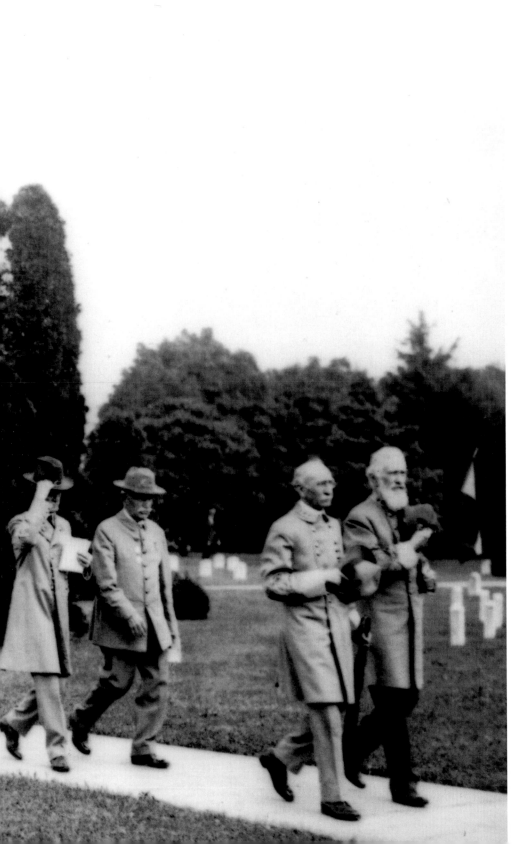

Confederate veterans in uniform leave the Confederate Memorial in Arlington Cemetery. The impressive Confederate memorial is rich in symbolism. On top of the thirty-two-foot monument, the larger-than-life figure of a woman represents the South. She holds a laurel wreath toward the south, commemorating the dead soldiers of the Confederacy. She holds a pruning hook on a plow stock, referencing the biblical passage "They shall beat their swords into plow shares and their spears into pruning hooks." She stands on a plinth with fourteen shields representing the thirteen Confederate states and Maryland. Minerva, Roman goddess of wisdom and war, is below with figures that represent the fallen South and the military services. Six vignettes depict Southerners of various races.

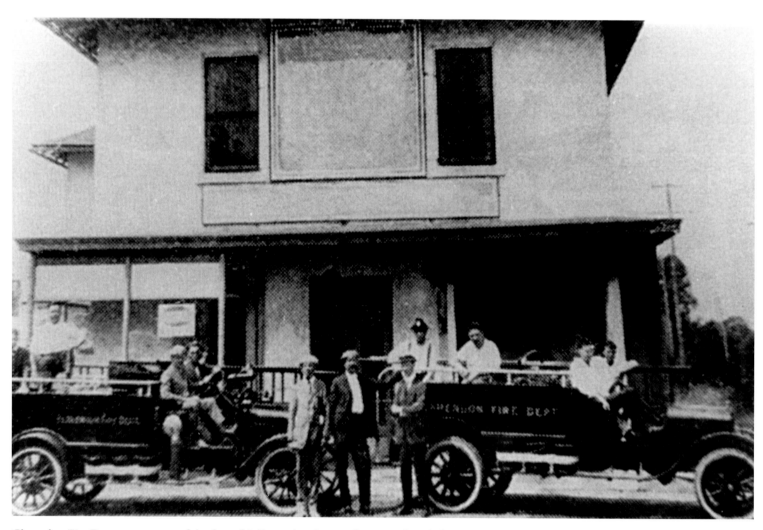

Clarendon Fire Department, one of the first of Arlington's volunteer fire units, founded in 1909 and shown here around 1921. The building, originally Ives Hall, is now the Clarendon Citizens Hall, having seen a variety of uses over the years, including newspaper office and pool hall. Firefighting was all-volunteer until 1950.

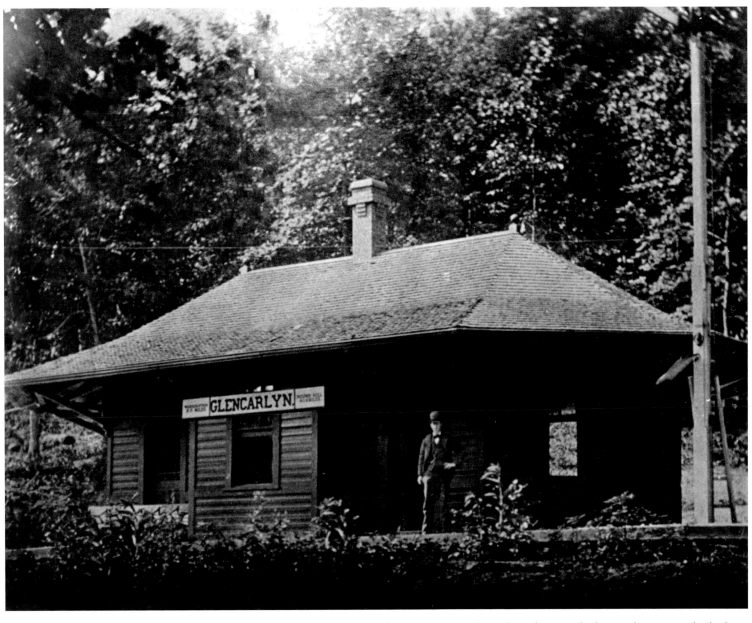

This Baltimore and Potomac Railroad train station at Glencarlyn, photographed around 1910, was built about 1890. Samuel S. Burdett, a former Missouri congressman and Union commander, developed Glencarlyn as the first residential neighborhood community in the county, platted in 1887. This was on the site of the Carlin Springs resort, which had included two springs, an ice cream parlor, a restaurant, a dance pavilion, and a swimming hole A new station was built in 1918.

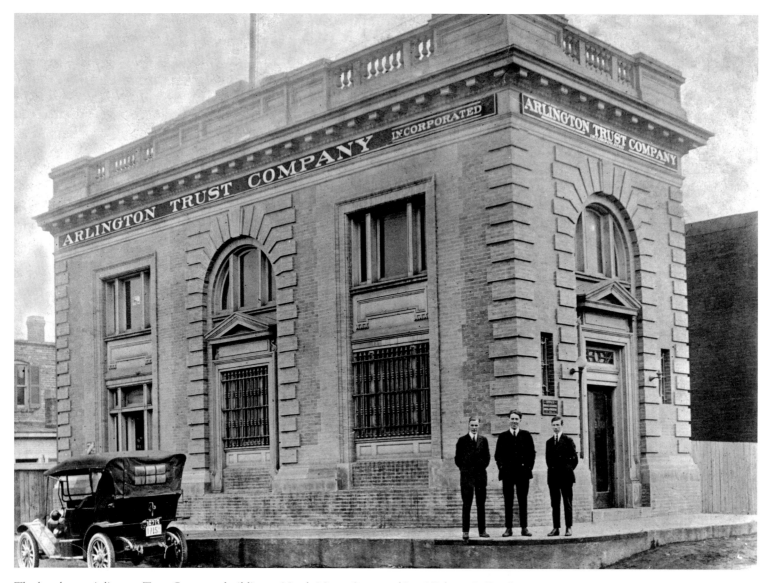

The handsome Arlington Trust Company building at North Moore Street and Lee Highway in Rosslyn was a important landmark. The Arlington Trust Company was organized in 1913 by most of the eminent men of the county and a few Washingtonians, including Fall Church's M. E. Church, W. C. Gloth, John B. Henderson of Washington, and Commonwealth's Attorney Crandal Mackey. The new institution took over the 1908 Arlington National Bank building in Rosslyn, expanding it in 1915 and 1927. In 1977, ATC merged into Financial General Bankshares. The gentlemen pictured here around 1913 are employees C. T. Merchant, Herman L. Bonney, and Bernard Boldin.

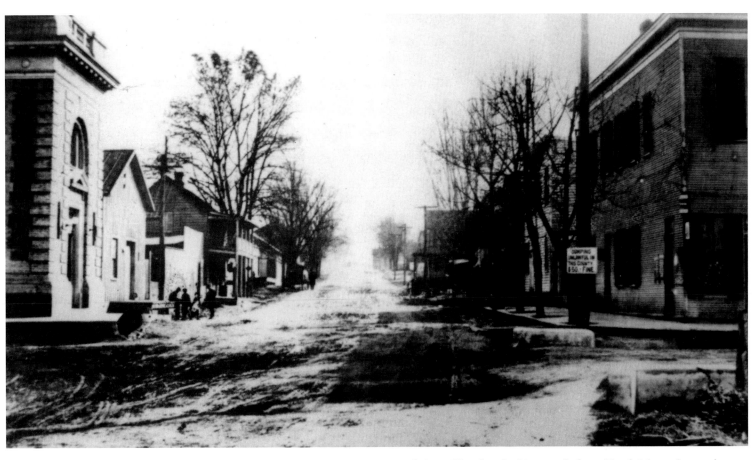

A 1914 view of Rosslyn, looking south down North Moore Street, the very picture of a small, sleepy, Southern town. Arlington Trust Company is partially visible on the left.

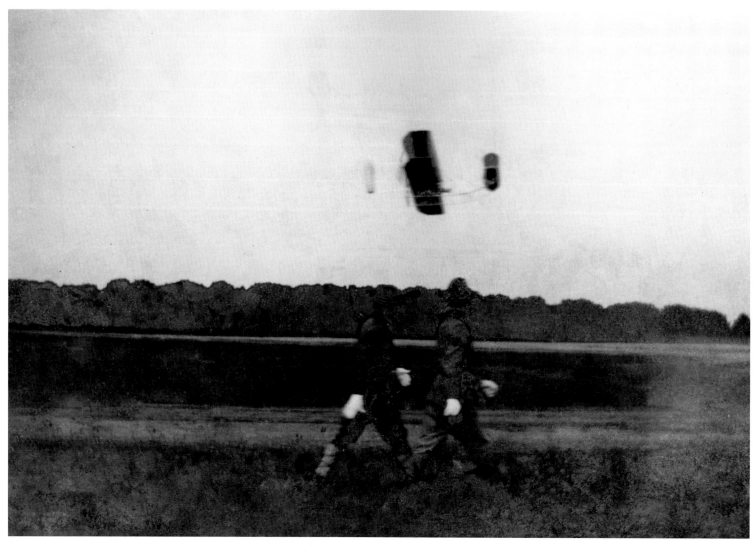

Two soldiers at Fort Myer witness an "aeroplane" flight. In 1908, Orville Wright began his experiment and flew here. Only a few days after that flight, Lt. Thomas H. Selfridge was killed in a plane crash. This image is probably Wilbur Wright flying the Signal Corps Flyer or perhaps the first plane the U.S. Army purchased—for $25,000 plus $5,000 bonus (for beating the 40 mph speed goal).

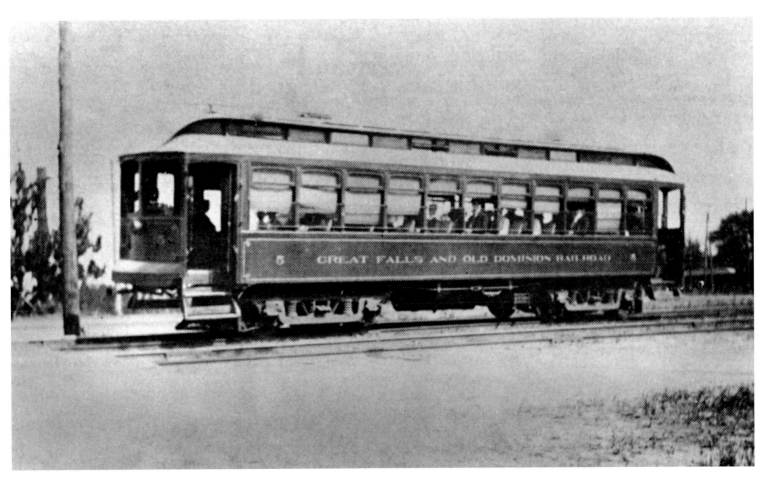

Great Falls & Old Dominion Railway Company opened service in 1906 between Great Falls and Washington. In Great Falls, three thousand people attended the tournament and ball at the opening celebrations. George G. Boteler, general manager was feted and received a gold watch for his accomplishment. In 1912, it became part of Washington & Old Dominion Railway. Newspapers made much of the picturesque scenery along the route (and soon of the new housing developments nearby).

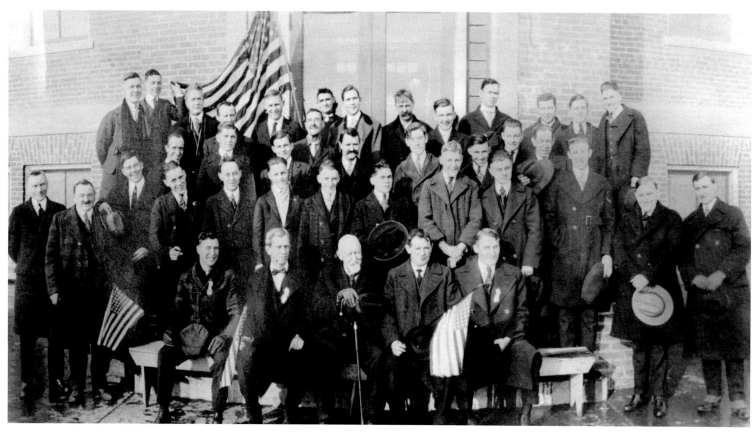

Members of the Independent Order of Odd Fellows on the steps of Ballston School. The Odd Fellows (or IOOF) were a fraternal organization offering social and financial support to members. The county played host to several lodges; this is probably Cherrydale #42 Lodge, the county's oldest.

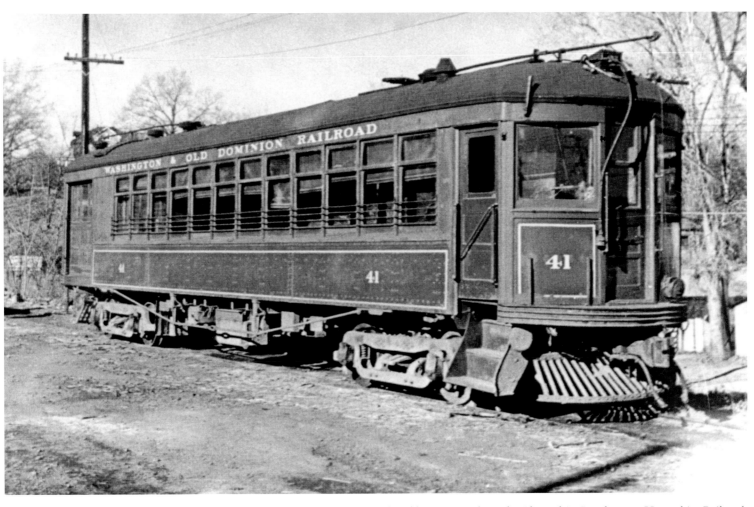

Washington & Old Dominion Railroad began in 1847 as the Alexandria, Loudoun & Hampshire Railroad. The railroad terminated in the town of Bluemont, Virginia, rather than going further west to the agricultural markets as intended. Instead, it brought farm products from the Virginia countryside into Washington, transported mail, and offered local freight service and passenger service for Washington commuters who lived in Virginia and worked in Washington. The years of World War II brought increased business, but the passengers fled in the postwar years. Passenger service ceased by 1951, and the railroad was shuttered in 1968.

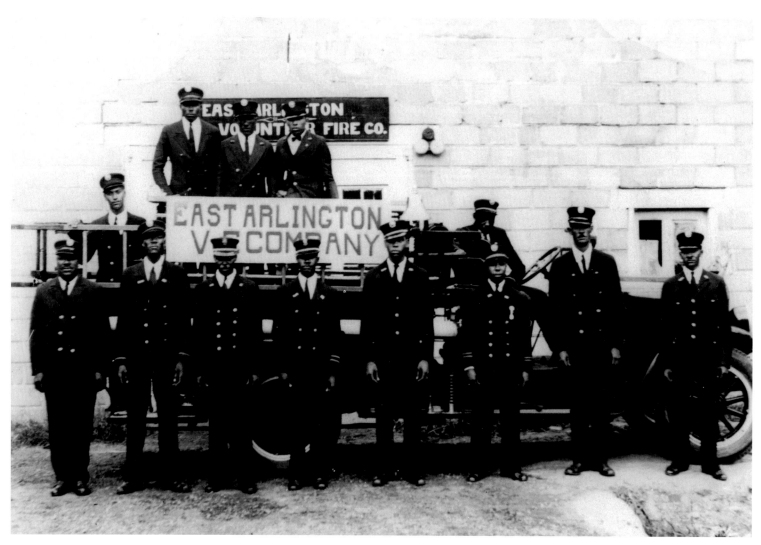

Organized firefighting began in Cherrydale in 1898. Early in the twentieth century, more companies were formed, including the all-black East Arlington Volunteer Fire Company shown here. East Arlington (also known as Queen City) was a tight-knit black community with its roots in the Reconstruction Freedman's Village. In 1941, the area was acquired by the federal government and demolished for construction of the Pentagon complex.

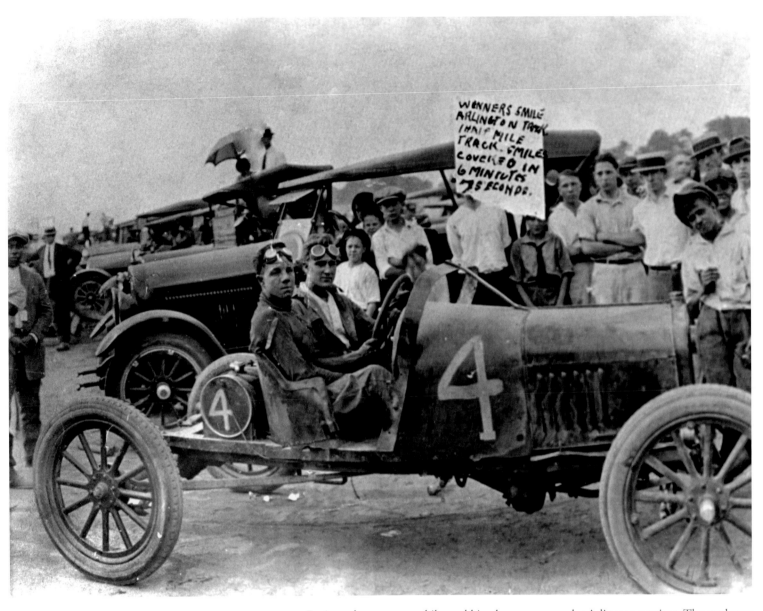

Racing—horse, automobile, and bicycle—was a popular Arlington pastime. The track was located in Jackson City, at the end of the bridge to Washington, D.C. The time recorded here of six minutes and seven seconds betters that of George Fisher (seven and one-quarter minutes) in 1922.

The Rucker building (built 1927) stood at 3179 Wilson Boulevard, where the Clarendon Metro stop now is. The Rucker building housed a variety of important local organizations, including the Arlington Chamber of Commerce and the Clarendon 50th anniversary committee. It also served as a meeting place for a variety of organizations, including the local Democratic party. George H. Rucker's real estate firm helped develop much of Arlington. He was also clerk of the court.

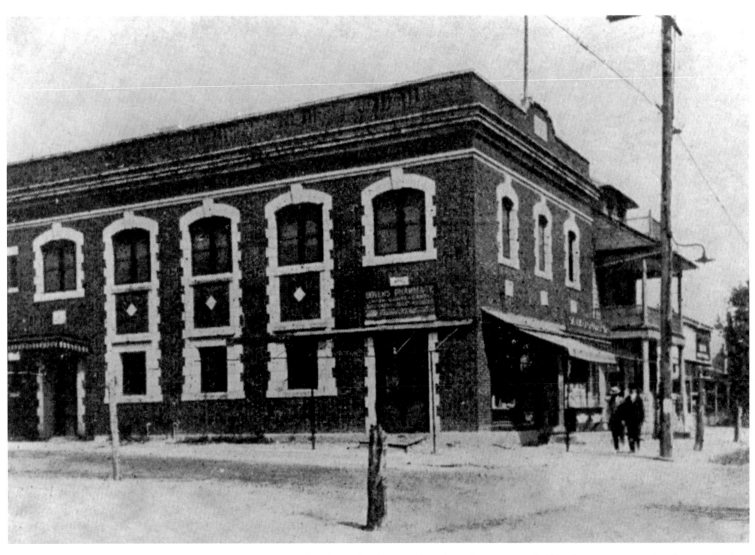

This handsome building is the Clarendon Masonic hall built in 1909. Local architects Harding and Upman designed it of red brick with Indiana limestone trim. The first floor was designed to house a store, and a side entrance for Masonic events, protected with the iron awning or marquise visible on the far left. The hall was part of a building boom in Clarendon, going up at the same time as the firehouse, schoolhouse, a town hall, and two churches.

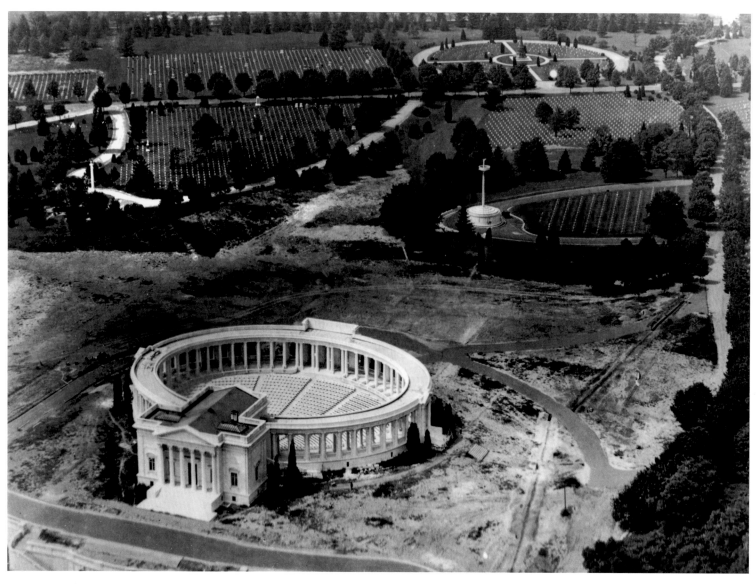

Aerial view of Arlington Cemetery to the west around 1921, dominated by the 5,000-seat Amphitheater. Visible further west is the mast of the USS *Maine* Memorial.

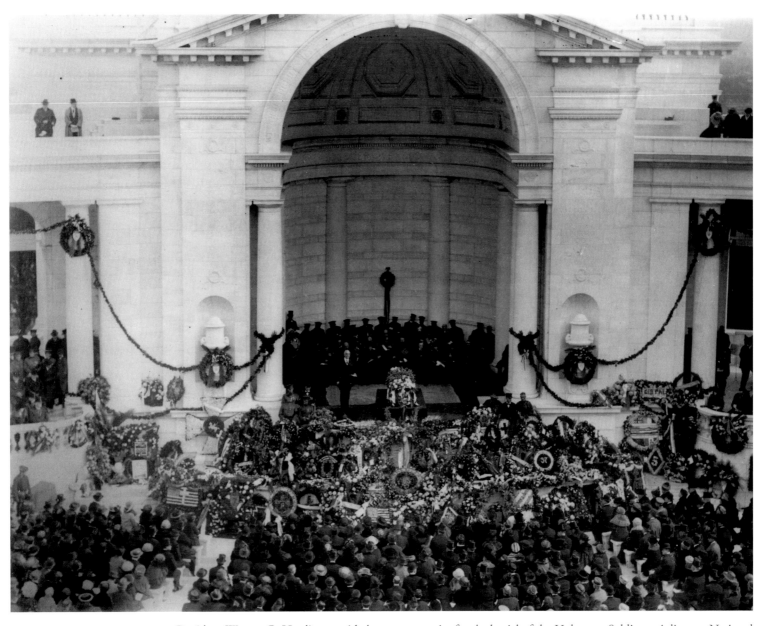

President Warren G. Harding presided over ceremonies for the burial of the Unknown Soldier at Arlington National Cemetery, November 11, 1921. An enormous crowd of over 100,000 gathered to salute the war dead. Harding's speech was also broadcast to loudspeakers at Madison Square Garden in New York and Civic Auditorium in San Francisco.

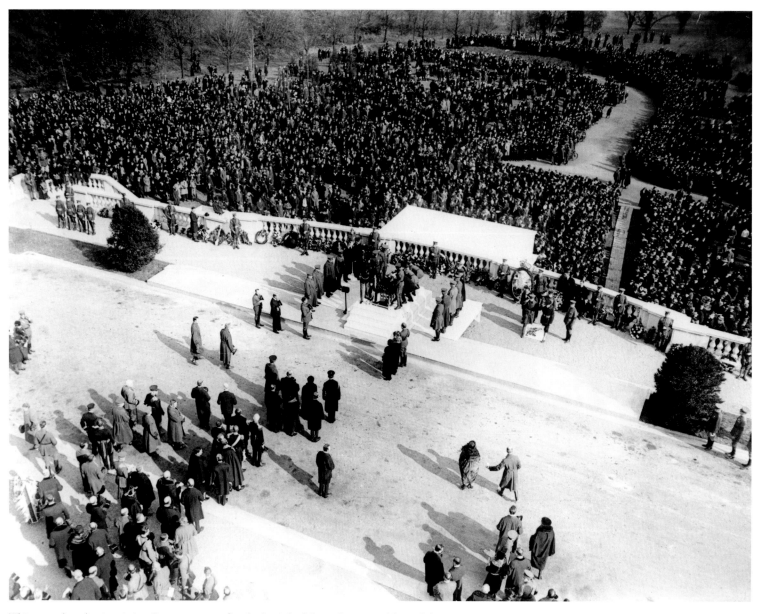

This crowd at the Armistice Day ceremony for the burial of the unknown soldier of the Great War. Over 100,000 people flooded the area. The president was trapped in the traffic jam and only arrived at 11:55 AM for the ceremony, which was to start at noon. This was one of the events which prompted the construction of a new Potomac River crossing—Arlington Memorial Bridge.

An interesting intersection of local Arlington and the federal government, around 1920. Pictured here are: Col. Robert Dye, superintendent of Arlington Cemetery; Frank L. Ball; and Ball's son, Frank, Jr. The elder Ball was the dean of Arlington attorneys, served in the state senate, and was an amateur local historian. He died in 1966, having started his legal career in 1908. His son followed in his legal footsteps. Dye would go on to establish the Columbia Gardens Cemetery and several subdivisions in Ashton Heights nearby.

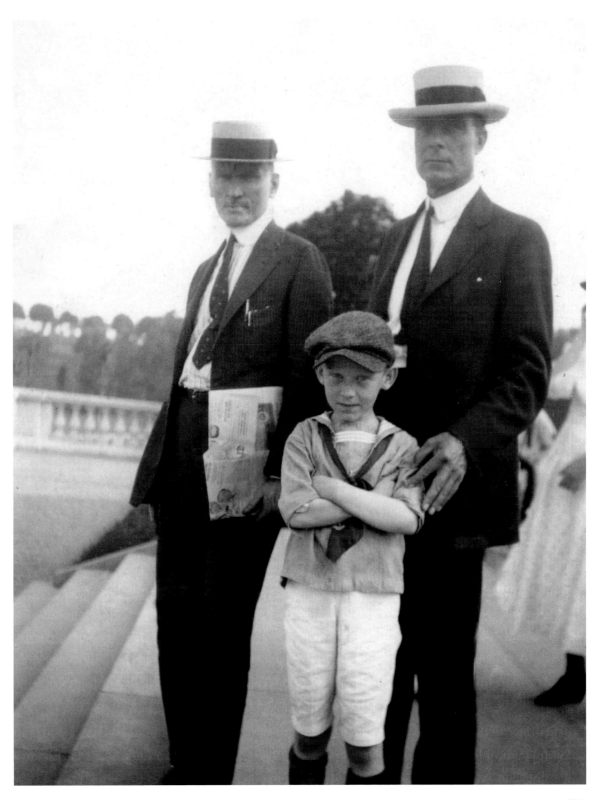

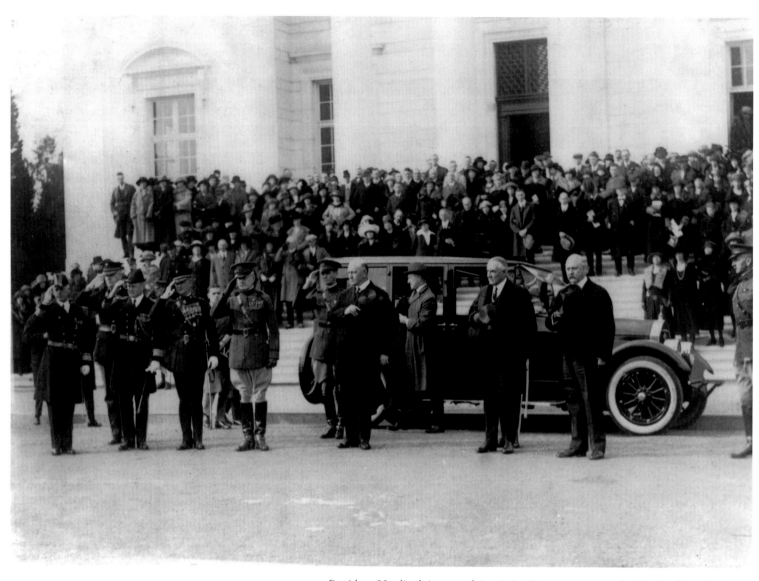

President Harding's inaugural Armistice Day ceremony at the Tomb of the Unknown Soldier in 1921 began a tradition. He repeated the ceremony in 1922.

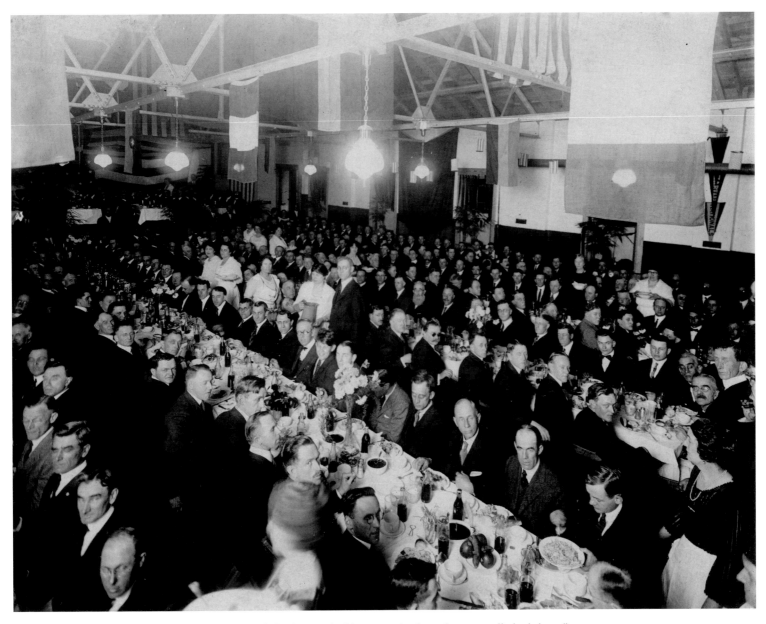

The caption on this photo from around 1924 reads "When we had banquets in those days we really had them."
This is a huge gathering of at least five hundred men for the Cherrydale Fire Department banquet. Starting in
1916, these were grand affairs with addresses from prominent Virginia politicians.

This and the following image show the damaged Chain Bridge around 1927. The 1874 bridge was showing strain from so many years in service.

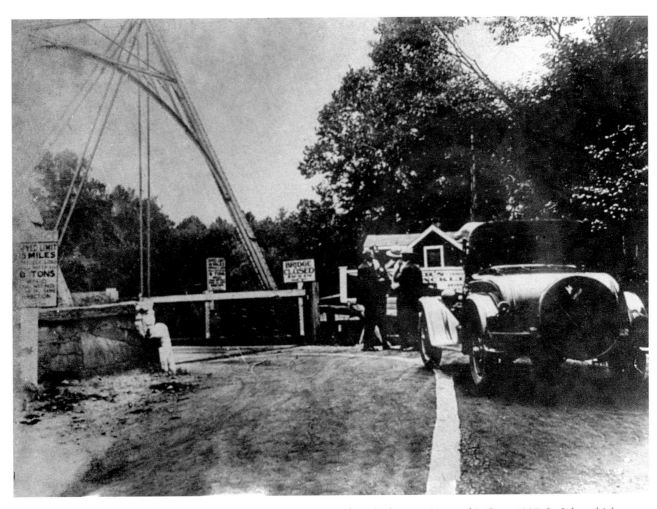

Weight restrictions for vehicles were imposed in June 1927. In July, vehicles were banned until a Virginia-side abutment was repaired.

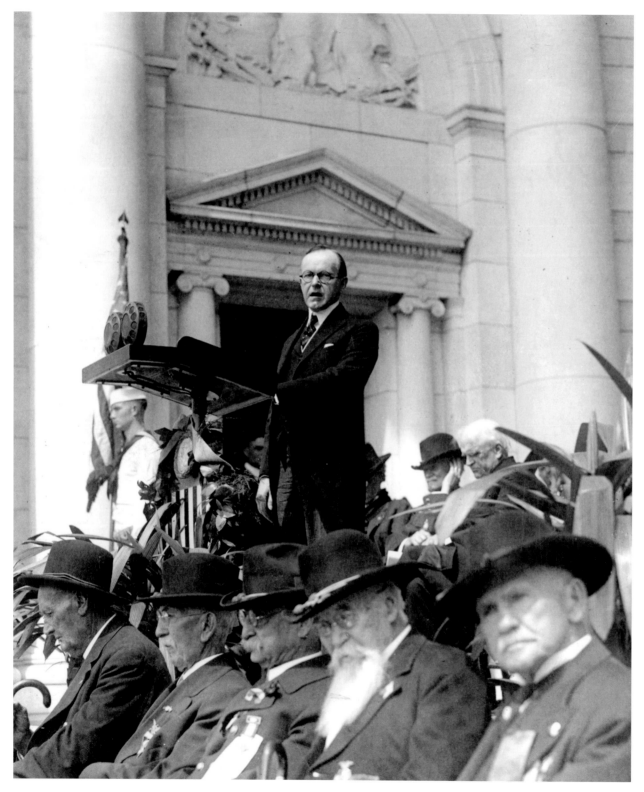

President Calvin Coolidge speaking at Decoration Day (now Memorial Day) ceremonies at Arlington, May 30, 1925. Aged Civil War veterans of the Grand Army of the Republic sit below him. Two thousand people attended, filling the amphitheater. Graves at cemeteries throughout the city were decorated. The speech was broadcast across the nation.

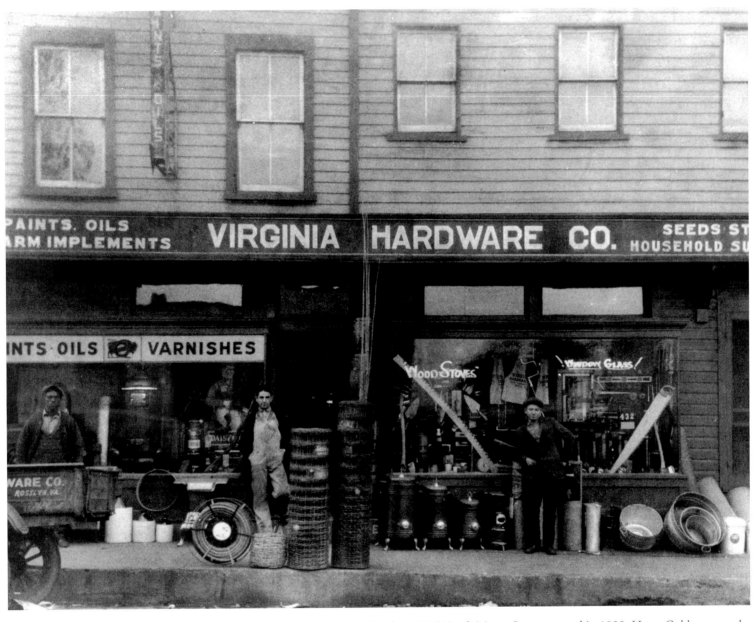

Virginia Hardware Company in Rosslyn, 2016 North Moore Street, opened in 1923. Harry Goldman ran the landmark business for many years. In 1963, it moved to Clarendon at 2915 Wilson Boulevard.

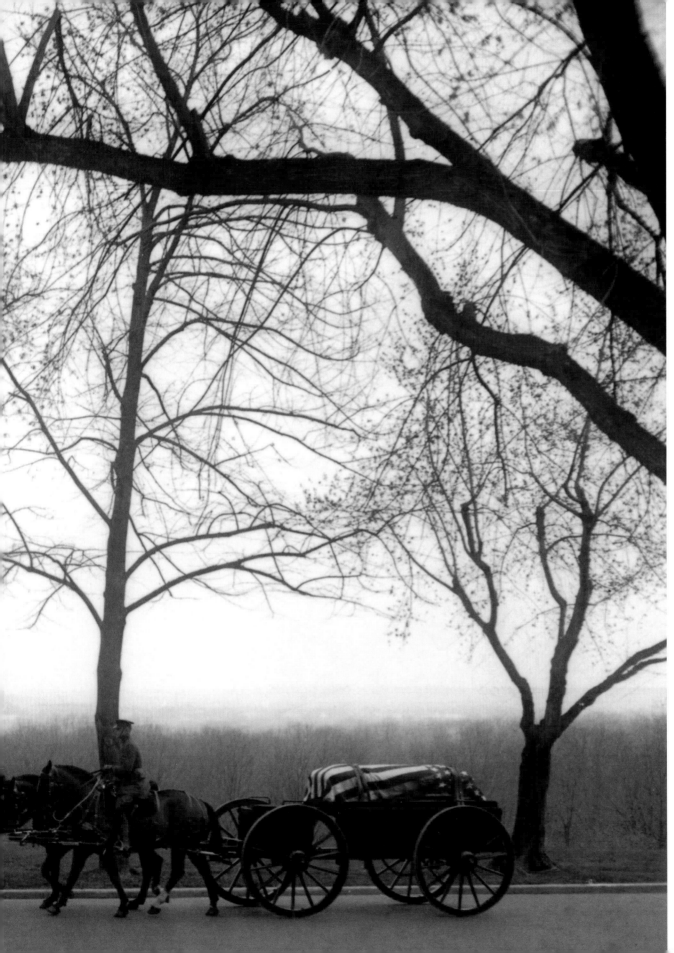

This image from one of National Photo Company's Herbert E. French albums is one of a sequence of images documenting the ceremony of the interment of a soldier at Arlington Cemetery, around 1926.

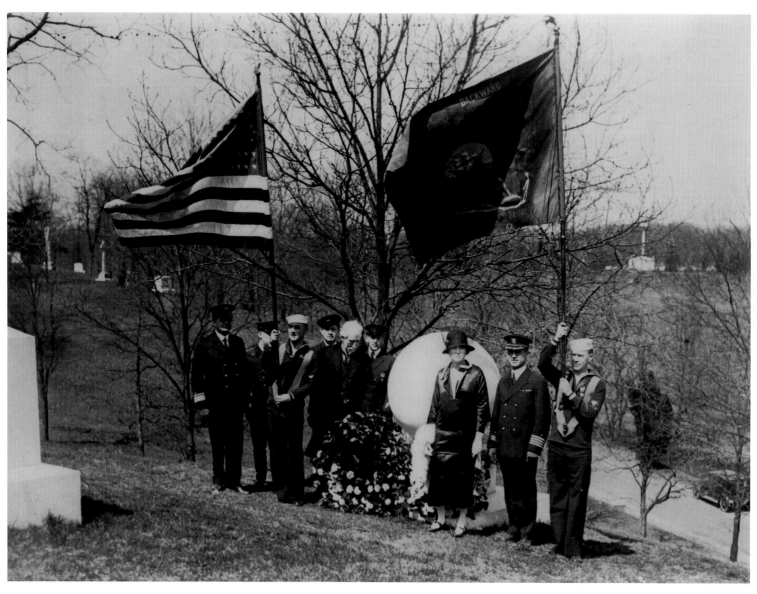

The observation of the sixteenth anniversary of the discovery of the North Pole, observed at Admiral Robert E. Peary's grave on April 6, 1925. The eighth anniversary of the United States' entry into the First World War was also observed with a moment of silence. Admiral Luther Gregory, Dr. James Howard Gore, Mrs. Edward Stafford, and Capt. E. W. Scott are among those seen here. Gregory and Gore gave the eulogies, and Scott was master of ceremonies.

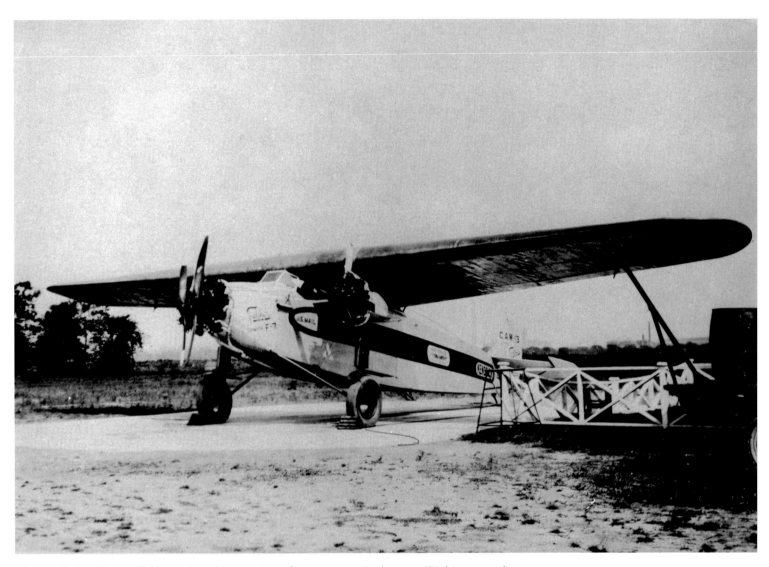

The *Kendrick* at Hoover field, 1926, at the inception of passenger service between Washington and Philadelphia. Philadelphia Rapid Transit Co. started the service in the summer of 1926, taking passengers to and from the Sesquicentennial Exposition in Philadelphia. Two planes provided the service, the *Kendrick* (named after Philadelphia mayor W. Freeland Kendrick) and its sister Fokker plane. Anthony Fokker, inventor of the plane, flew on one of the early flights and managed the service. The *Kendrick* crashed November 11, 1926. The PRT was also the operator of Philadelphia's rail transit.

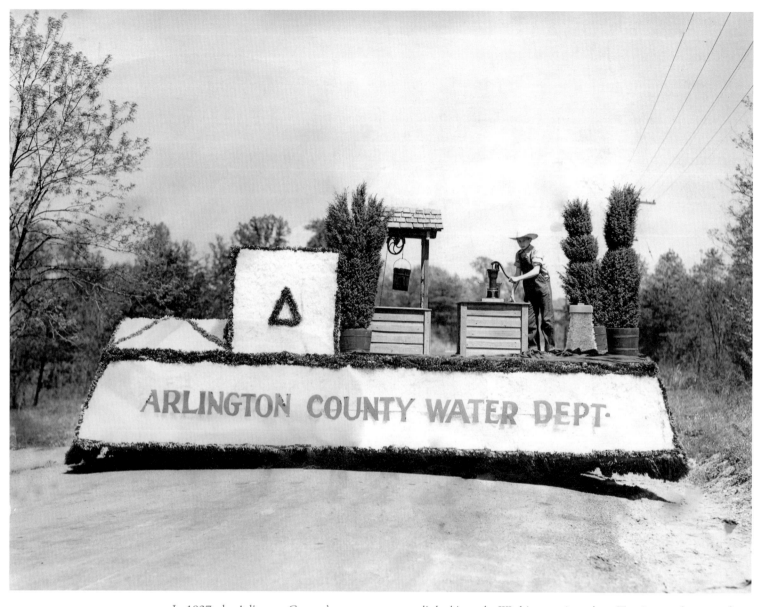

In 1927, the Arlington County's water system was linked into the Washington Aqueduct. Turning on the water from Dalecarlia Reservoir came with massive celebration—a parade, speeches, barbecue, fireworks, and dancing. The parade began at the Peace Monument just west of the U.S. Capitol, wending its way through Washington, across the Potomac, and all the way to Lyon Village. This float hearkens back to earlier days of wells and water pumps.

Arlington Beach was an amusement park on the Virginia shore of the Potomac just north of the Highway Bridge. It opened May 19, 1923, to a crowd of 7,000, and flourished in the 1920s. Swimming, rides, games, and a merry-go-round were featured, in addition to canoeing. It later added a Ferris wheel and a roller coaster and had dancing and night swimming. General admission was free. It closed in 1929 and was demolished to expand the nearby airport.

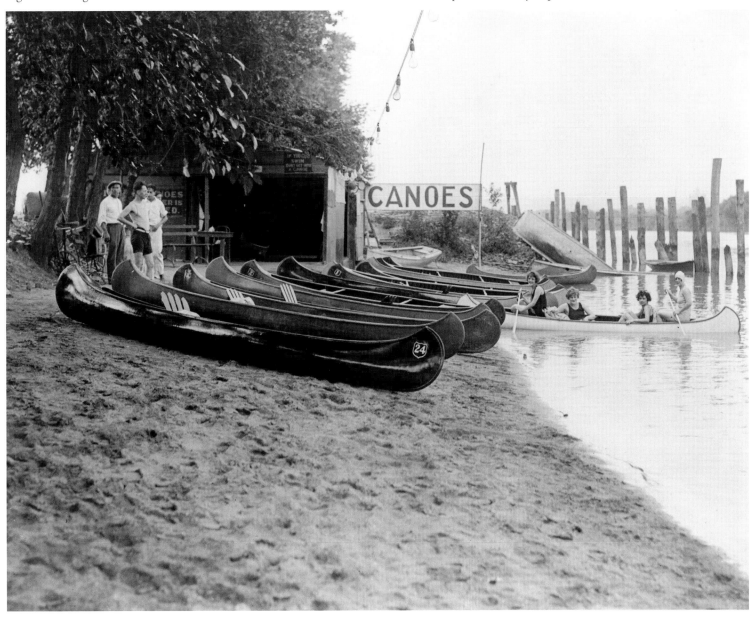

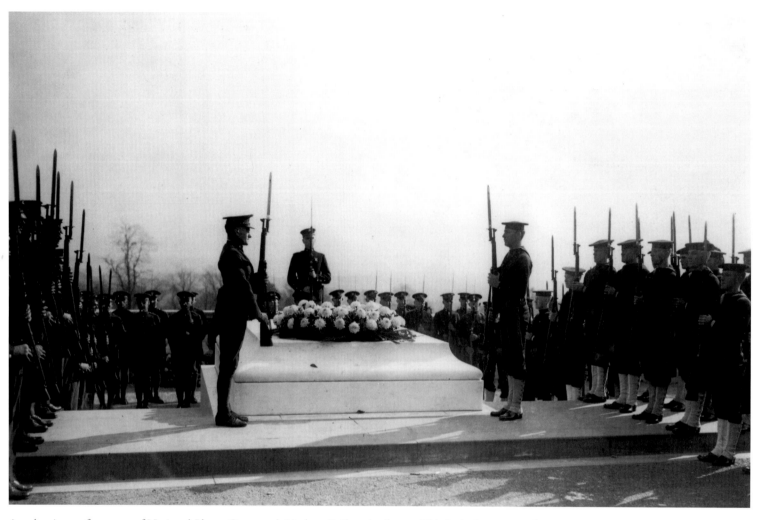

Another image from one of National Photo Company's Herbert E. French albums. This is the honor guard at the Tomb of the Unknown Soldier. This 1926 image shows the simple slab on the tomb before the January 1932 installation of the now-familiar, large, marble memorial in the form of a sarcophagus.

The Amphitheater at Arlington National Cemetery, completed in 1921. The GAR's Ivory G. Kimball lobbied for the construction of the new, grander place of assembly. A commission reported in 1909, legislation was passed in 1913, and ground was broken in 1915. This white marble edifice, designed by Carrere and Hastings replaced the original amphitheater, which was built in 1868.

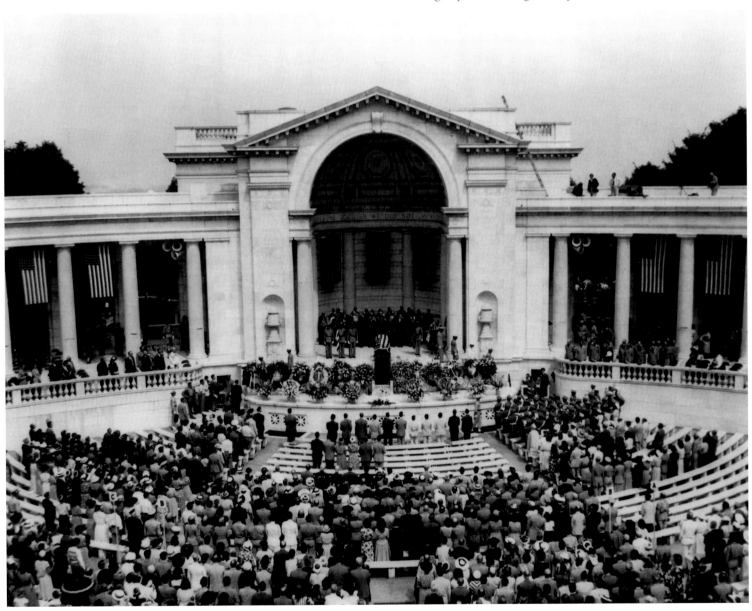

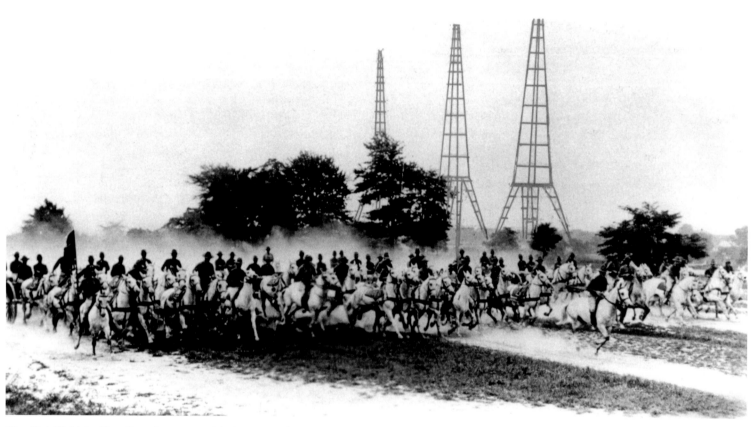

The 55th Field Artillery Battalion was widely known as the "White Horse Battery." In 1929 they engaged in a mock battle with the "Black Horse Battery" under the eyes of famed Sergeant Alvin York at the annual Army exhibition. This commemorated his exploits at the Argonne during the Great War. The radio towers in the background were a Washington area landmark from 1913 to 1941, broadcasting time and weather. It was here the term "radio" was popularized. Early experiments in 1913 tested communication to the Eiffel Tower in Paris. Due to the new National Airport, the towers had to be removed to reduce the hazard to aviation. Note: this is a composited image.

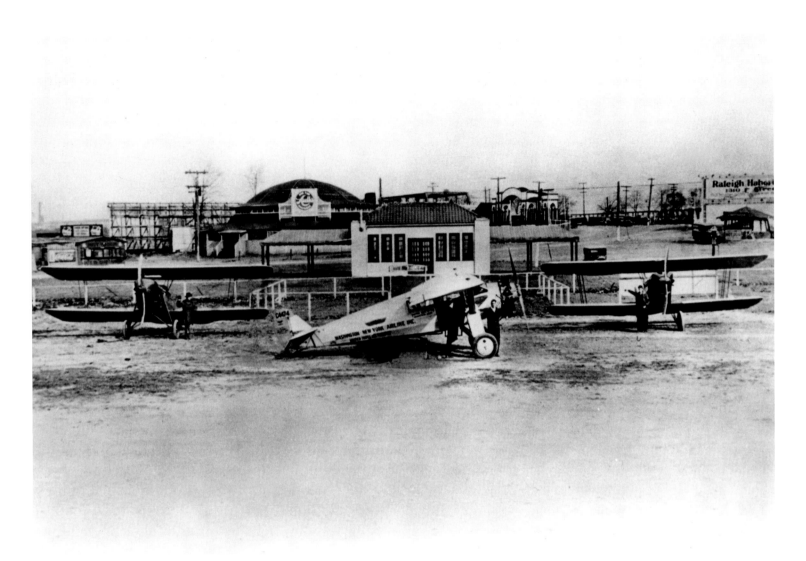

Two airports existed on the shore of the Potomac: Hoover Airport, which opened in 1926, and Washington Airport, which opened in 1927. Hoover Field was opened by Philadelphian Thomas Mitten who had a contract to fly for the postal service and hoped to foster a new age of passenger flight with flights to the Philadelphia Sesquicentennial International Exposition. The nearby Washington Airport hosted Seaboard Airlines, which flew daily to New York. In 1930 the two fields were combined into Washington-Hoover and a new art deco terminal built. Washington–New York Airline, Inc., for which the plane in the foreground flew, was established in the late 1920s.

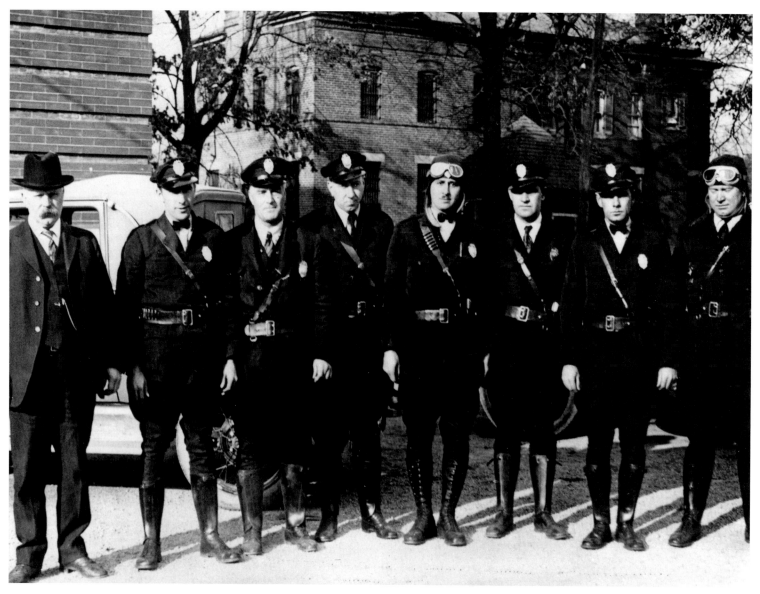

The well-turned out police department in 1929. From left are Sheriff Howard Fields, Jack Conway, Archie Richardson, Jim East, Hugh Jones, John Burke, Roy Cobean, and Raymond Crack. February 1, 1940, the Arlington County Police Department was formed, separate from the county sheriff's office, and had a force of nine. Harry L. Woodyard, a deputy sheriff for the county, became the first chief of police.

Captioned "Vine Street and Lee Boulevard" intersection, this and the following image will be more familiar as Arlington Boulevard and Lexington Street. The view west of this impressive boulevard is virtually empty of traffic, around 1930. Amidst controversy, the Lee Highway Association chose the route of the boulevard in 1926, the most southerly of the three options. Lee Intercontinental Highway was supposed to stretch from Washington to San Diego. President Hoover ceremonially turned the first earth at Fort Buffalo in 1931. Five miles were built, then progress stalled. The final connection to Memorial Bridge opened in 1938.

The view south from the intersection of Vine and Lee shows a still-forested rural area of the county.

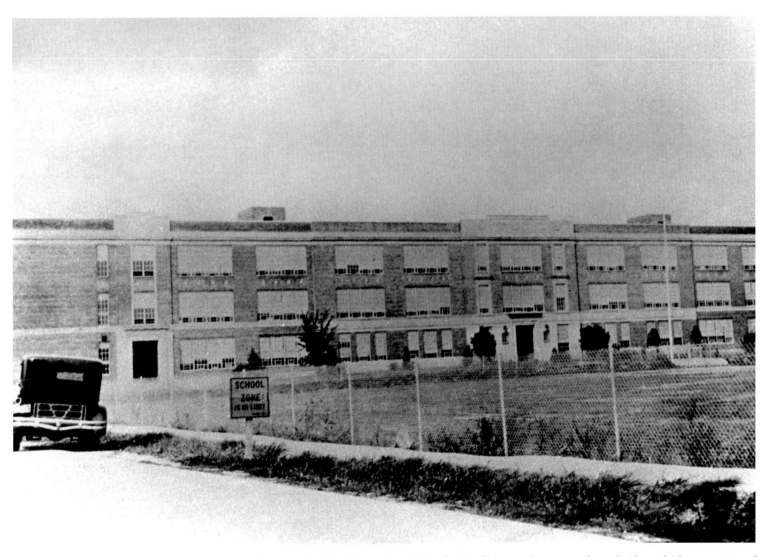

Opened in 1925 and built to replace the high schools lost to the county through Alexandria's annexation of several square miles of the southern edge of the county, Washington-Lee was controversial. Residents employed in Washington sent their children to high school in the District and did not see the need for (northern) Arlington to have its own high school.

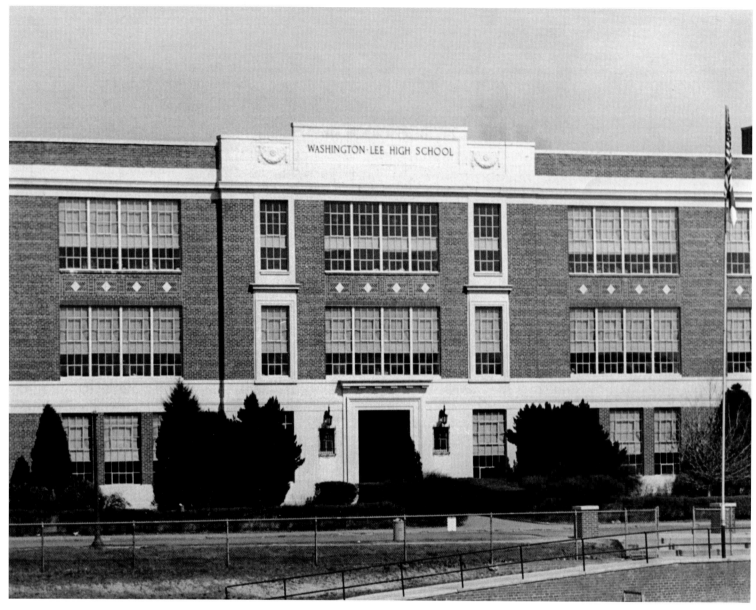

Washington-Lee opened in 1925 to over seven hundred students. Very fondly remembered by its graduates, the entire building has been demolished and replaced by a modern facility.

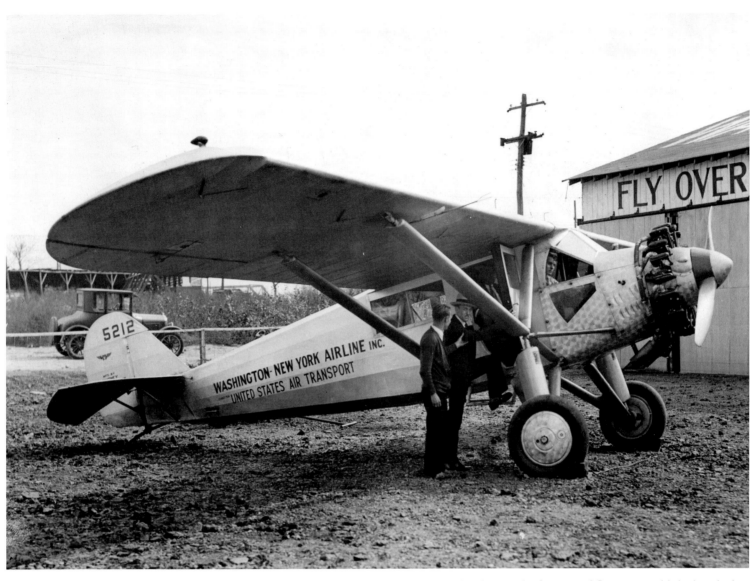

Washington–New York Airline, Inc., for which the plane in the foreground flew, was established in the late 1920s. One of their planes and a passenger are seen here at Washington Airfield around 1929.

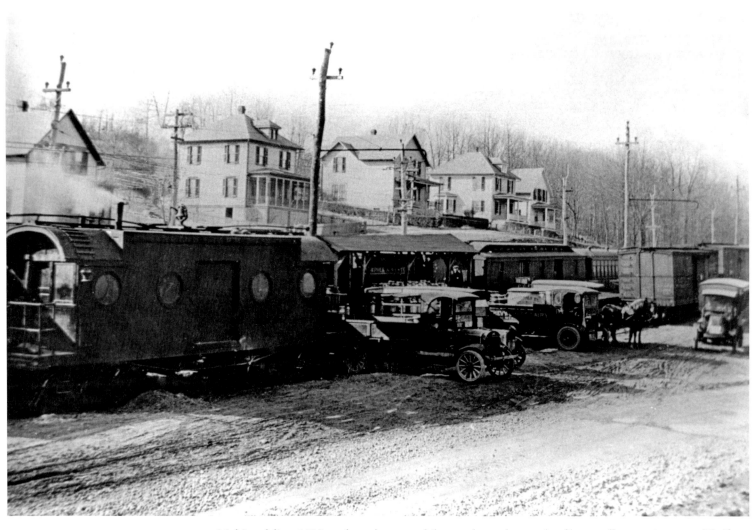

Multimodalism 1920s-style: early automobiles, trucks, and a couple of horses all at a train stop at Thrifton. Impressive houses sit just above the train stop. In 1920 the streets were being paved to connect the village with Dominion Heights, then further to nearby Rosslyn. The village slogan "A good place to live" was adopted in 1923.

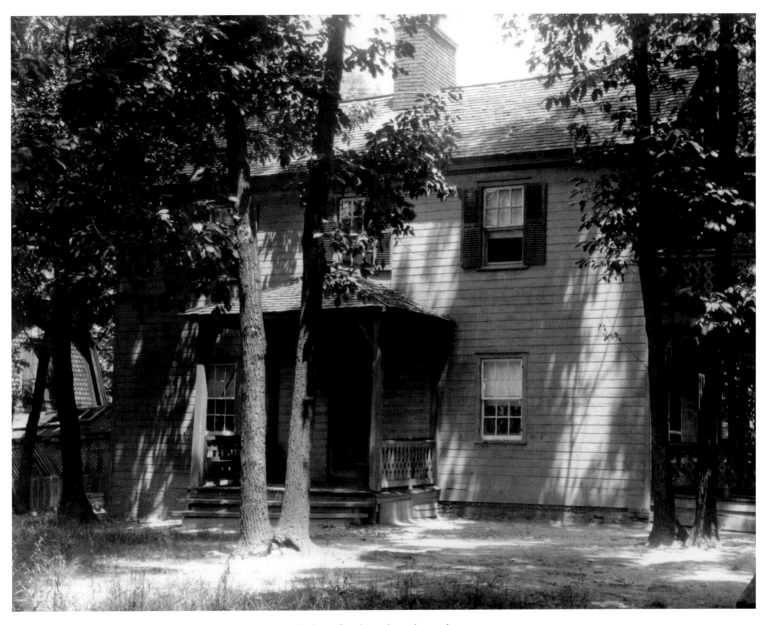

Preston was one of those houses owned by the expansive Calvert family and was located on the south side of the mouth of Four Mile Run at the Potomac.

Ballston Public School was built in 1893, replacing the Walker school built in 1877. It was built to the same plan as the Hume School, at Wilson Boulevard and North Randolph Street.

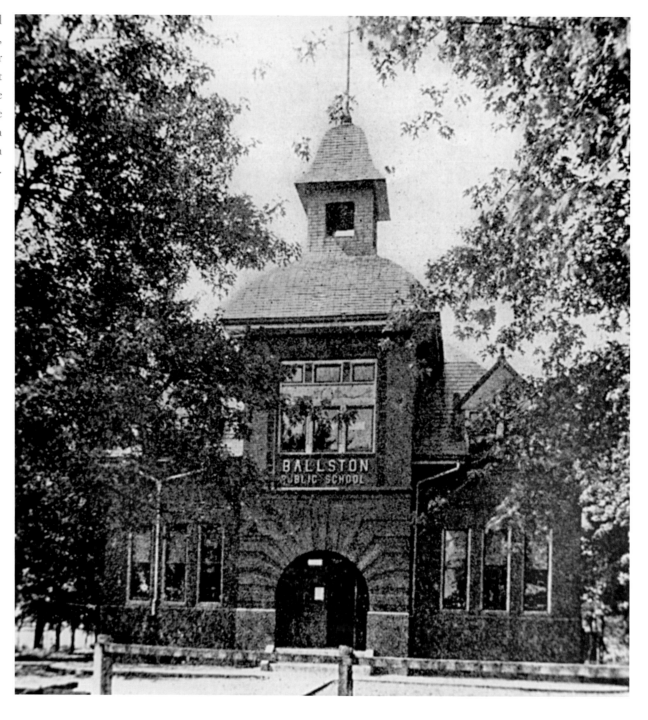

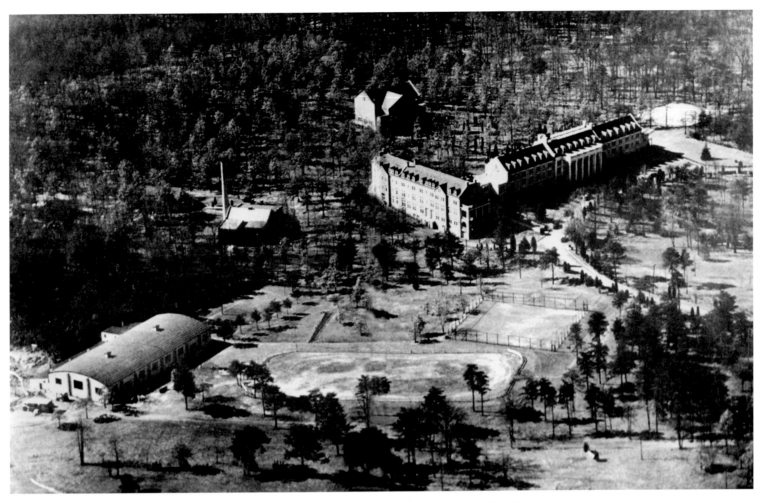

Arlington Hall Junior College was a private school for girls, opened in 1927. It was closed in 1942, when the United States government took it over to house the Army's Signal Intelligence Service. Arlington Hall was founded by William Martin, president of Sullins College, Bristol, Virginia. This image gives some idea of the extensive campus, which was an irresistible temptation for a space-hungry federal government. Upper right in the picture is the colonnaded main hall. To the lower left are the stables and riding area for the equestriennes.

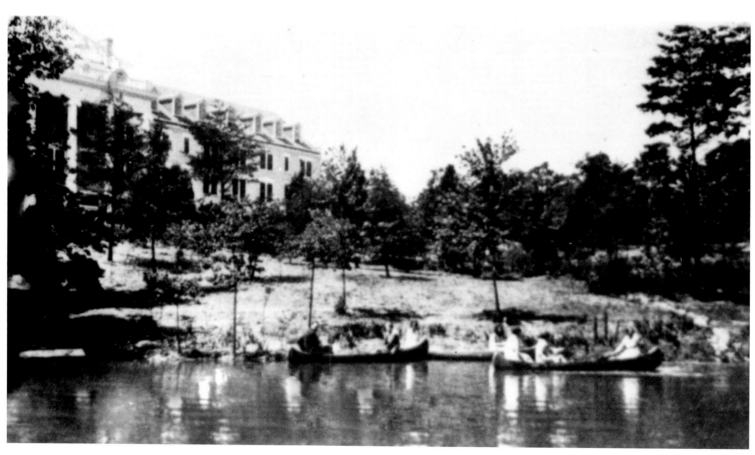

Further to the north of the Main Hall was a small lake, near where present-day Arlington Boulevard runs. It was large enough for students to use it canoeing.

The Arlington Hall school aimed to produce well-rounded young women, with an emphasis on academics, physical education, and the social graces. The Main Hall, in front of which these young ladies pose, opened in 1927 and was finished in 1928.

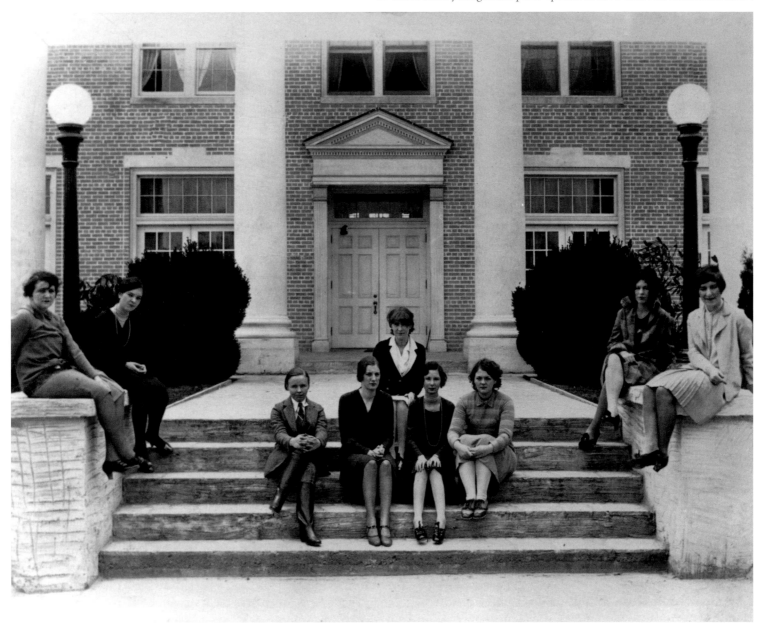

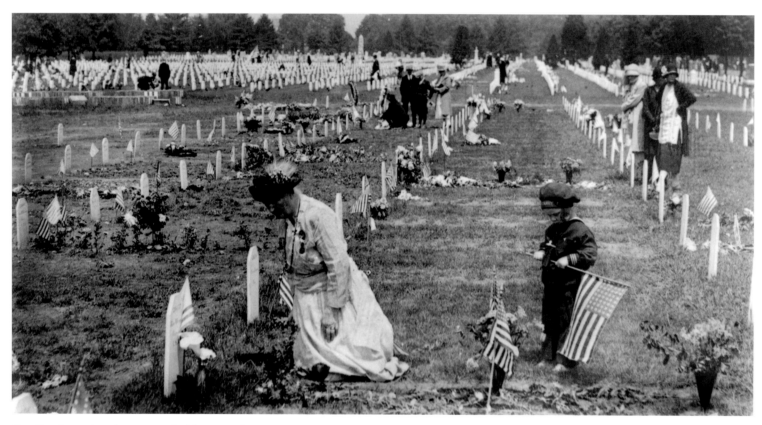

Families decorating the graves of soldiers at Arlington Cemetery on Decoration Day, May 30, 1929. President Herbert Hoover spoke at services at the cemetery, which was preceded by a parade. Decorations were placed at all cemeteries around Washington, and wreaths were placed on memorials throughout the city.

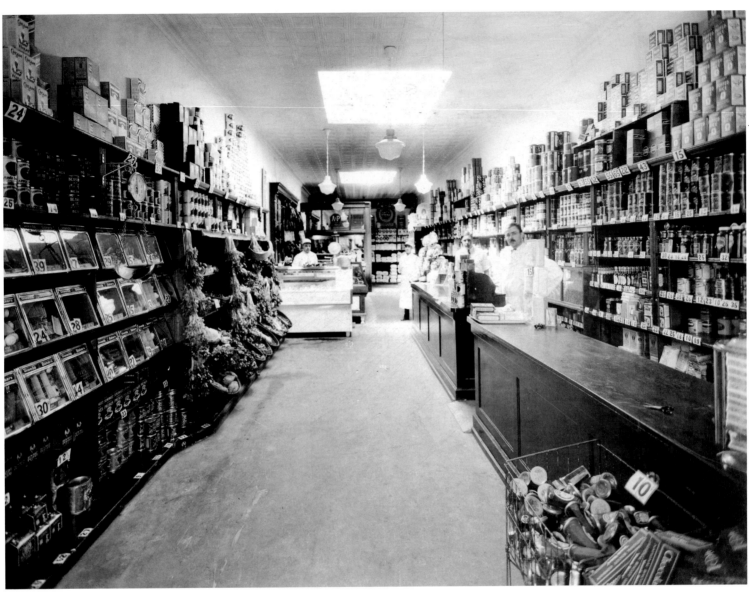

A rare interior shot of an A&P (Great Atlantic and Pacific Tea Company) store around 1930. The chain, founded in New York by George Huntington Hartford and George Gilman, once was the nation's dominant grocery retailer. This site is now Arlington Hardware at 2920 Columbia Pike.

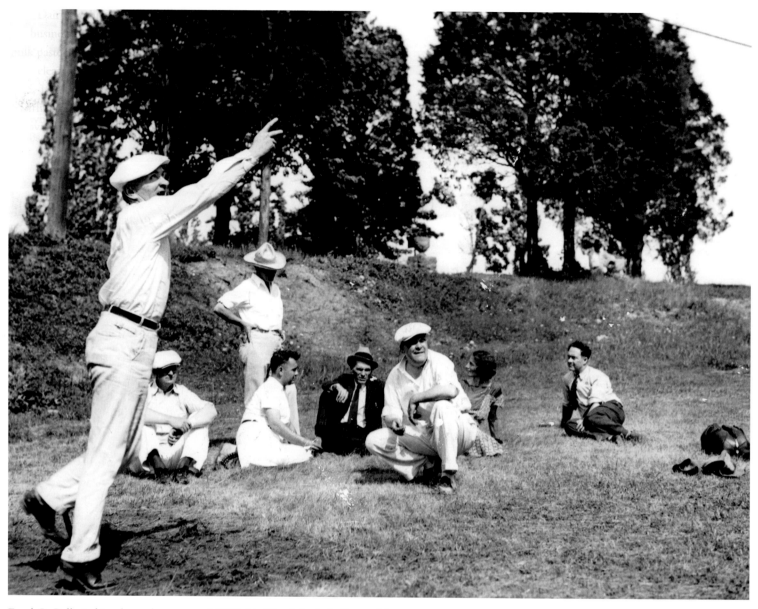

Frank L. Ball pitching horseshoes around 1930; his friends include Emory Hosmer, Homer Thomas, John Locke Greene, and John C. McCarthy. Gadfly Greene was a fellow lawyer and would serve as county treasurer. Hosmer would serve as a judge on the Arlington Circuit Court. McCarthy was Ball's law partner.

FROM WASHINGTON'S BACKYARD TO SUBURBAN HEARTLAND

(1931–1975)

Further ties to the District of Columbia were realized physically with the construction of Arlington Memorial Bridge. First envisioned after the Civil War, then proposed in the 1902 McMillan Plan, was designed to symbolically link North and South—Lincoln Memorial to Arlington House. Its construction was prompted by the hideous traffic woes faced by folks attending the 1921 dedication of the Tomb of the Unknown Soldier at Arlington Cemetery. President Harding and Vice President Coolidge were caught in "the worst traffic jam in the history of the city." Transportation routes designed to take residents home from their work in Washington to residential neighborhoods in the county, or beyond in Falls Church and Fairfax, were unable to handle the huge influx of automobiles headed for Arlington Cemetery. Begun in 1926, the bridge opened without ceremony in 1932.

This new access opened Arlington to more residential development. Garden-apartment complexes such as Colonial Gardens and the Buckingham Village pioneered developments in suburban residential development. The federal government presence mushroomed during World War II with construction of the Pentagon in 1941 (still the third-largest office building in the world), which obliterated several neighborhoods, including the last remnants of disreputable Jackson City. The Arlington Hall finishing school for girls was seized to house military cryptographic efforts. National Airport replaced the woefully inadequate Washington-Hoover Field. The experimental farm was converted to other uses, including housing for "government girls"—women war workers. The county took its new role in the limelight very seriously, for example, publicizing its public health efforts.

In 1946 Arlington celebrated its centennial with a parade, floats, and speeches, but postwar Arlington faced a number of challenges, social and physical. The county struggled through fraught race relations, but took the lead in establishing the first integrated schools in the entire state of Virginia. The massive influx of population

during World War II and in the postwar years only exacerbated traffic issues. The county had been the starting point for an unfinished transcontinental route—Lee Intercontinental Highway (the county portion now Arlington Boulevard)—but was much less receptive to plans for the intricate, massive regional highway program in the 1950s. The Washington Beltway portion was built. Much of what was planned for the District of Columbia was defeated, but Arlington lost its fight and saw the construction of Interstate 66 (I-66). A mixed blessing, I-66 provided much of the route for Metro rail transit. The opportunity which transit offered spurred planning for the much more urban, densely populated Arlington of today.

Crandal Mackey, who died in 1957, was one of the great men in Arlington history. In 1903 he was narrowly elected Commonwealth Attorney for the county on a "good government" platform. His acts to clean up vice in the county are the stuff of legend. Frustrated by apparent obstructionism on the part of the county sheriff, Mackey organized a posse to breakup pool-room gambling dens in Jackson City, St. Asaph's, and Rosslyn. Long legal delays led to a truce in Mackey's war on vice in January 1905, but by 1908 the Washington *Post* could fondly reminisce about past days gambling in the Washington area, including St. Asaph's and Jackson City. Mackey ran for reelection in 1911, declaring "so long as I am on the job this evil will not exist."

The youngest victim of this crash at Washington-Hoover Airport on November 7, 1931, was fourteen-year-old Preston Paynter, a McKinley High School student. Pilot Frederick Korte and Lester K. Dennis also perished. The engine on the two-year-old Challenger biplane failed. Here, a group of onlookers survey the wreckage.

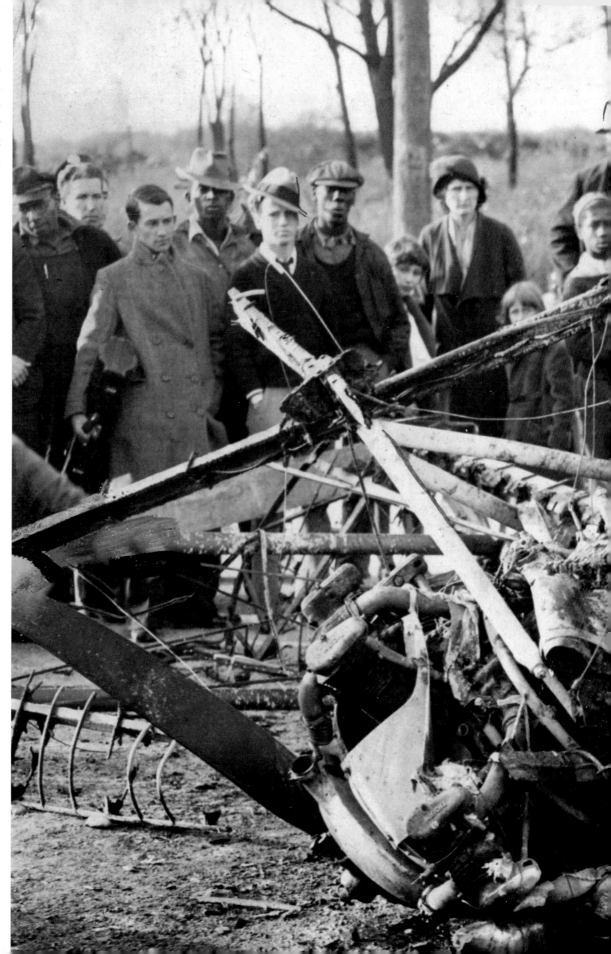

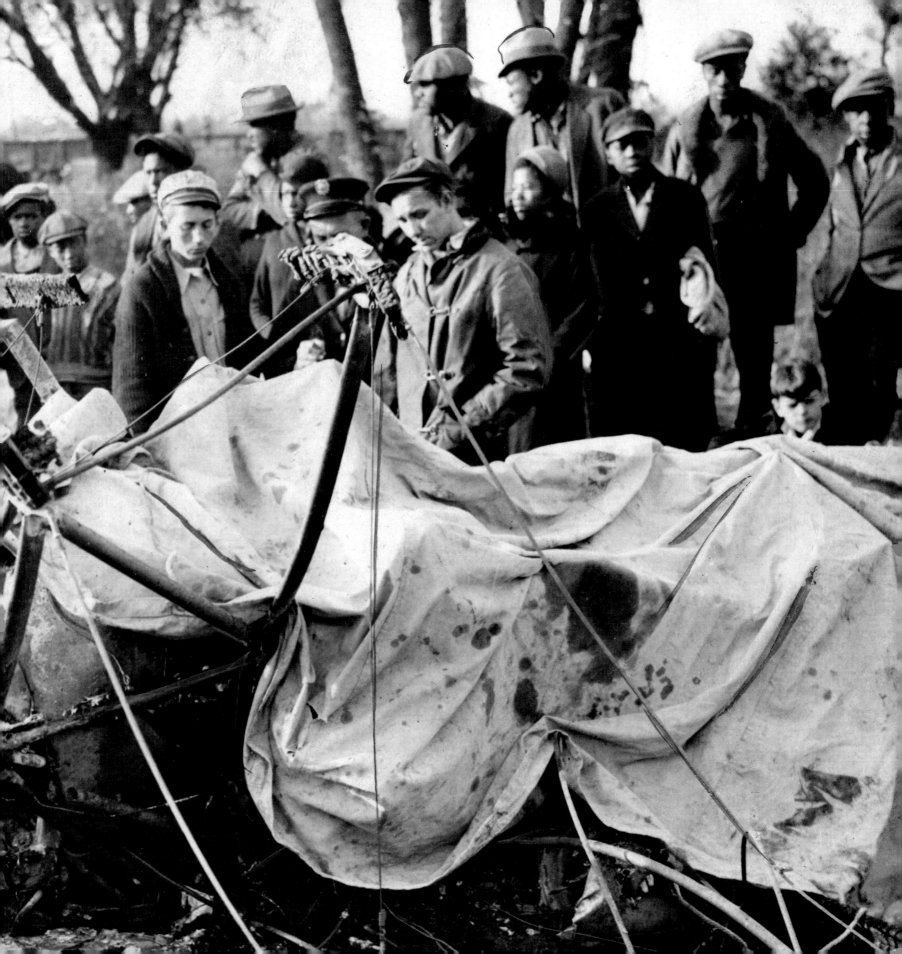

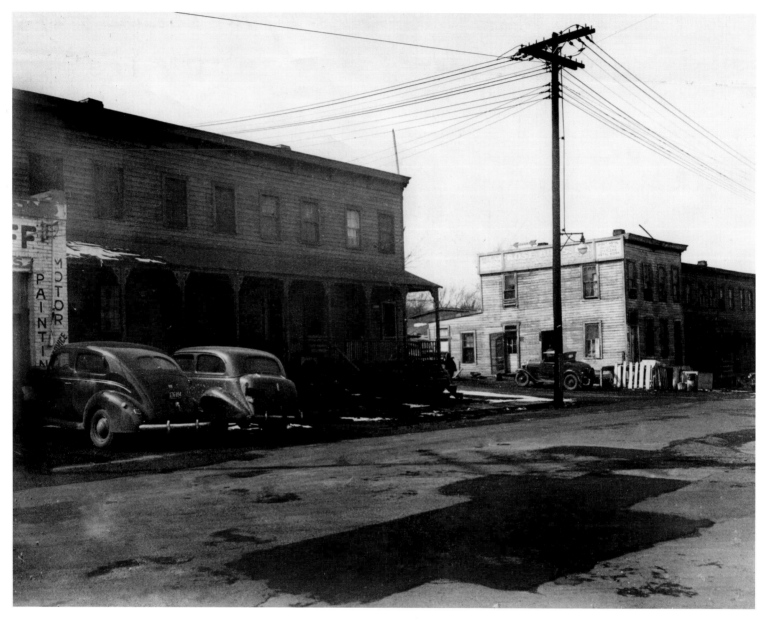

A quiet, daytime picture of Fort Myer Drive, also known as "Pork Chop Row." This neighborhood in Rosslyn was notorious for gambling, drinking, and other vices.

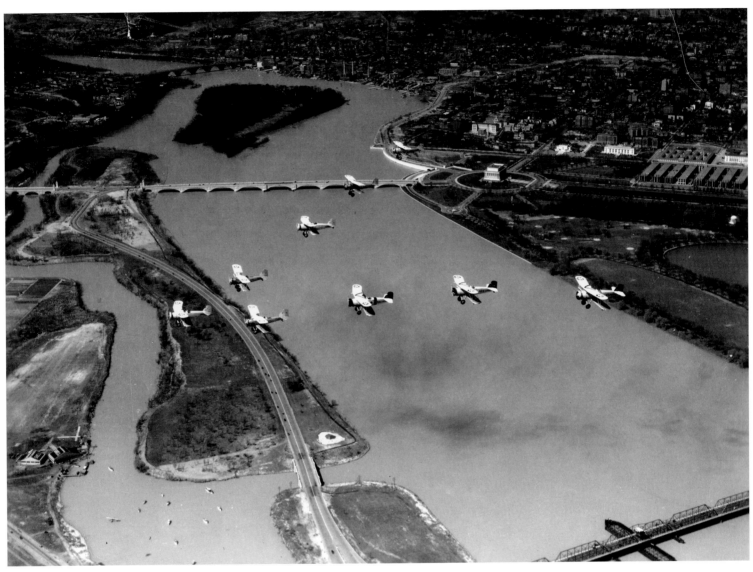

Impressive 1938 view of the Potomac and the Arlington Memorial Bridge, with nine planes flying in formation. This view shows Rosslyn and Georgetown at the top, and the recently completed Arlington Memorial Bridge below Analostan Island, linking Virginia and the District. Washington's military temporary buildings known as "tempos" are visible on the upper right.

A 1934 view of Lee Memorial Boulevard (now Arlington Boulevard) in Glencarlyn. The ambitious project to extend the two-hundred-foot-wide highway across the country never did reach its intended goal of San Diego.

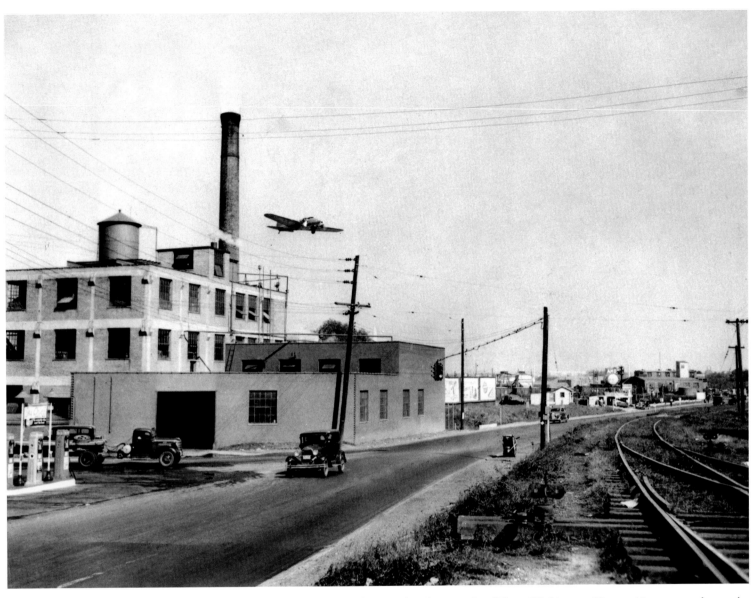

This image shows a plane low on takeoff from Washington-Hoover Airport over the nearby commercial strip. The airfield was hampered by its poor location, divided by a major road, and on low-lying land prone to flooding.

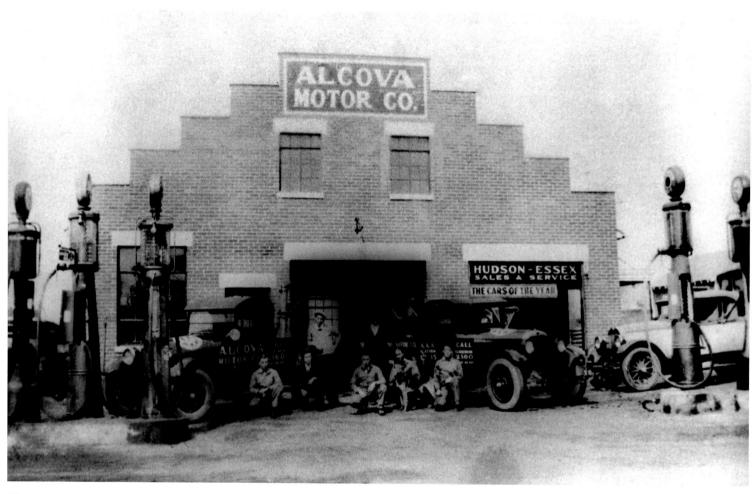

Alcova Motor Company employees proudly posed in front of the shop. In the center is a 1930 Essex Sun Sedan. On the right, the white car is a 1917 Hudson Phaeton. These employees may have been part of Alcova's 1931 winning football team.

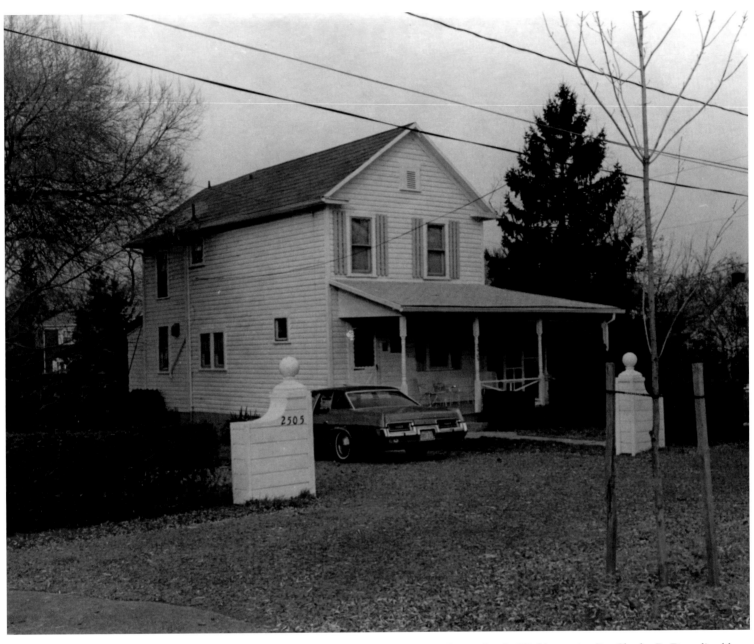

The Drew house at 2505 First Street, South. Washingtonian Dr. Charles R. Drew lived here in the Penrose neighborhood from 1920 to 1939. An African American physician, Drew later pioneered efforts in blood transfusion. The house has been placed on the National Register.

The Arlington Experimental Farm lay on four hundred acres of what had been the Arlington estate. A variety of agricultural experiments took place there, including development of sugar cane resistant to blight and domestication of soybeans. Grass for golf greens was developed after German grasses became unavailable due to World War I. In the 1930s, programs began to be transferred to Beltsville, Maryland, and the Arlington farm was closed in 1941.

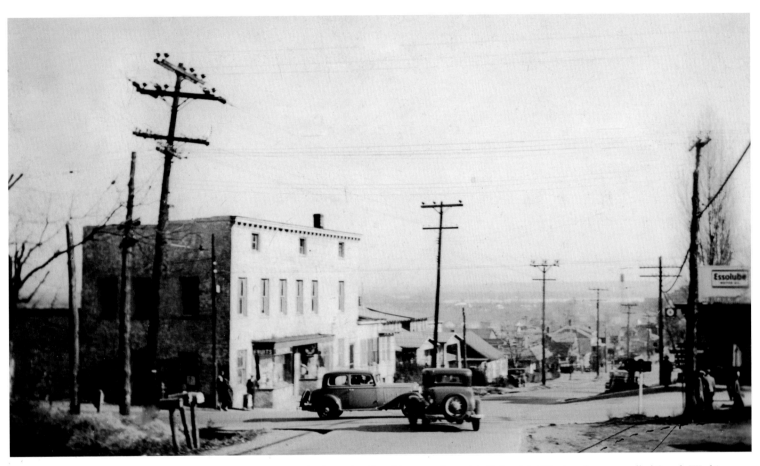

The Georgetown and Alexandria Road intersection with Columbia Pike in what was called South Washington, illustrating the potential for roadway improvements, December 2, 1934. The pike had been constructed in 1808.

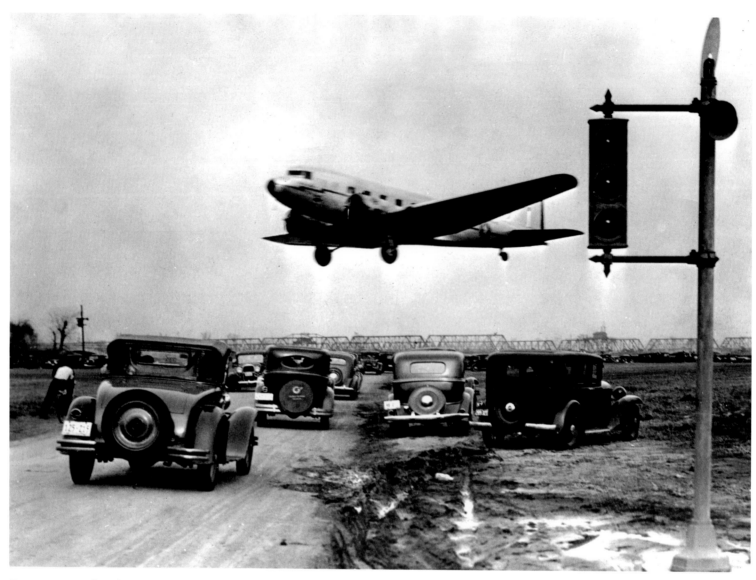

Famous image of airplane taking off from Washington-Hoover Airport, passing perilously near to the cars on the road below. In the distance is the Highway Bridge which replaced Long Bridge.

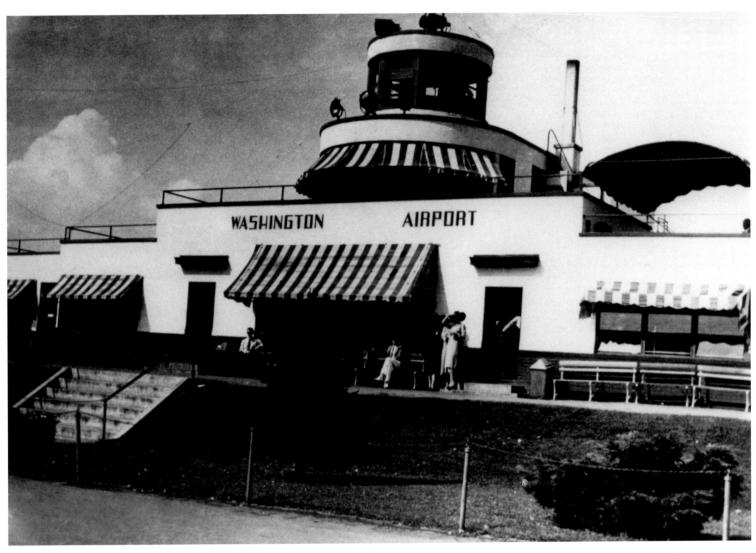

Washington Airport was the original southern airfield, combined with Hoover Field to the north to become Washington-Hoover Airport. This photo is from around 1935.

Carrie Sutherlin (left) was the president of Arlington Hall Junior College. Frances Jennings (right) was the dean. Photographed around 1937, the two proudly show off some exotic gifts, including several bunches of bananas.

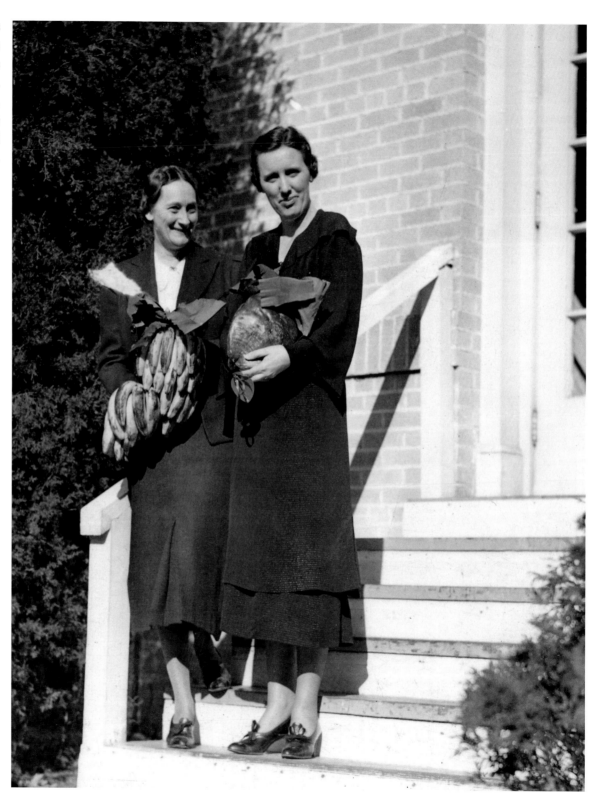

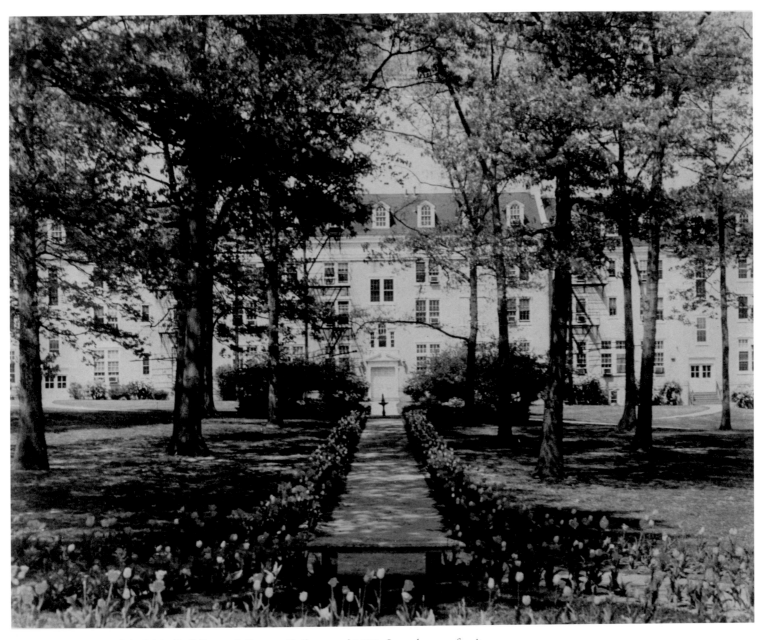

The south entrance of the Main Building at Arlington Hall, around 1930. Several years after it opened, the flowers that bloom in the spring create a bucolic setting.

Buckingham Village garden apartment complex, toward the south. In 1936 Paramount Communities, Inc., purchased land between North Carlin Springs Road, North Glebe Road, and Lee Boulevard (now Arlington Boulevard). Allie Freed, the chairman of the Committee for Economic Recovery under President Franklin D. Roosevelt, spearheaded the development of Buckingham Village. He aimed to spur economic recovery through privately financed housing developments, supported by financing provided by the Federal Housing Administration (FHA). The first units opened in 1937 and project was mostly complete by 1941. The complex was promoted as a successful example of affordable housing—a New Deal housing-program success and an example for the nation.

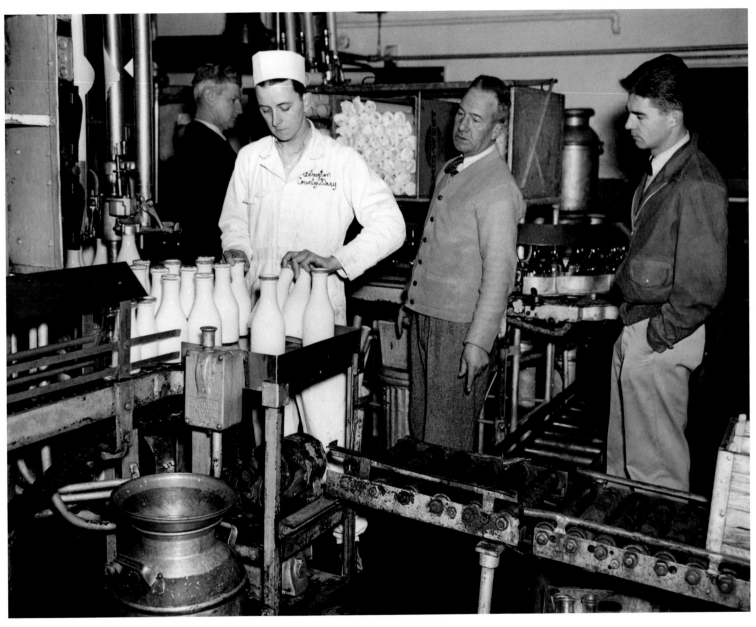

The District of Columbia had very stringent milk quality standards, which Arlington dairies that supplied the capital had to meet. Arlington Dairy had a rating of 99.54 out of 100 for raw milk, and above 90 for pasteurized in 1939.

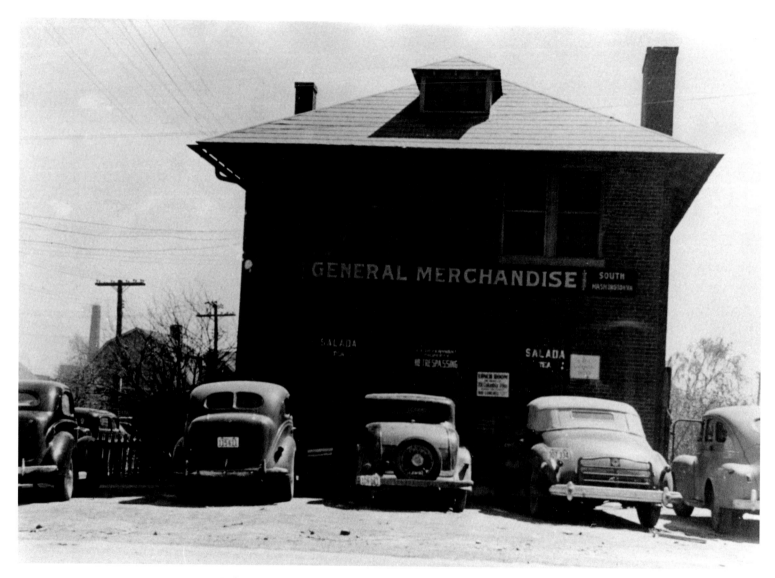

Jackson City at the Virginia end of the Long Bridge was also called "South Washington," as seen on the store sign pictured here around 1939. Construction of the Pentagon swept away a variety of stores, industries, and homes, including the African American neighborhood of Queen City or East Arlington.

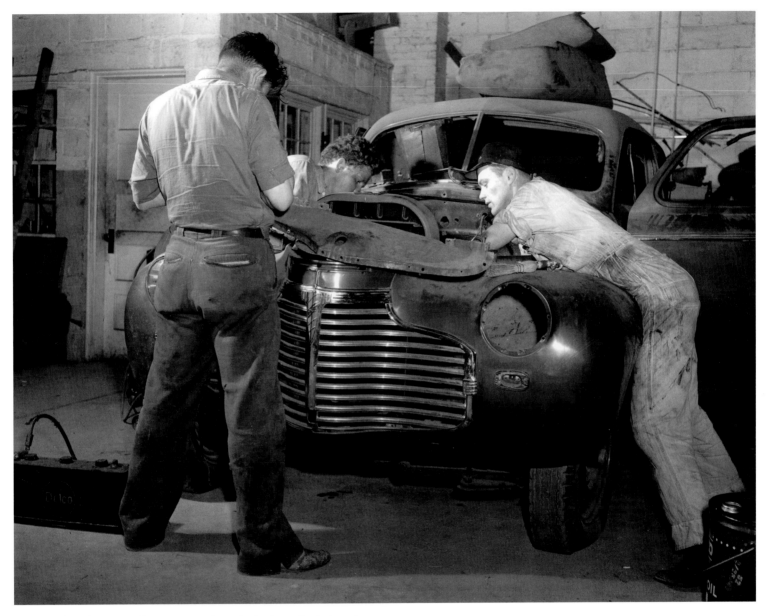

A team of mechanics working on restoring a junked car. A whole series of pictures were taken by FSA photographer John Collier at Martin Auto Body in Arlington, May 1942.

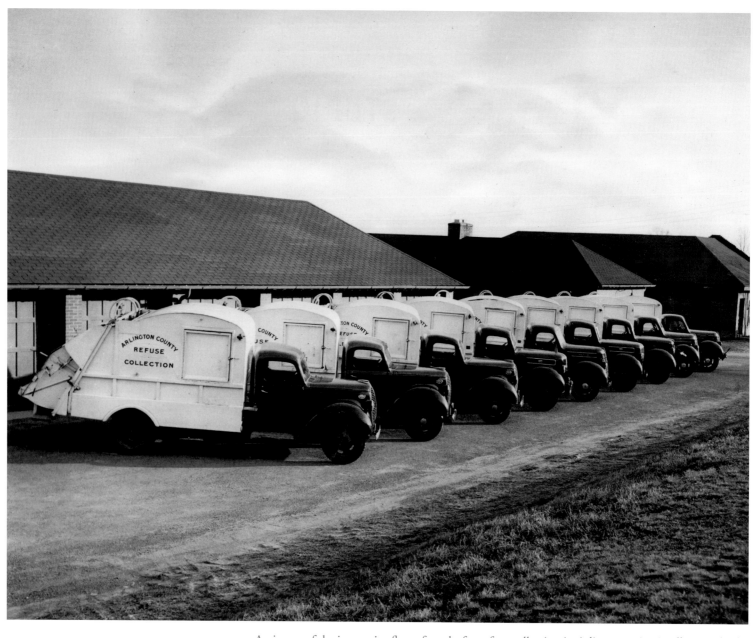

An image of the impressive fleet of trucks for refuse collection in Arlington, nine in all. In 1942 the county began residential refuse collection, ending private contracting, but with no provision for commercial establishments.

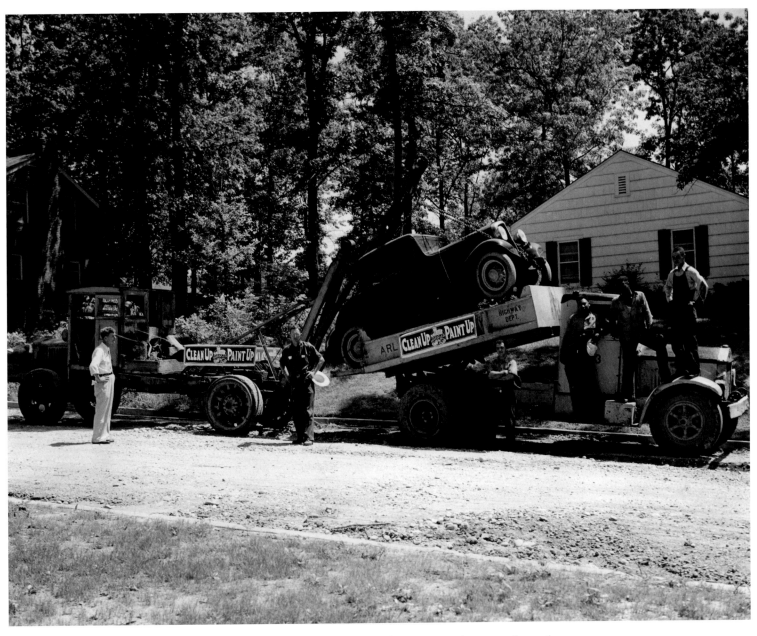

Arlington took its image (and the reality behind it) seriously. County-wide clean-up campaigns started as early as 1932, spurred by civic associations which had sponsored them locally since the early 1920s. Shown here is part of the effort in the "clean up and paint up" campaign from 1942. The county provided trucks to remove junked automobiles and bulk trash such as tree branches for free.

Dairy production was big business in Arlington. This milk pasteurizer is all sparkling clean for inspection, June 25, 1940. Nelson Reeves was Arlington's last dairy farmer, leaving the business in 1955.

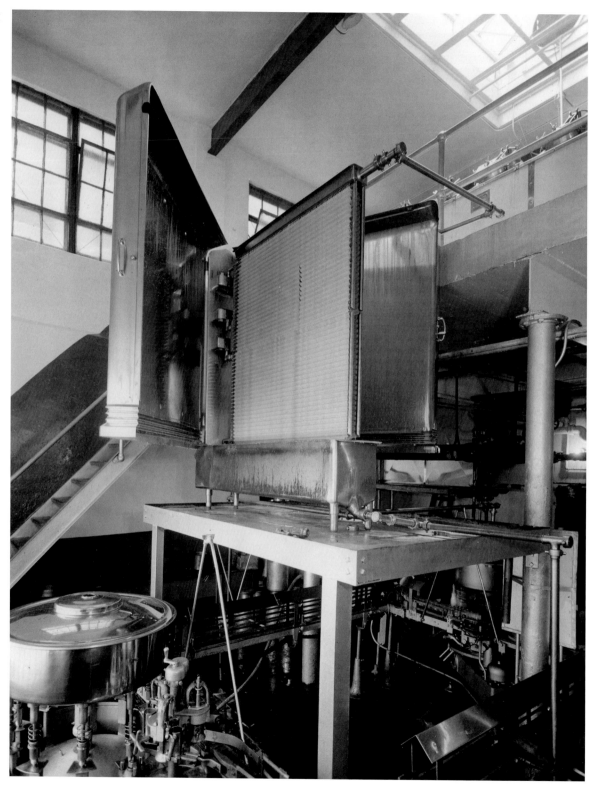

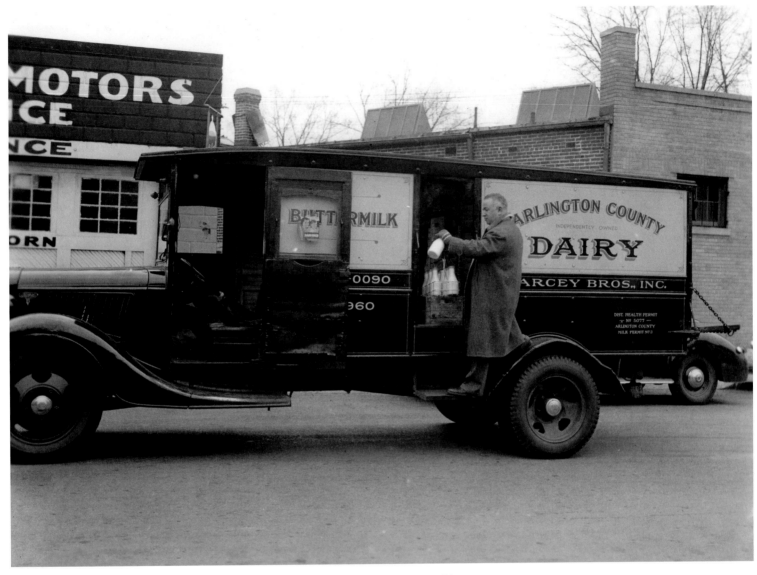

Marcey Brothers ran Arlington County Dairy, from what is now the Cooper-Trent Building on Wilson Boulevard. This image is from the Public Health Department's Rural Health Conservation scrapbook of 1940.

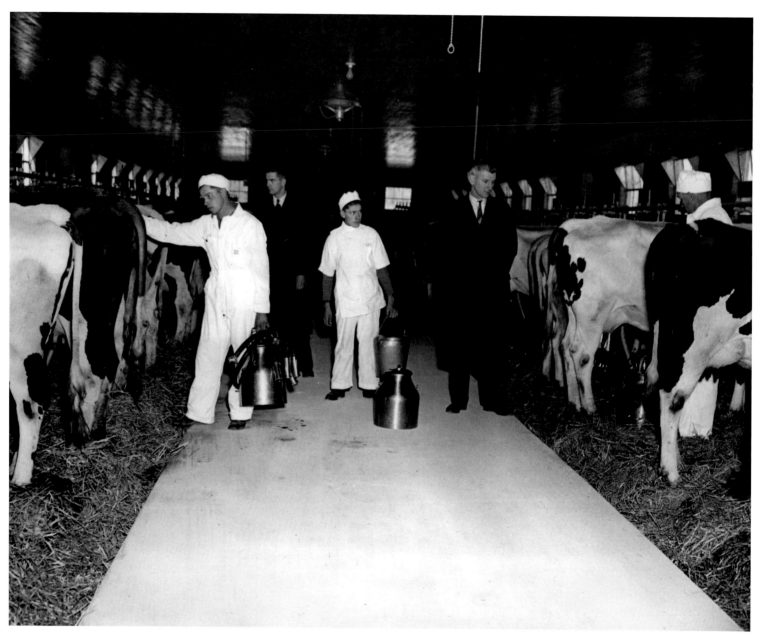

Health Department officials, looking a bit out of place as they inspect dairy cattle in 1942. Arlington helped supply Washington with milk, as part of the capital's milkshed. In the 1930s the Federal Trade Commission investigated milk supplies and Congress could be counted on to keep a watchful eye on the issue; Congressman Smith of Alexandria called for the investigation of "bootleg" milk sales in the District in 1939. Increases in demand led to price increases and union strife.

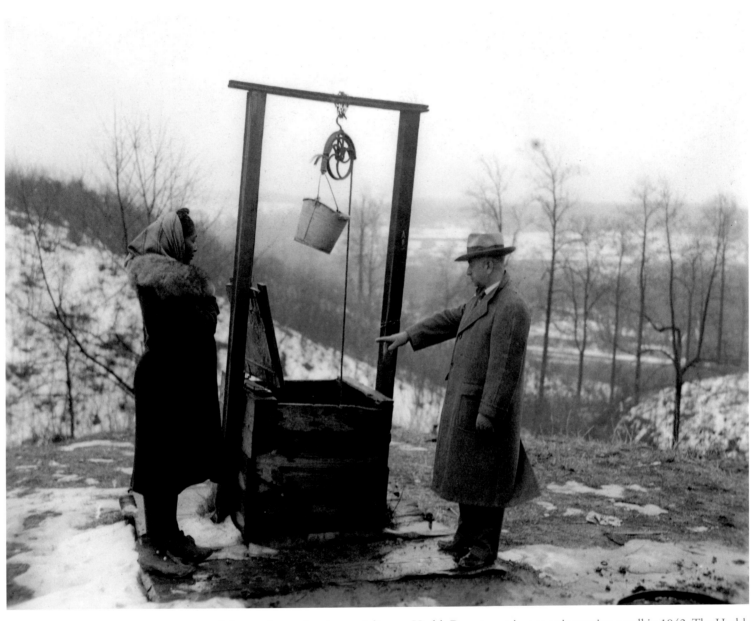

A famous image showing an Arlington Health Department inspector inspecting a well in 1942. The Health Department was organized in 1919. From this strikingly rural image one wouldn't guess that this was in the suburbs of Washington, D.C. This image is from the department scrapbook.

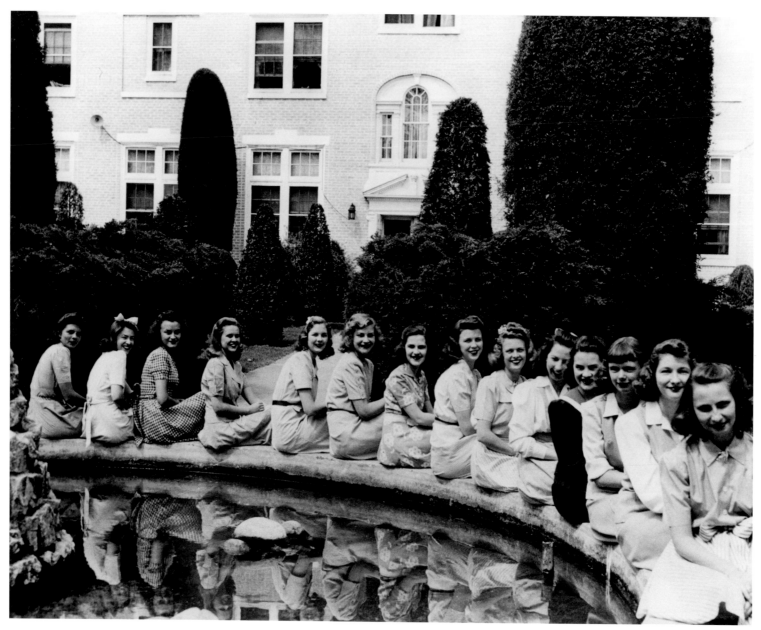

A baker's dozen of students plus one, sitting on the fountain at the south entrance to Arlington Hall's Main Building around 1940. The fountain was a favorite gathering spot for students and faculty alike. Note the shrubbery, which has been tamed into sculpted forms.

Some of the students at Arlington Hall were equestriennes and competed against fellow junior college students (winning the first competition in 1936). This photo was taken on the school's C. C. Lamond riding arena.

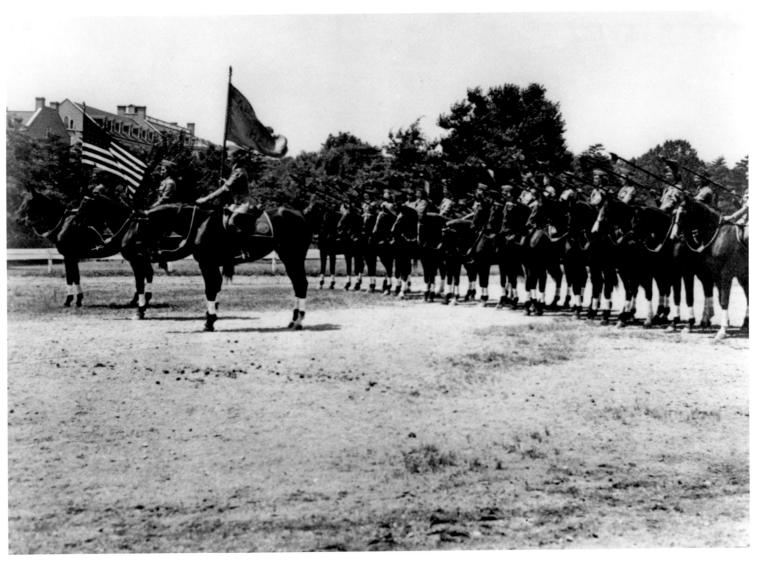

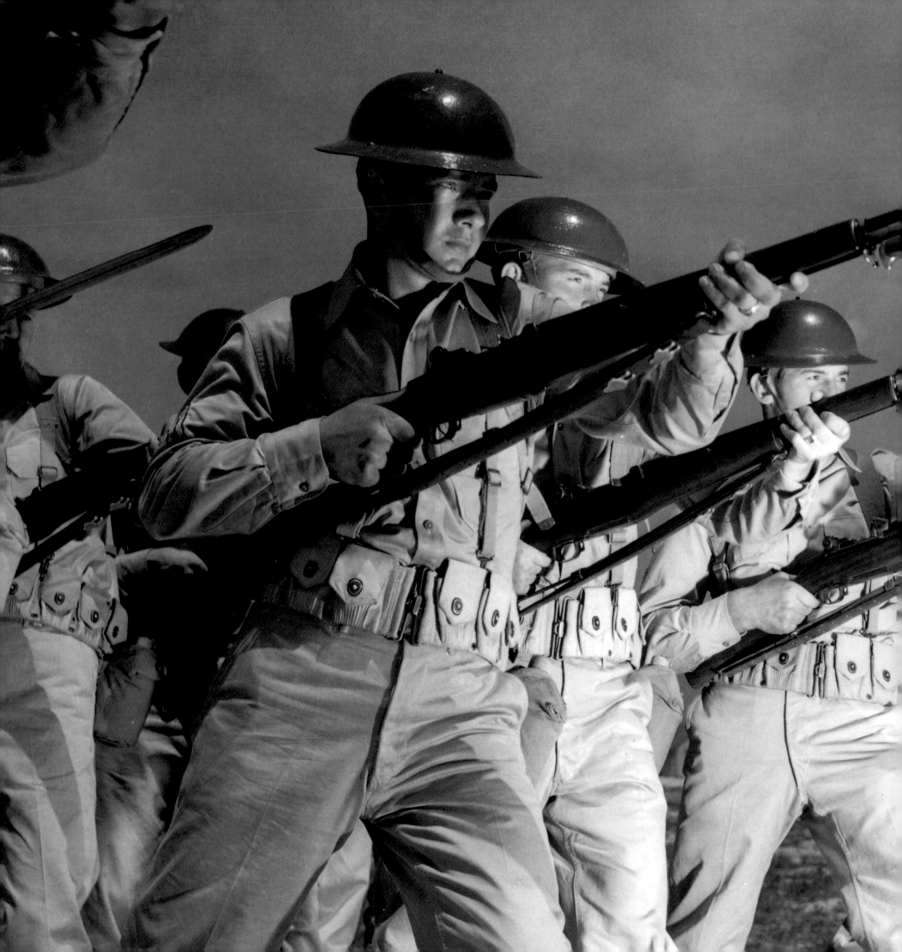

At Arlington Cantonment, members of Company M, 12th Infantry, execute bayonet maneuvers for the camera. Marion Post Wolcott was taking pictures for the Office of War Information.

Some soldiers inspect the new "trackless" tank being demonstrated at Fort Myer, April 21, 1941. This tank was manufactured by the Trackless Tank Corporation of New York and submitted to the Ordnance Department, U.S. Army, for inspection. Preliminary tests indicated that the tank might be adaptable for reconnaissance purposes, possibly replacing scout cars. The tank weighed ten tons and could reach speeds up to eighty-five mph on flat ground.

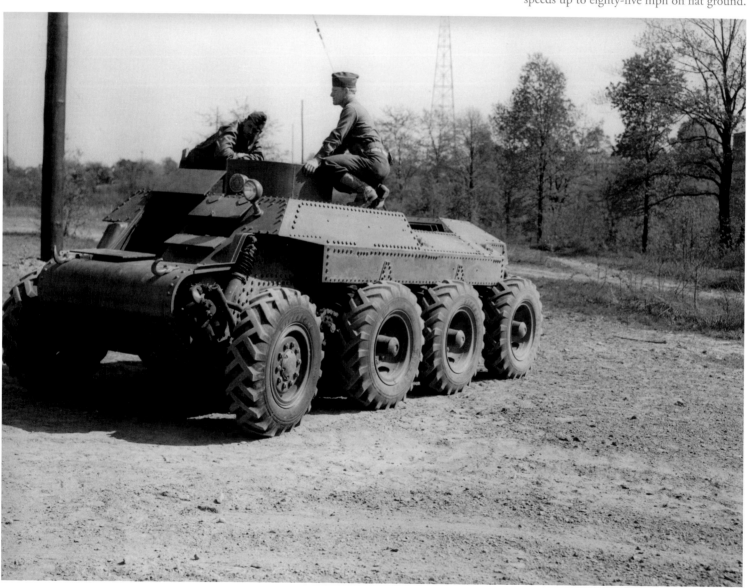

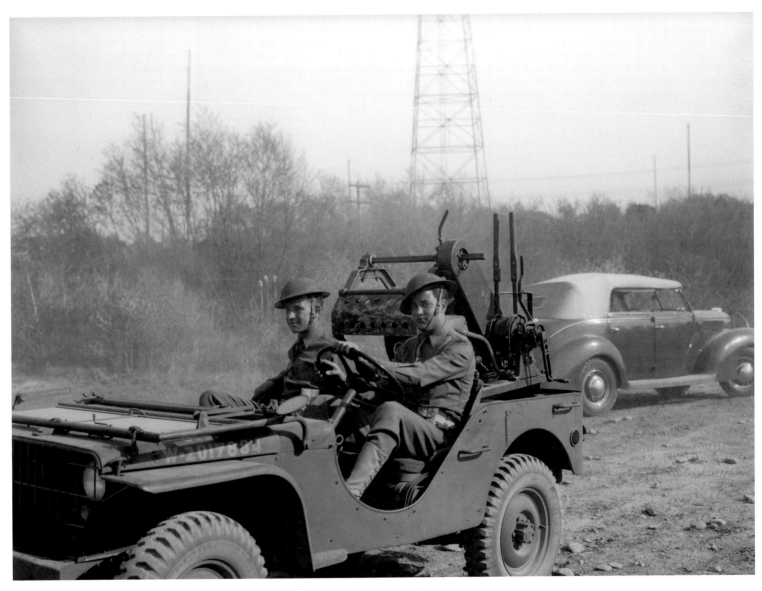

Besides the trackless tank, another prototype vehicle was put through its paces at Fort Myer, a new Bantam truck. This small, light vehicle was a low-silhouette, narrow-tread, 4-wheel-drive car with no armor protection, designed to carry three men and their weapons. Officially designated the "Truck 1/4-ton 4x4," servicemen called them "jeeps." The reason for the nickname has never been proven satisfactorily. American Bantam Car Company originated the design.

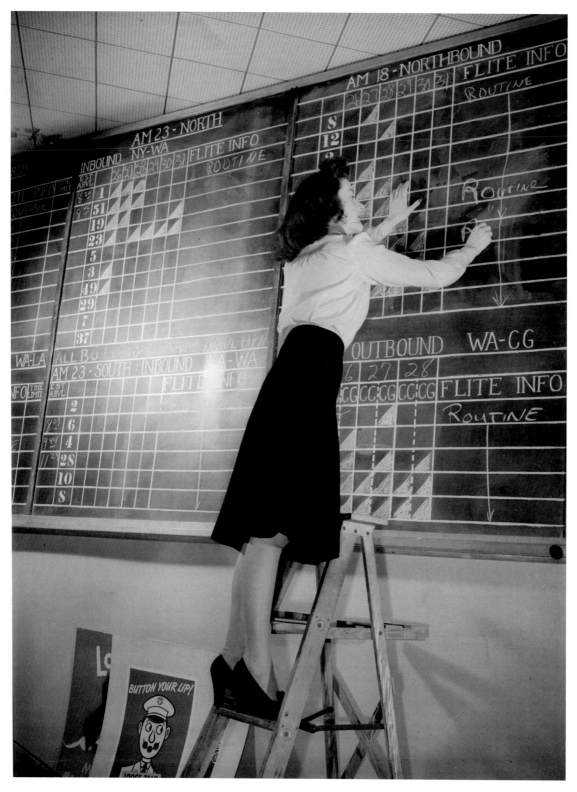

Kay Dowd marks the flight reservation board at National Airport. Howard Liberman of the Farm Service Administration took this photograph as part of a sequence of women airport and aircraft workers in August 1942. (She may have also moonlighted in the theater—a Kay Dowd was in Ed Wynn's *Boys and Girls Together* at National Theater the previous September.)

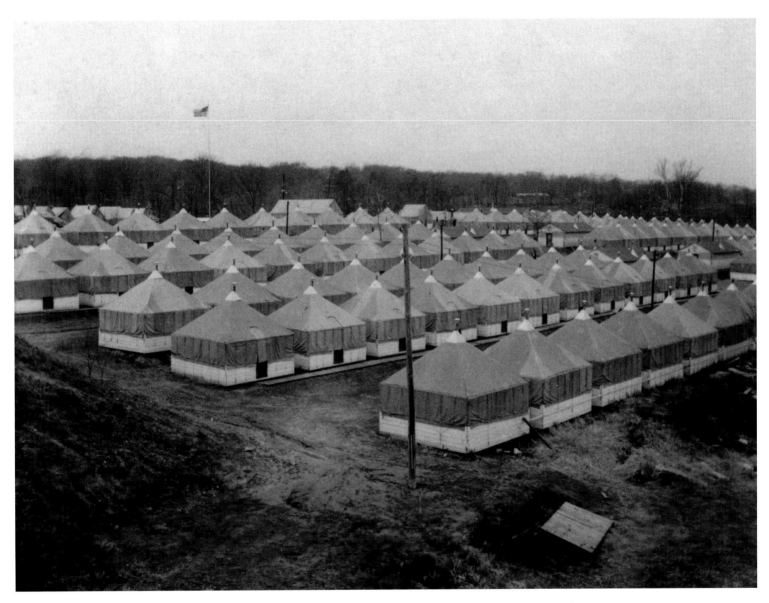

The tent colony at Arlington Cantonment at Fort Myer looks rather temporary, if in a military way. In May 1941, these tents were erected to provide accommodations for 268 visiting soldiers of the 12th Infantry. The tents were borrowed from 4-H, and the land was that of the Arlington experimental farm. Nightly rental was fifty cents. The cantonment was later developed into South Post Fort Myer, which disappeared with expansion of Arlington Cemetery in 1960. In its brief existence, it published a newspaper, the *Arlington Cantonment Sentinel* and was the home of the Provost Marshal General School.

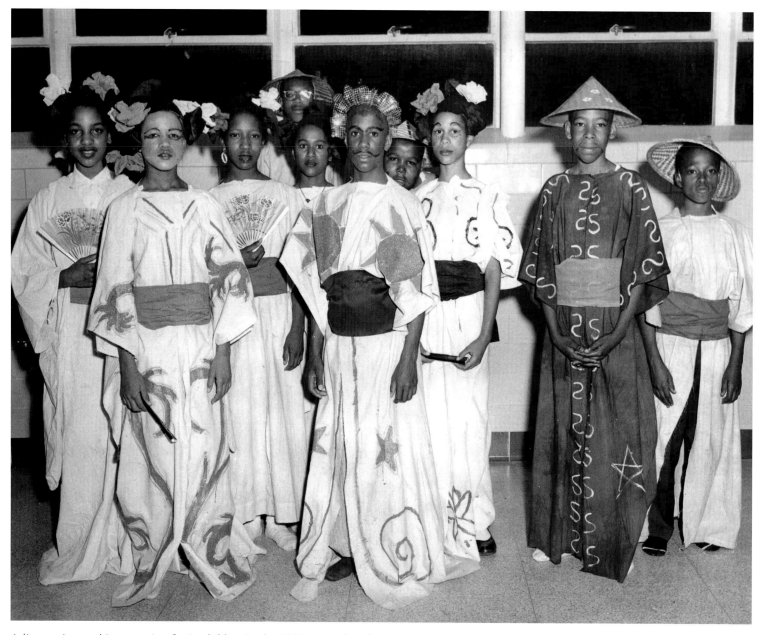

Arlington invested in recreation for its children in the 1940s, even though it was segregated. Here African American youth prepare for a performance of the *Mikado* (or something very similar).

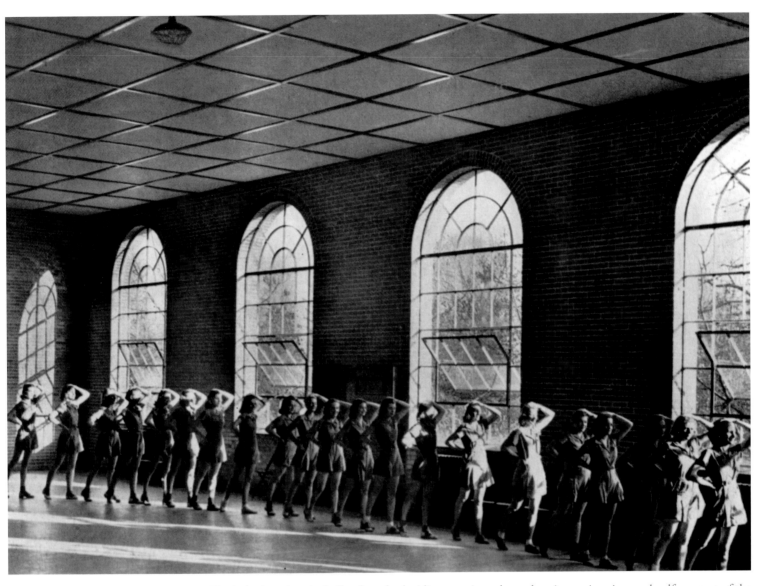

Physical education, including horseback-riding, tennis, archery, shooting, swimming, and golf was part of the educational program of Arlington Hall, all designed to produce well-rounded young women. Photo is from about 1940.

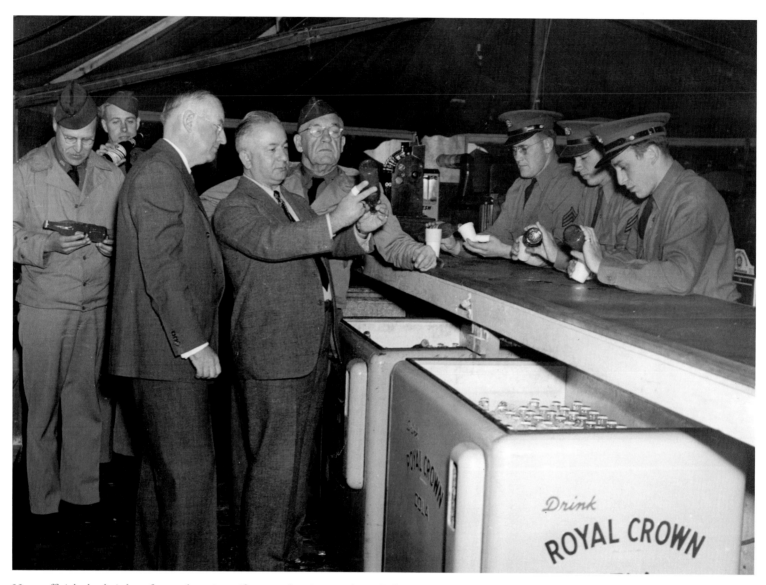

Here, officials do their best for our boys in uniform, as they inspect the soda fountain
and its products at Arlington Cantonment. This is a posed photo; the cap is still on
the bottle from which the sergeant at the far end of the counter is "pouring" a drink.

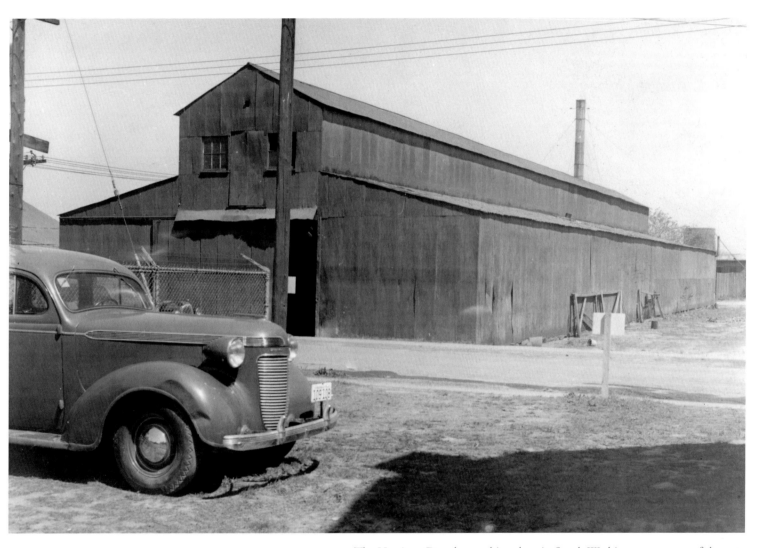

The Harrison-Douglas machine shop in South Washington was one of the not-so-attractive facilities torn down for the construction of the Pentagon in 1941. It was located at Columbia Pike and Alexandria-Georgetown Road.

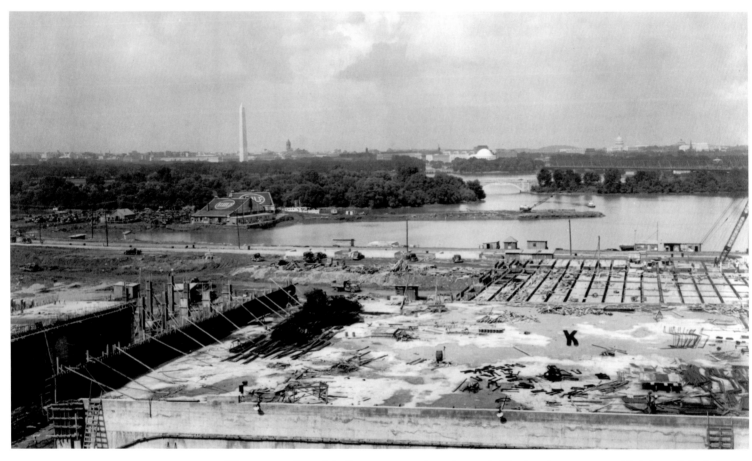

The construction of the Pentagon was a herculean task. The location was ramrodded through by Brigadier General Brehon B. Sommervell, Chief of the Construction Division of the Office of the Quartermaster General. Construction was by the John McShain company, which could honestly boast that they "built Washington"—or at least many of the federal facilities of the 1930s and 1940s.

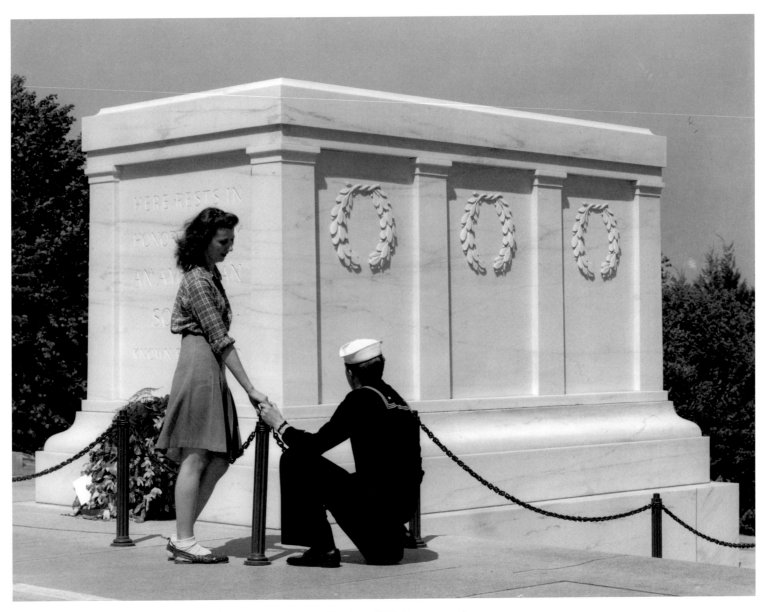

With the Tomb of the Unknown Soldier being one of the notable sites of Washington, and especially significant in wartime, FSA photographer John Collier posed this photogenic couple there, one in a sequence of images he made in this study in May 1943.

The Pentagon was built in sixteen
months, on a difficult site. Part
of the site was fill, dredged from
the Potomac River, part was
land snatched from a variety of
businesses and residents. Queen
City, a small African American
neighborhood, was bulldozed, as
were factories and shops. The last
remnants of disreputable Jackson
City disappeared.

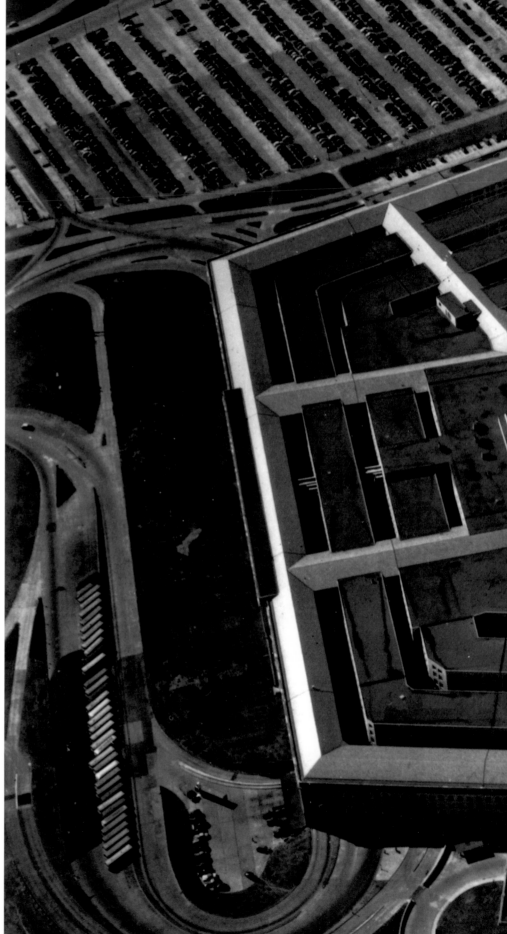

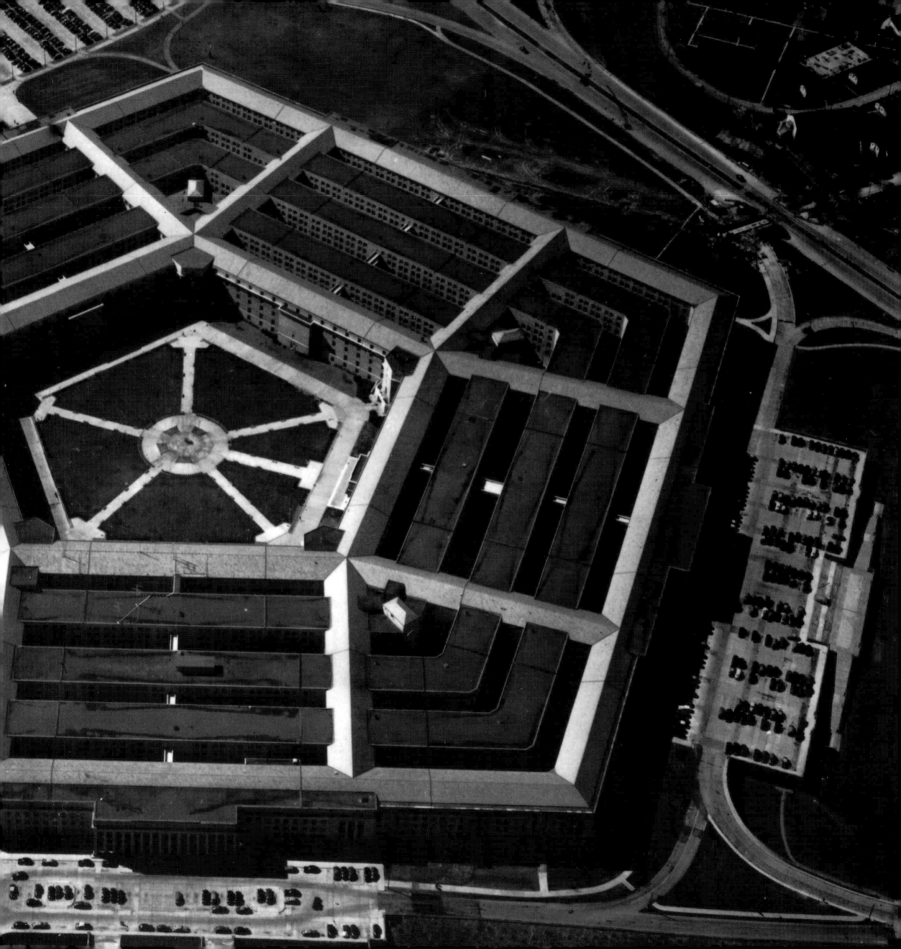

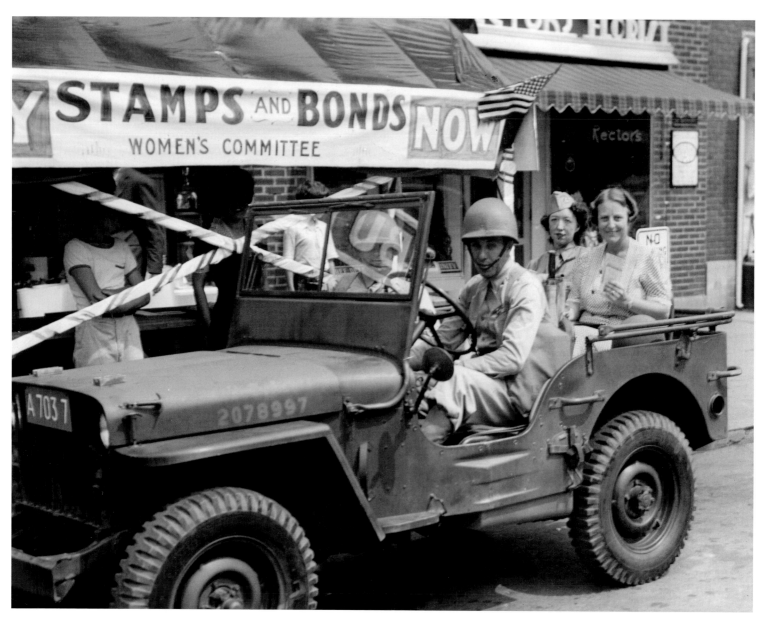

One of the charming members of the Women's Committee poses in a jeep with a WAC and two soldiers around 1942. The Alcova Theater where the war bond program was administered is immediately behind the photographer.

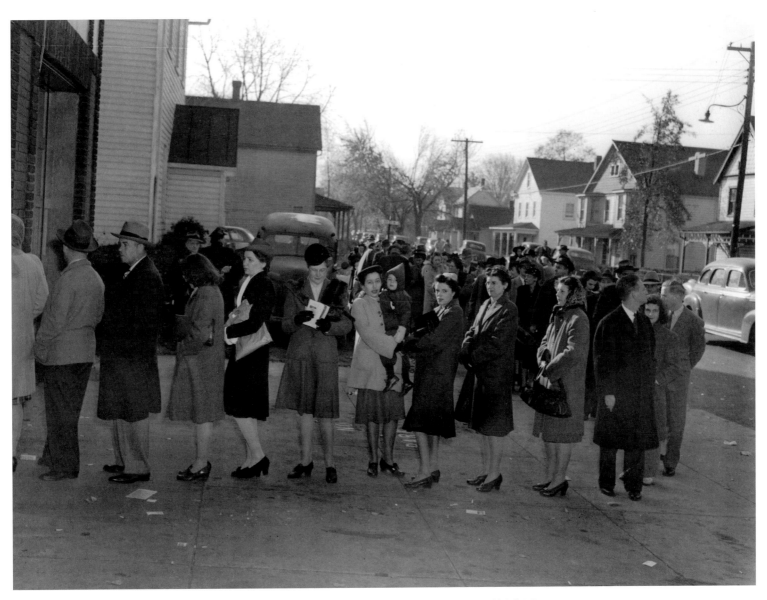

Citizens line up outside the firehouse to vote in the 1944 presidential election, November 7, 1944. This long line is indicative of the predicted record turnout in Arlington (56,784 voters), where a county board member, congressman, and two constitutional amendments were on the ballot. Clear, crisp weather and the contest between four candidates for Congress brought a heavy turnout. Photographer Maria Ealand, niece of Edward Bruce, who headed the Treasury's arts program, worked for the Office of War Information.

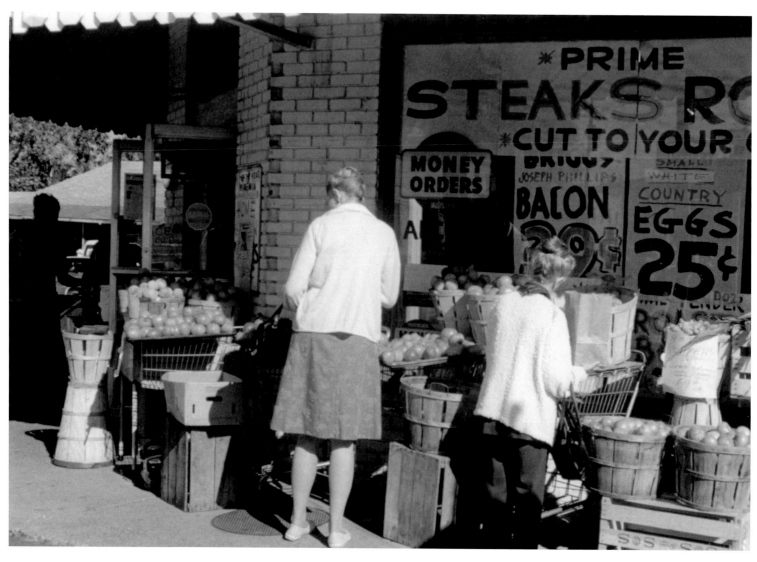

Postwar image of agricultural bounty, as a woman selects from the heaps of tomatoes.

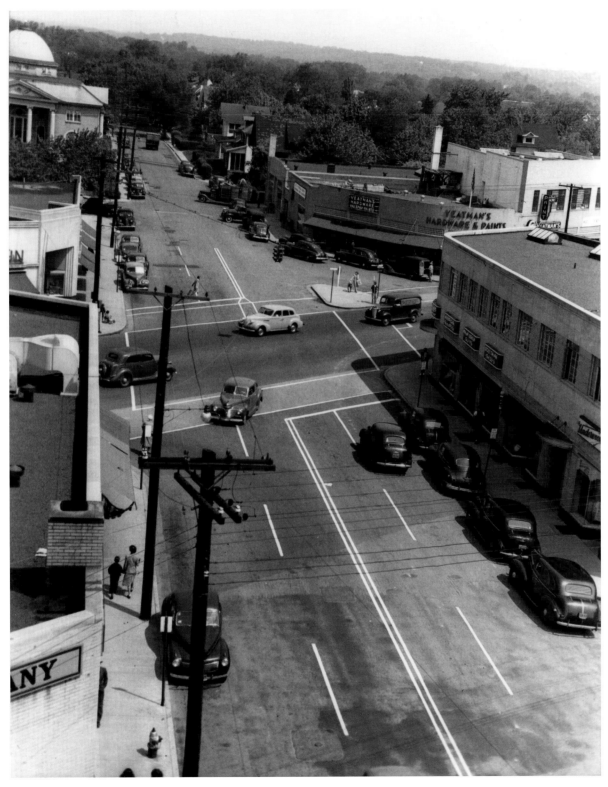

"Downtown" Arlington, that is Clarendon. It was here that the major shops clustered. Yeatman's Hardware, pictured in the upper right, opened in 1940, and Sears, J. C. Penney, and F. W. Woolworth were on Wilson Boulevard. George M. Yeatman, president of Yeatman's Hardware was a prominent civic leader in Clarendon, as he had been previously in Washington. Here, Wilson Boulevard merges with North Hartford and North Highland Streets. Today, Clarendon Metro station is located on the immediate lower left of this image.

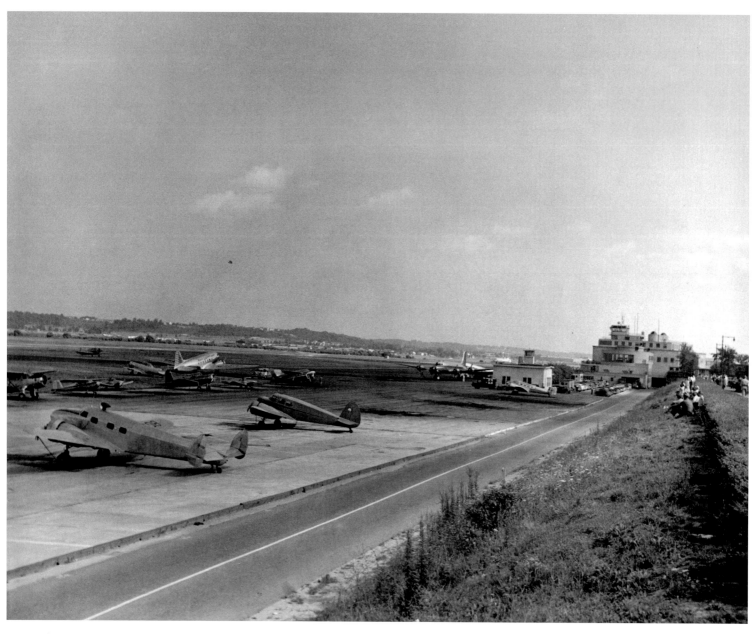

National Airport opened in 1941, replacing the sorely antiquated Washington-Hoover Airport to the north. Here, spectators enjoy sitting on the hill overlooking the runways, watching the planes take off and land in 1946.

Arlington voted to spend $15,000 celebrating its centennial in 1946—$10,000 in government funds and $5,000 private. Concerts, a parade, and historical pageant were included in the week-long celebration. The *Washington Post* pointed out the tremendous growth in what it termed Washington's "bedroom community." There were 57,000 residents in Arlington in 1940, growing to an estimated 140,000 in 1946. Pictured here that September, some equestrians lead the parade past a replica of the old train/trolley stops on Lee Highway.

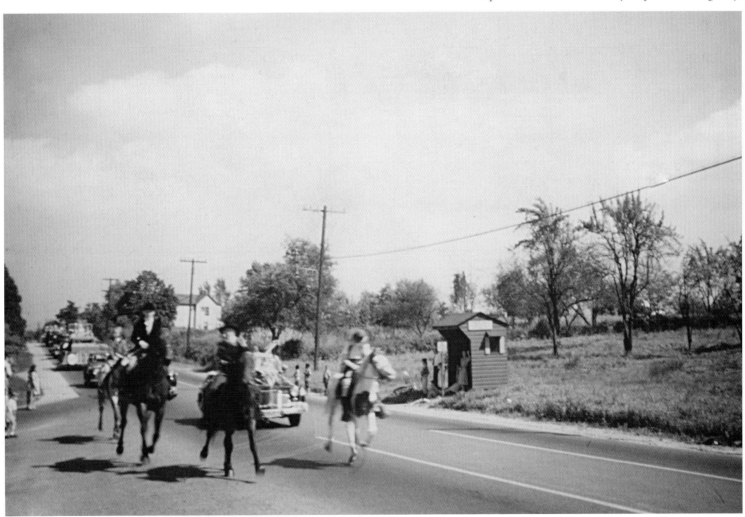

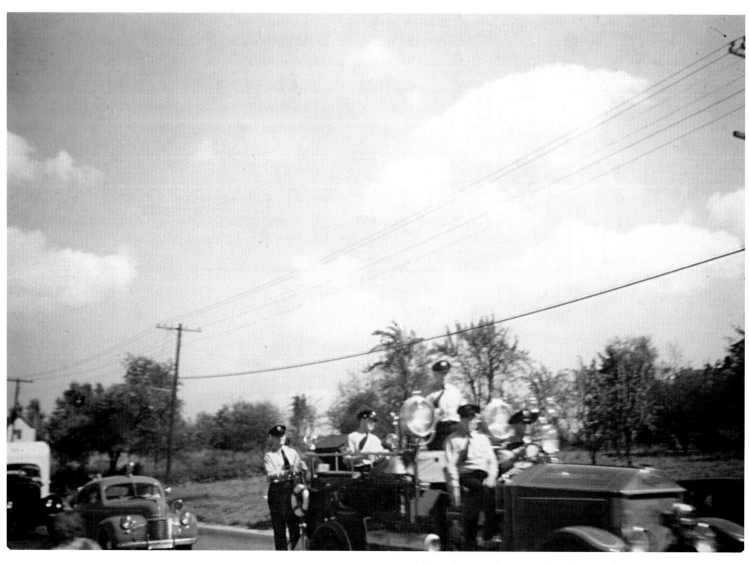

Viewed from the same location, the Arlington firemen pass by on antique
equipment in the centennial parade, September 1946.

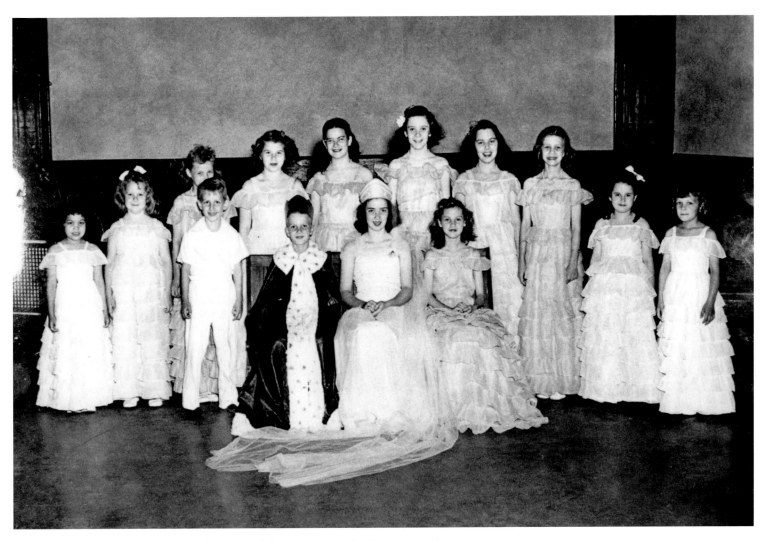

Postwar years brought prosperity to Arlington and the opportunity for the young to dress up in school pageants. Pictured here are students from Cherrydale school in 1946.

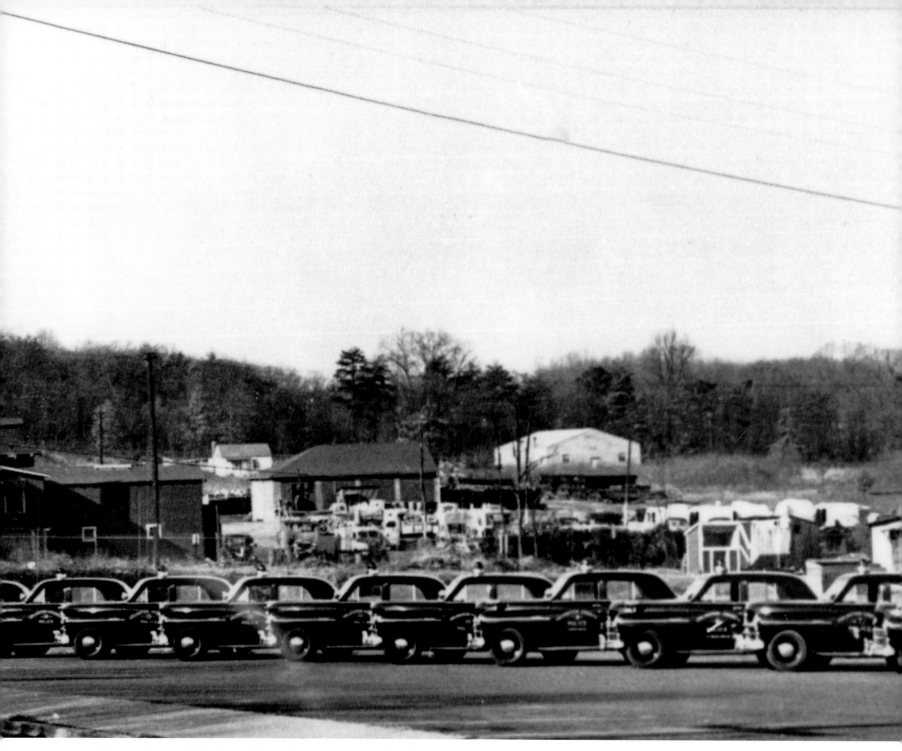

Arlington County Police show off their fourteen new patrol cars in 1946.

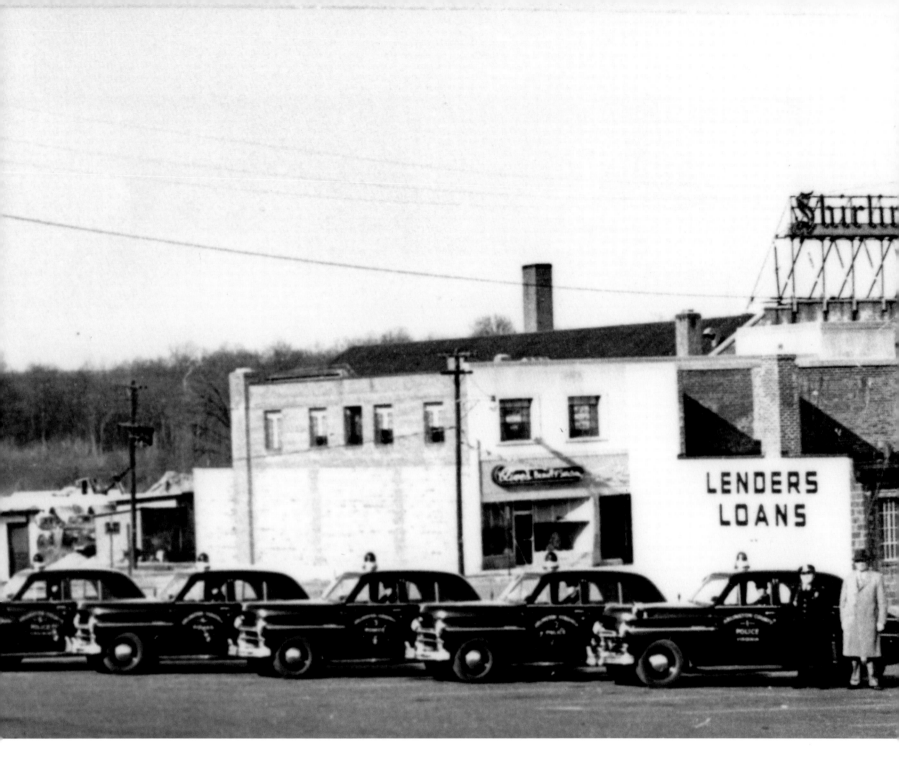

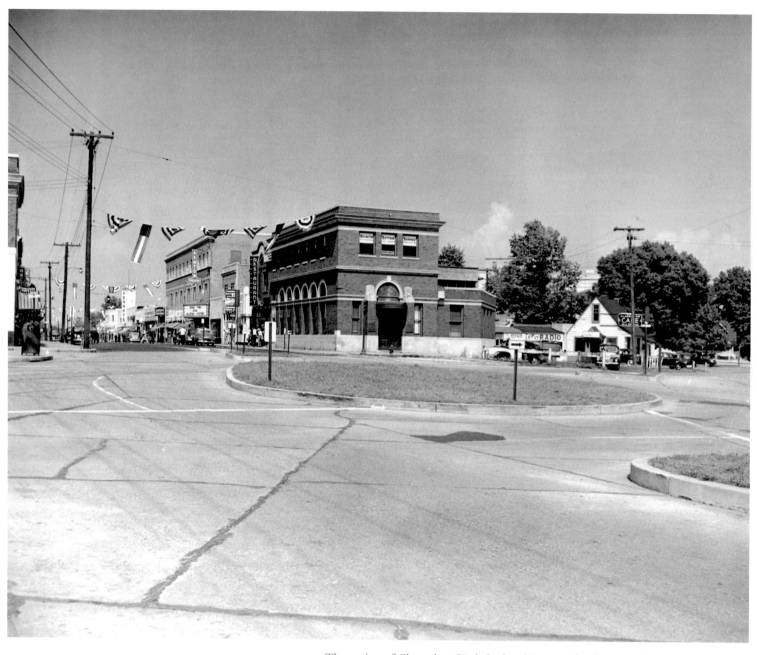

The paving of Clarendon Circle looks a bit worse for the wear, but Wilson Boulevard downtown is festooned with flags and bunting, presumably for the centennial celebration. Ashton Theater, visible in the middle left of the picture, would have been the site of bond drives during the war.

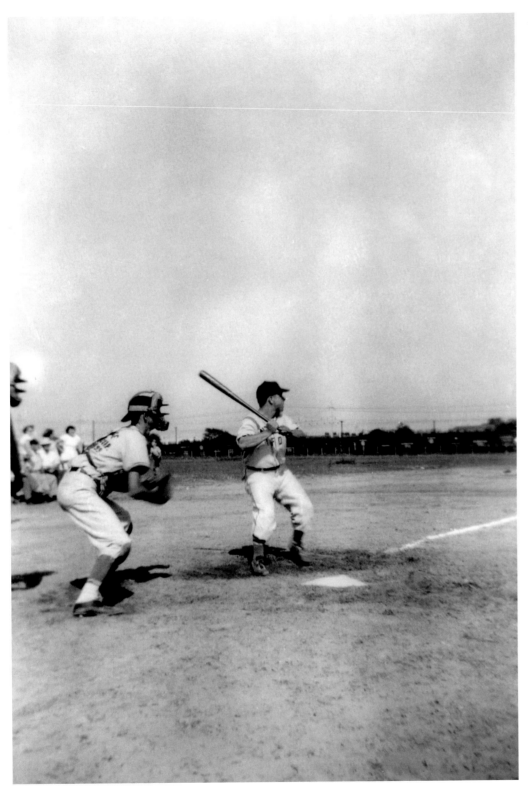

Arlington County Fire Department was an entirely volunteer system until 1940, when the county shifted to a fully paid department, supplemented by a volunteer force. Here, around 1948, members of the Arlington County volunteer firemen's association play baseball.

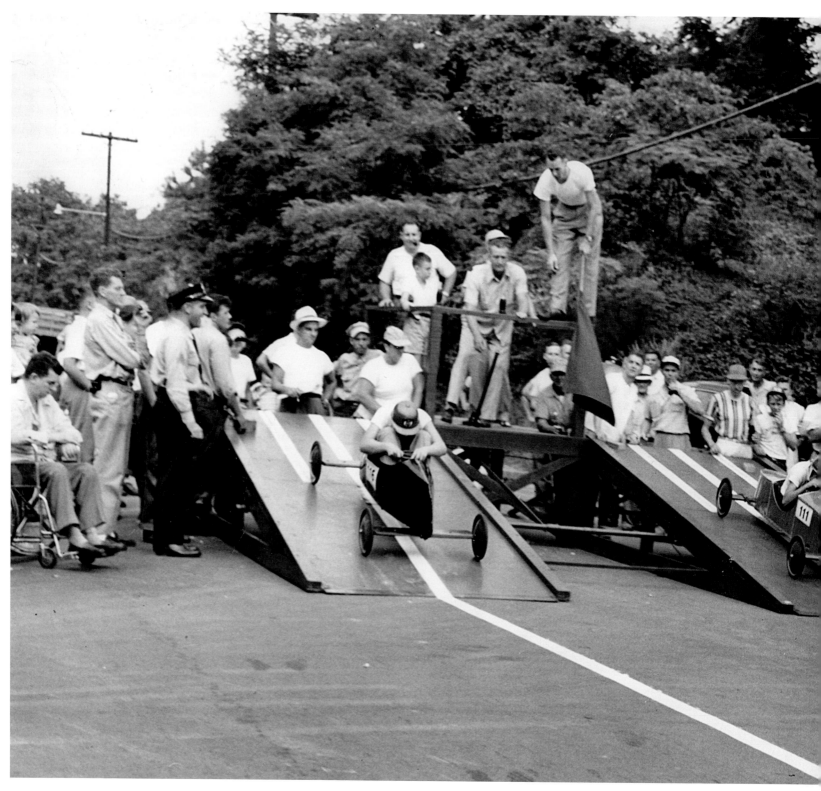

160

Soap box racing was taken very seriously in the 1940s. In 1949, the national competition was witnessed by 40,000 people—148 entries from the United States, Canada, and Panama. Arlington's race here is on a much smaller scale but just as appreciated by the spectators.

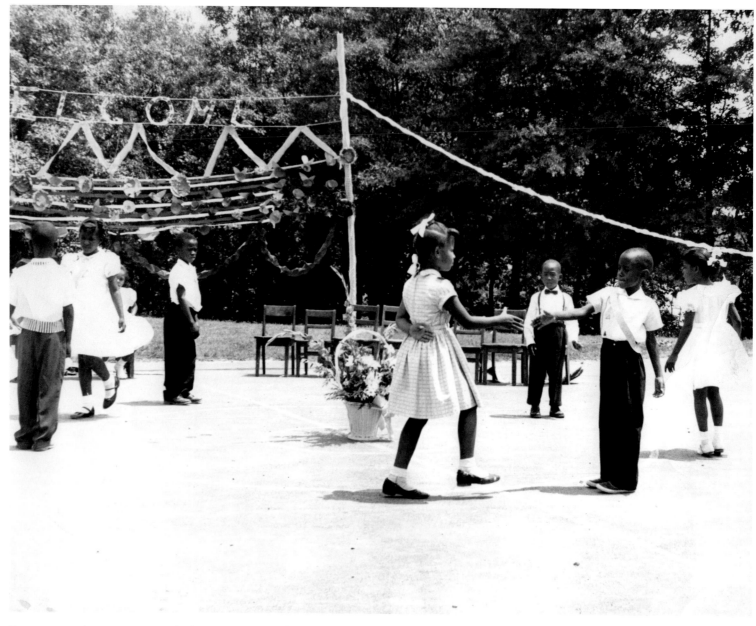

Postwar years also saw a new emphasis on recreation. While segregated, a great deal of energy was invested in activities for African Americans. Here we have a dance—with a mix of emotions evident on the children's faces.

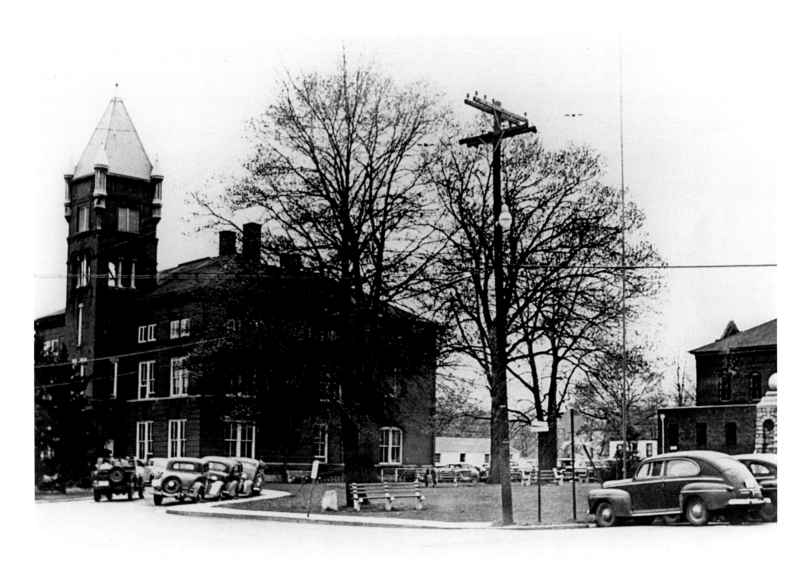

Arlington's courthouse, which by the 1940s was inadequate to the needs of the county, is seen here around 1945, before the construction of two flanking wings.

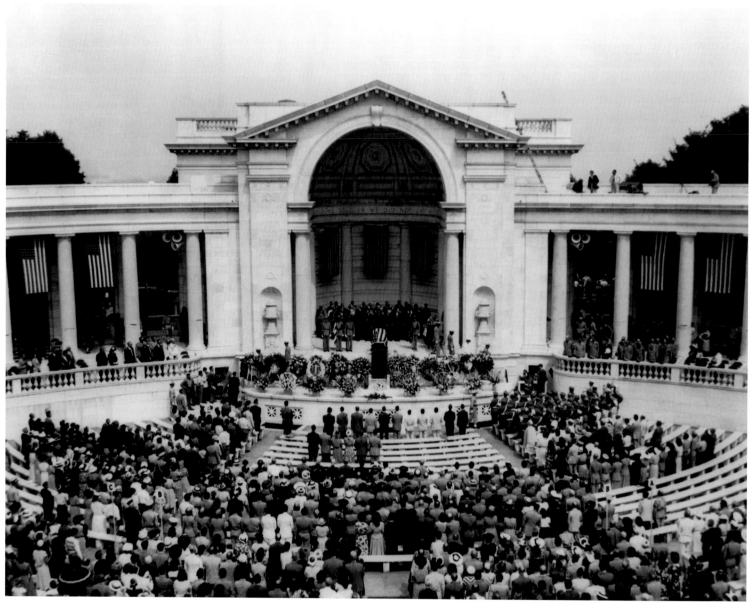

Funeral of General John J. Pershing at Arlington National Cemetery Amphitheater, July 19, 1948. He died at Walter Reed Hospital, and his body then lay in state in the Capitol Rotunda. Crowds numbering 300,000 lined the streets to witness the funeral cortege of the much-respected "Black Jack" Pershing. Pershing picked his gravesite at Arlington years before, marked now by the simplest of marble headstones.

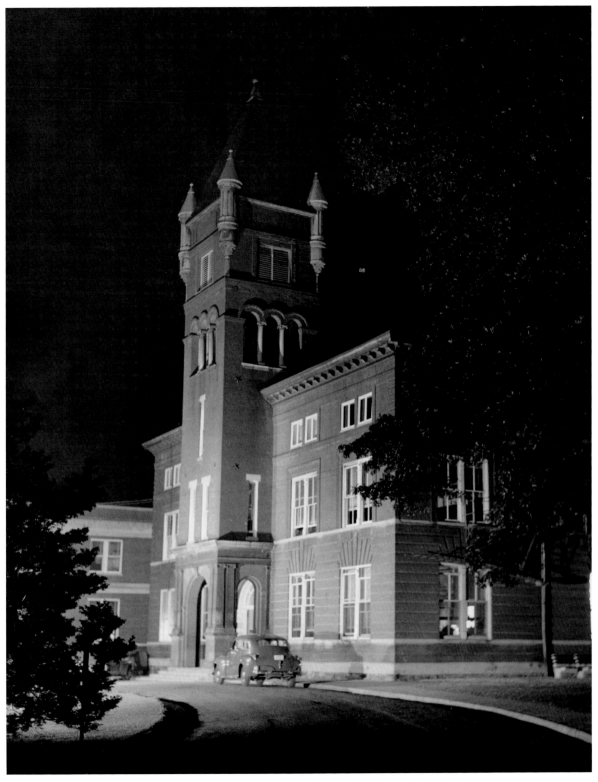

An atmospheric image of the old Arlington County Courthouse, built in 1898. Frank L. Ball, long-time Arlington politico, saw its dedication as a twelve-year-old boy and its demolition sixty-two years later. The replacement building was demolished in 1997.

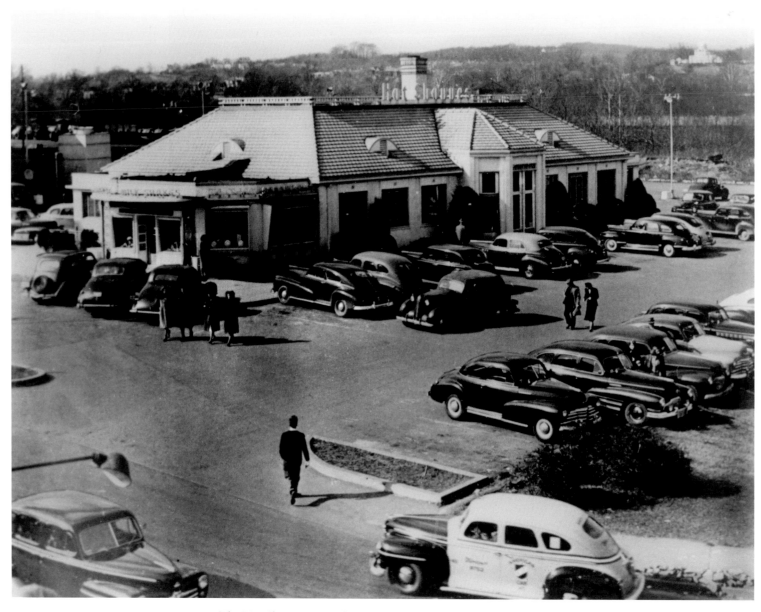

The Hot Shoppe in Rosslyn opened in 1940. Owner J. Willard Marriott said the one shown here, the tenth Hot Shoppe, was probably the most beautiful of all to that date (about 1949). "The Rosslyn Hot Shoppe is where you had to go after dances," according to 1943 Washington-Lee High School graduate Norman Trahan.

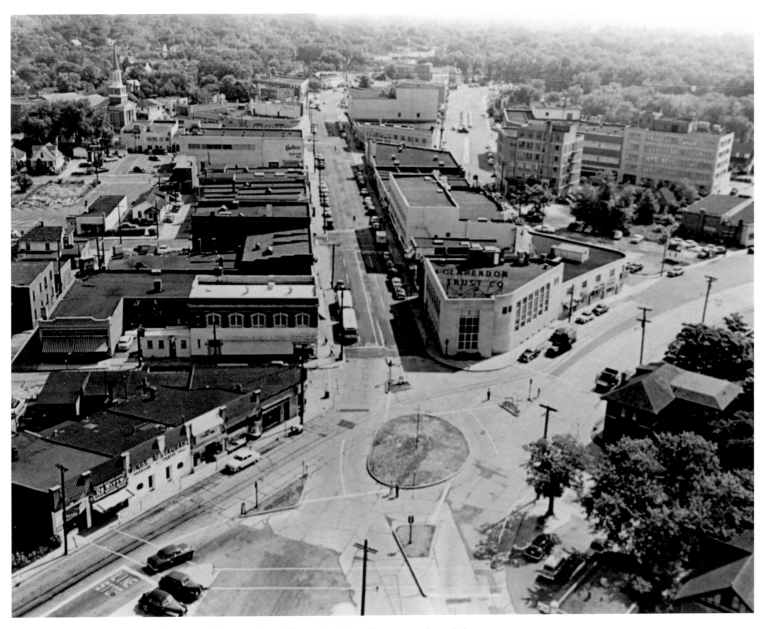

A later view of Clarendon Circle, around 1950. Here, Clarendon Trust Company (founded 1921) has reclad and expanded its building, seen at middle right. Across the street to the left is an altered, but still recognizable Masonic Hall.

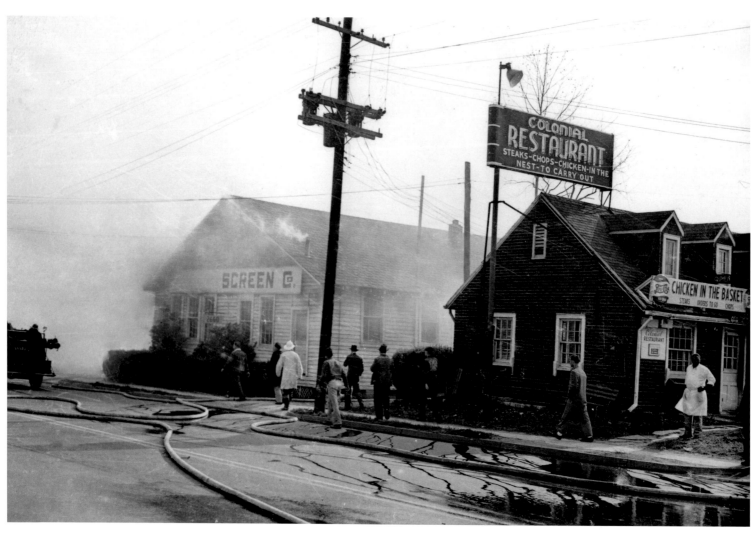

Colonial Restaurant was a fixture of Arlington life, even fielding a sandlot baseball team. This, in addition to "Steaks - Chops - Chicken - in - the - Nest to carry out." Here, in April 1951, firemen put out a fire at the neighboring Washington Screen Company, also a longtime local business.

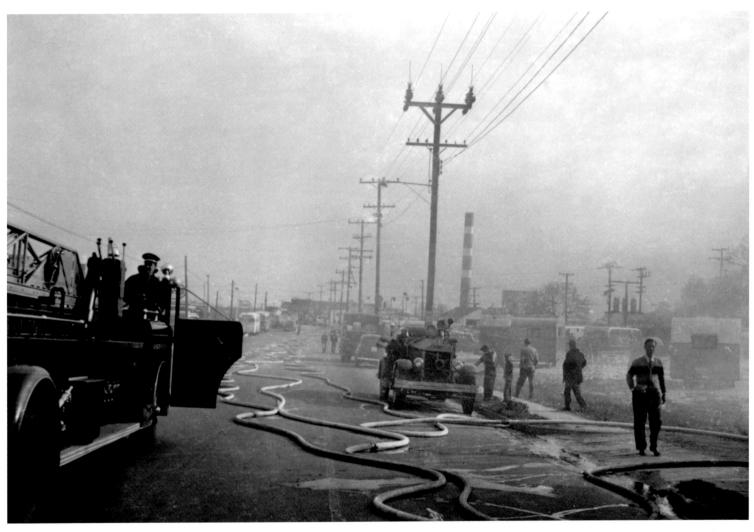

As firefighters fight the screen factory fire, spectators watch. In the distance are the businesses along the Alexandria-Georgetown Road in April 1951.

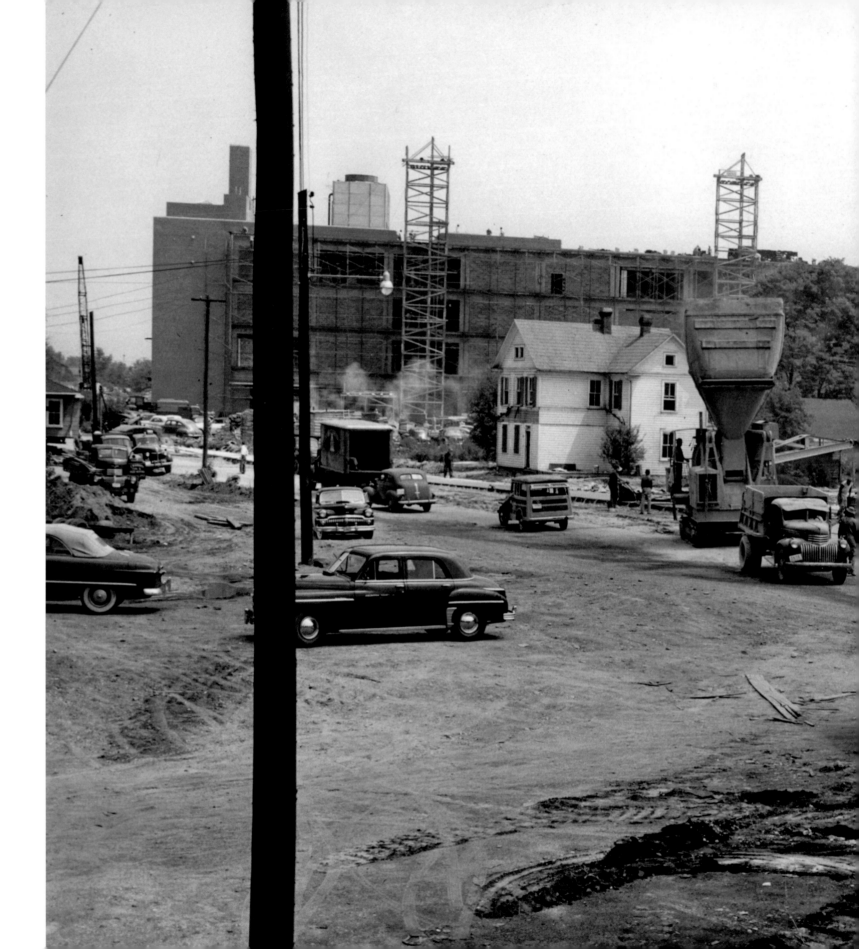

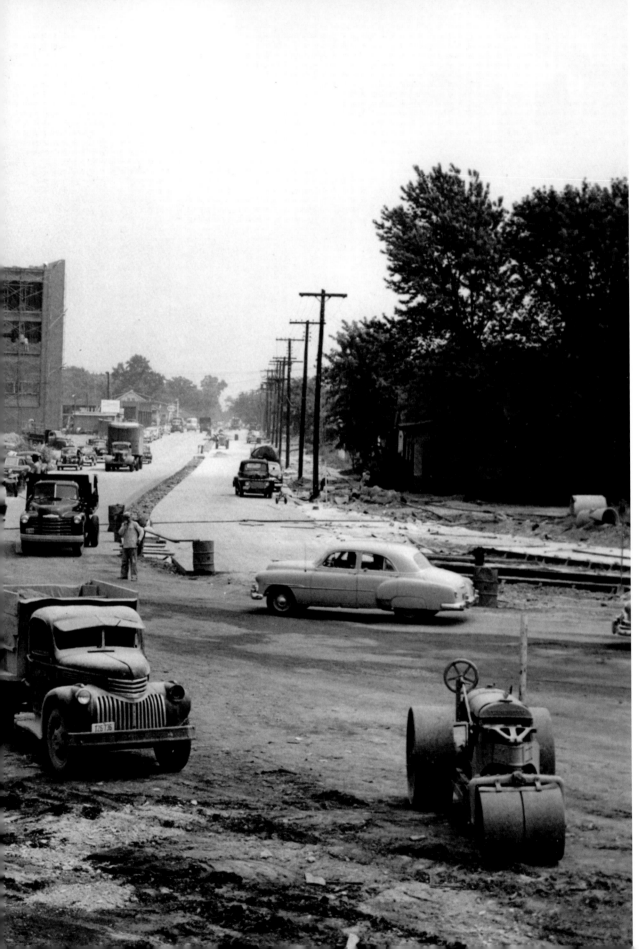

Progress comes to Parkington. Pictured here in the summer of 1951 is reconfiguration of the roads and parking lot expansion. The large building in the background is the new $6.5 million Hecht's department store, part of the Parkington Shopping Center. This facade would be sheathed almost entirely with glass windows where six-foot-high letters would spell out messages to drivers speeding by. Sutton's Feed Store is the white frame building at the intersection. Parkington has been replaced with Ballston Commons Mall.

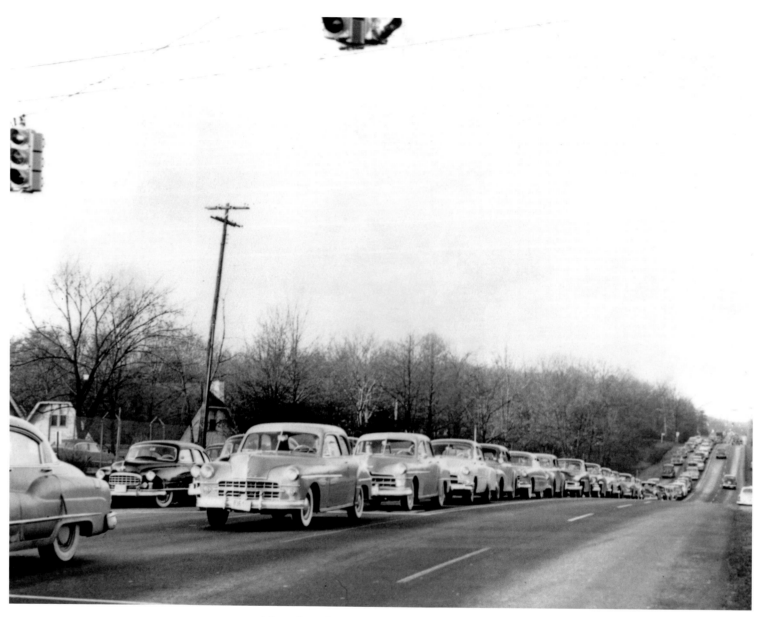

A long, long, long line of cars on their way from Virginia into the District of Columbia at 8:45 AM, December 7, 1951. This is Lee (now Arlington) Boulevard west of Glebe Road. To the left, out of frame, is Arlington Hall. In March of 1951, it was announced that an "electronic brain" would be controlling twelve traffic lights to manage traffic flow from Glebe Road to Arlington Memorial Bridge. It's not clear from this picture whether that could be deemed a success, not if it caused traffic backups like this.

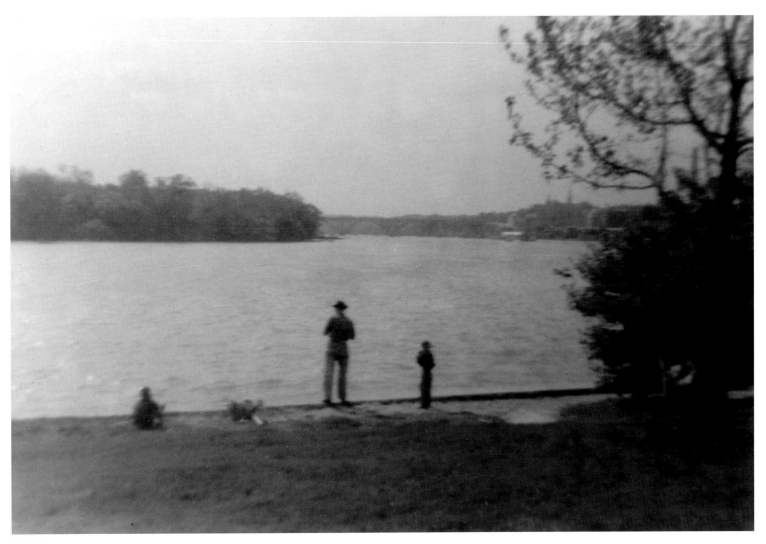

Group fishing along the Potomac River on the Virginia shore, looking toward Theodore Roosevelt Island (formerly Analostan Island) in June 1952.

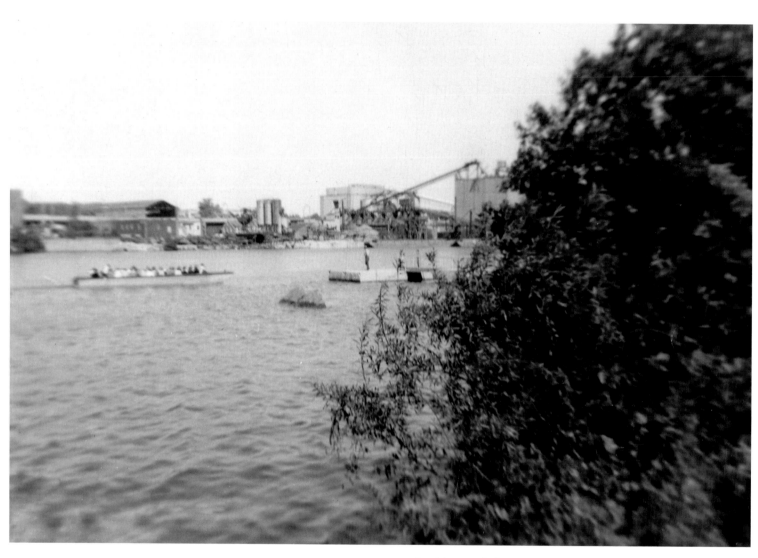

Looking north from Theodore Roosevelt Island to the Georgetown
waterfront. A boat slips by in June 1952.

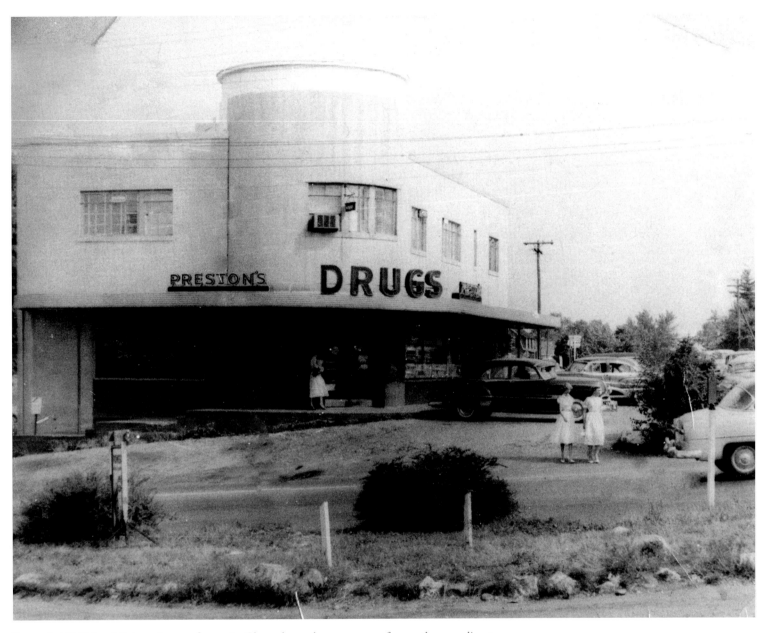

Preston's (4740 Lee Highway) was a fixture in Clarendon, a hang-out spot for youth, according to recollections of Barbara Ball Savage. This photo was taken around 1955.

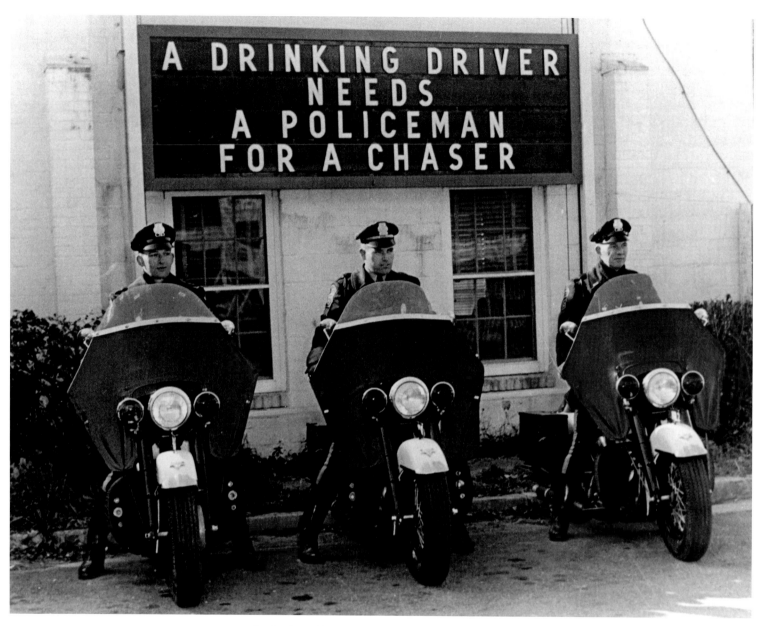

"A drinking driver needs a policeman for a chaser." Around 1955, three motorcycle policemen stand vigilant (and posed) to pursue and catch any drunk driver who might cross their path. The Arlington police force came under criticism in the 1950s. A report called for them to "primp up smartly and show a bright face," and to learn jiujutsu.

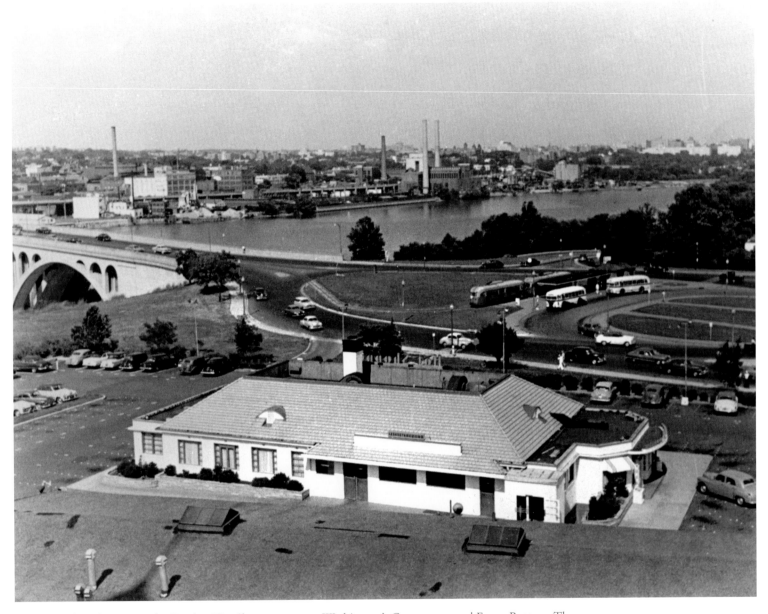

A view north and east over the Rosslyn Hot Shoppe across to Washington's Georgetown and Foggy Bottom. The transfer station in Rosslyn Circle, at the center of the picture, has streetcars waiting to go back to Washington and buses to go into Arlington, as cars stream across Key Bridge. Georgetown's Whitehurst Freeway is visible, elevated between the waterfront industries, around 1955.

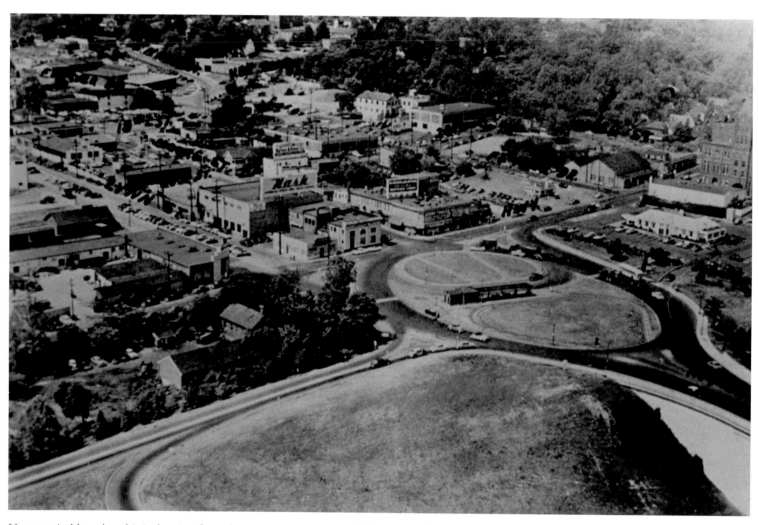

Unrecognizable today, this is the view from the previous image turned 180 degrees. Rosslyn retains its small-town, perhaps run-down aspect. The Cherry Smash bottling plant is in the far right, behind the Hot Shoppe. Just south of the circle is the venerable Arlington Trust Company.

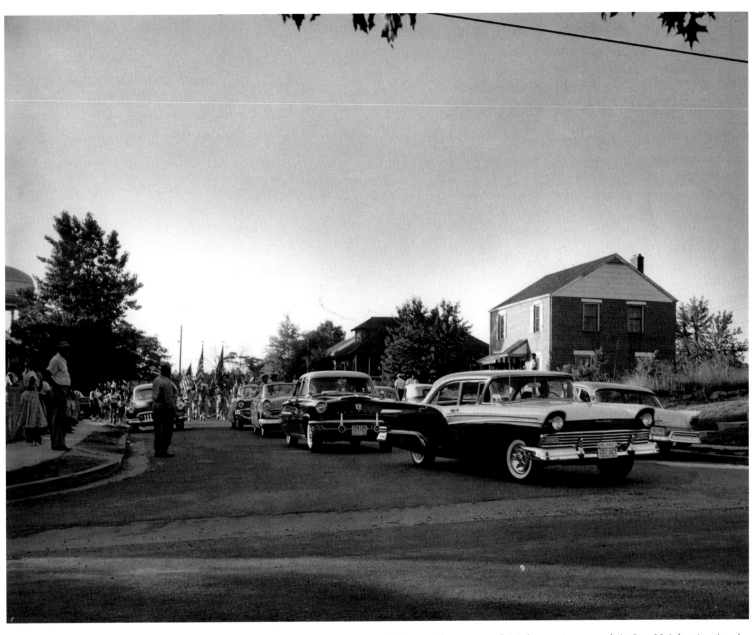

Everyone loves a parade! Arlingtonians march in Lee Heights (notice the water tower barely visible on the left).

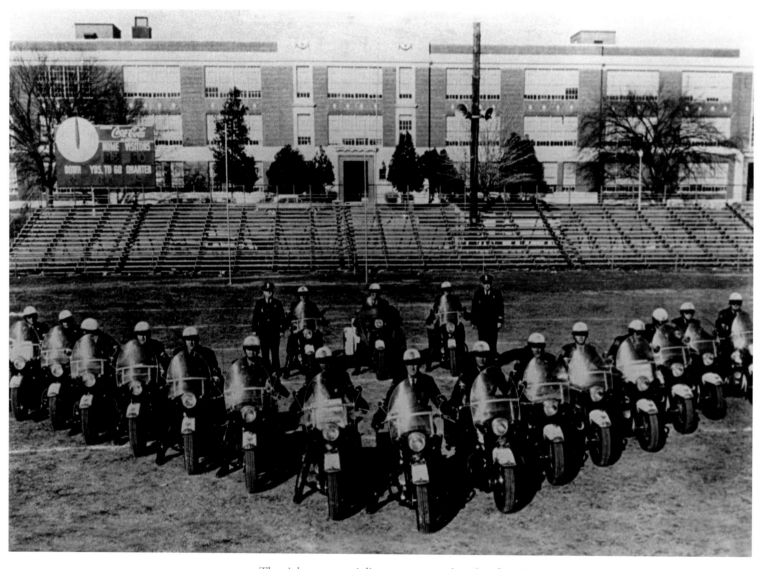

The eighteen-man Arlington motorcycle police force in 1958, just as vigilant as several years before but with new motorcycles, posed here at Washington-Lee High School. A more populous and heavily trafficked county needed a larger motorcycle police force.

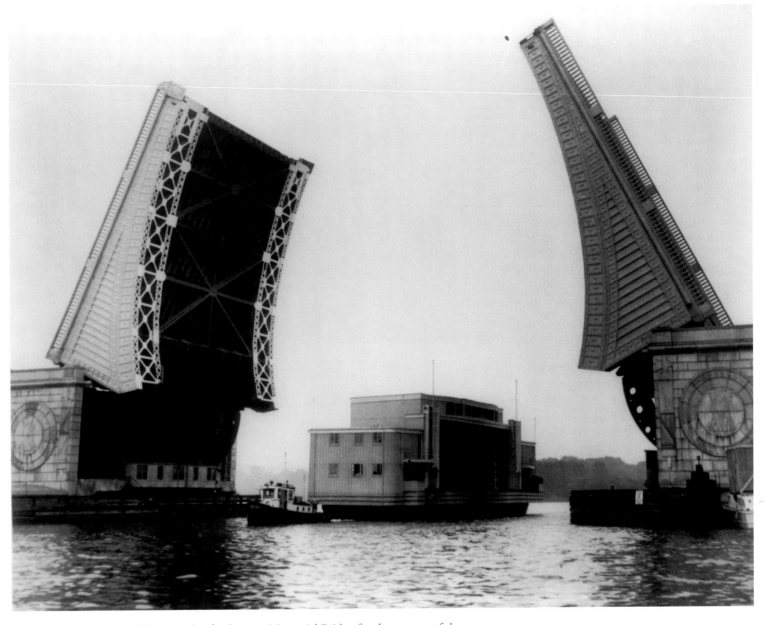

Extremely rare opening of the bascule of Arlington Memorial Bridge for the passage of the Watergate concert barge in 1952. The barge was moored at the Watergate steps above Memorial Bridge for twenty years, from 1945 to 1965, until it became unsafe to use.

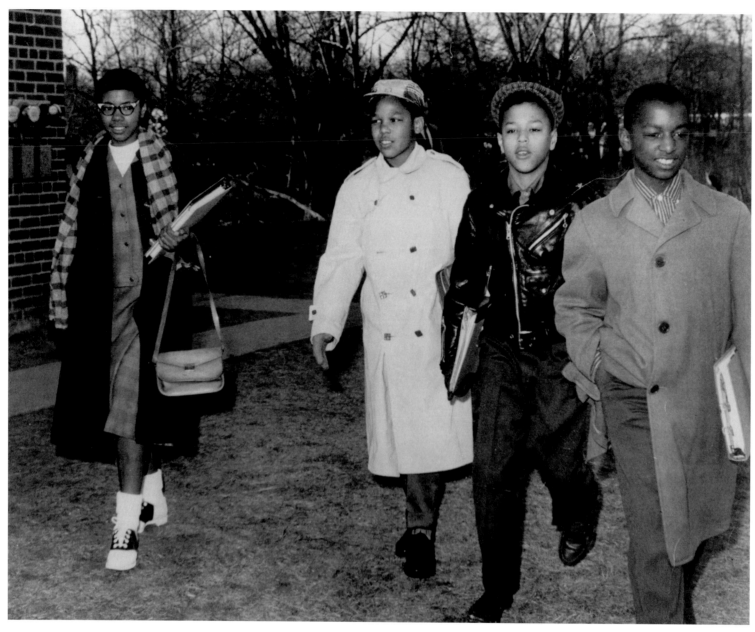

The Brown vs. Board of Education ruling which struck down "separate but equal" schooling nationwide was not immediately accepted in Virginia. The legislature launched a campaign of "massive resistance" which denied state funds to schools which integrated. This was struck down by the courts in 1959, leading to immediate integration of the schools.

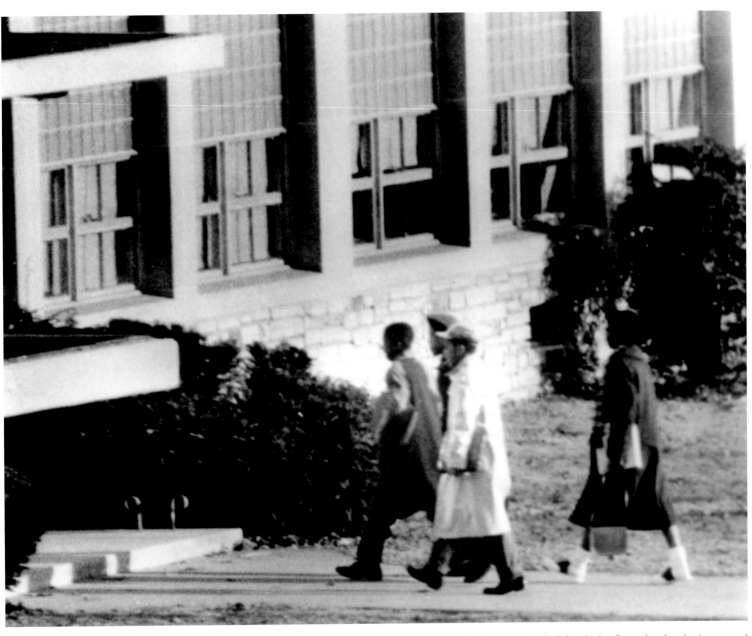

February 2, 1959, four African Americans entered Stratford Junior High School, the first school to be integrated in the entire state of Virginia. Ronald Deskins, Michael Jones, Lance Newman, and Gloria Thompson were greeted by a massive police presence, approximately eighty-five officers. Reports and recollections say they passed without incident.

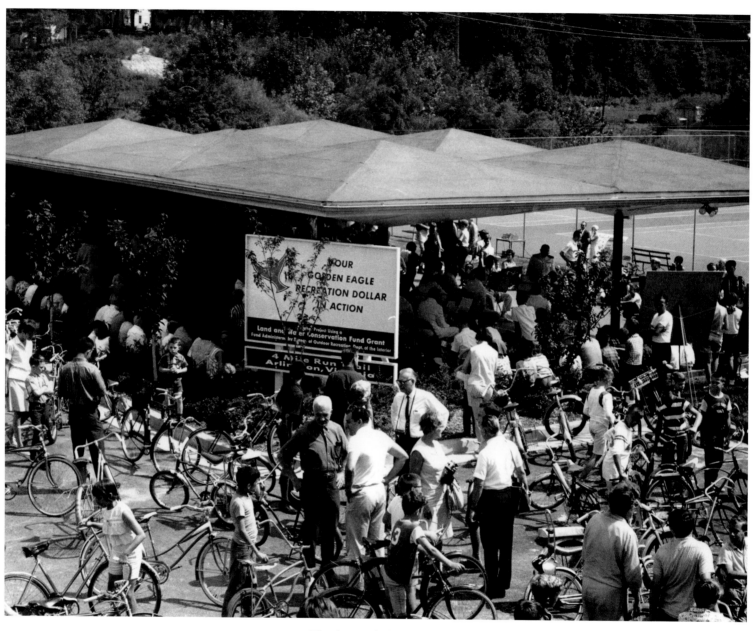

The three-mile bicycle path at Four Mile Run opened September 4, 1967. The $35,000 project ran from North Roosevelt Street to Columbia Pike along the creek. Here, a big crowd of cyclists mills around waiting for the opening.

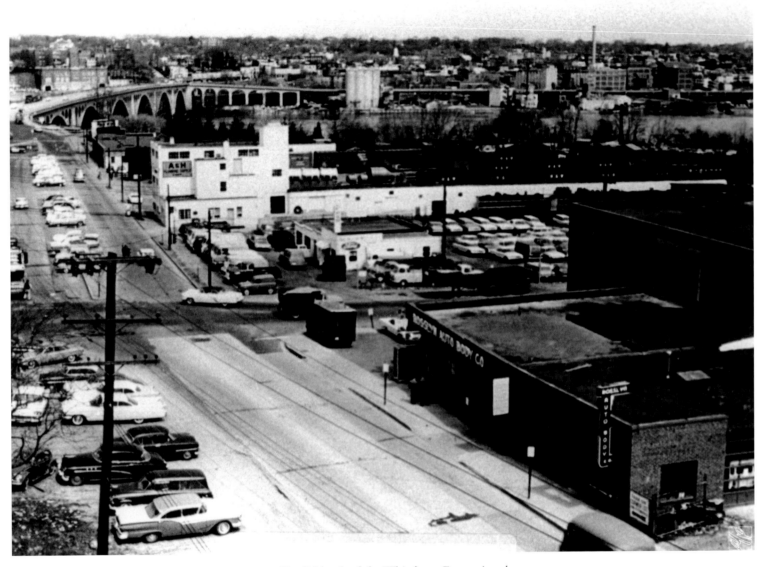

A view of Rosslyn along North Lynn Street, across to Key Bridge (and the Whitehurst Freeway) and Georgetown's slightly less industrial waterfront. Redevelopment has not yet come to Rosslyn, which still has parking in the center of Lynn Street in this photo from about 1962.

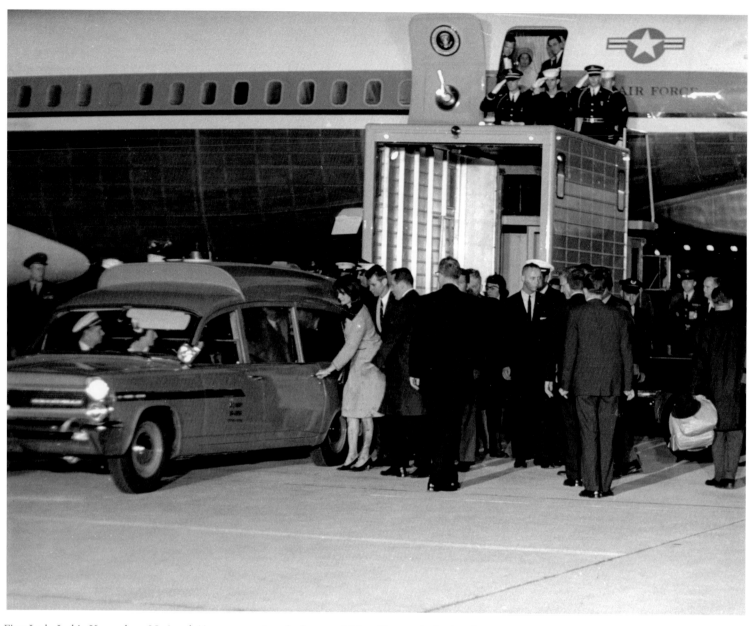

First Lady Jackie Kennedy at National Airport, entering the hearse which will carry the body of slain President John F. Kennedy to his final resting place in Arlington Cemetery, 1963.

North Moore Street, one block west of Lynn Street, in 1963.

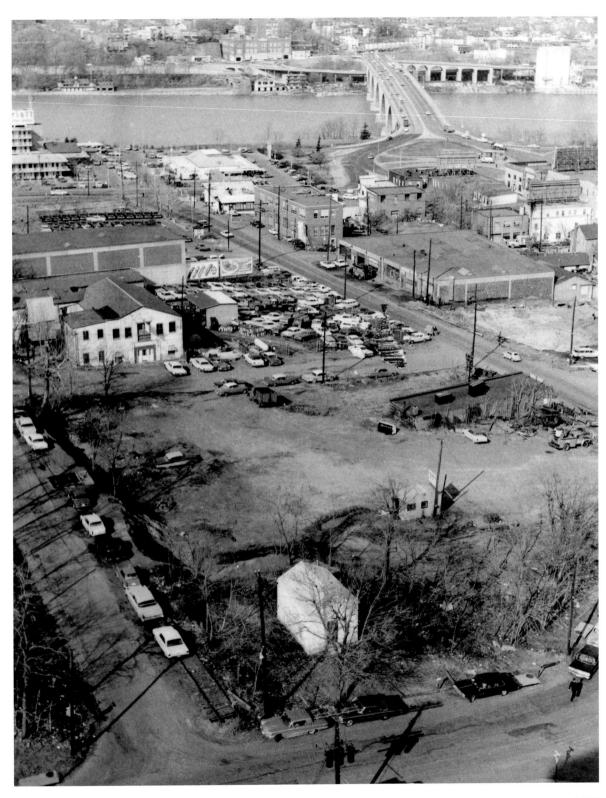

A historical marker in front of the church reads: "Walker Chapel, a small frame country church of the Mount Olivet Circuit, was dedicated at this location on July 18, 1876. It was named in honor of the Walker family who donated the Walker Grave Yard as the site for the church. A new frame church was built nearby in 1903 although the original chapel structure continued in use as a Sunday school until its demolition in 1930. The present building dates from 1959. The earliest recorded burial in the adjacent cemetery was that of David Walker, who died in 1848." The 1903 church had been Arlington's oldest, until its 1959 demolition; the new church opened in 1960.

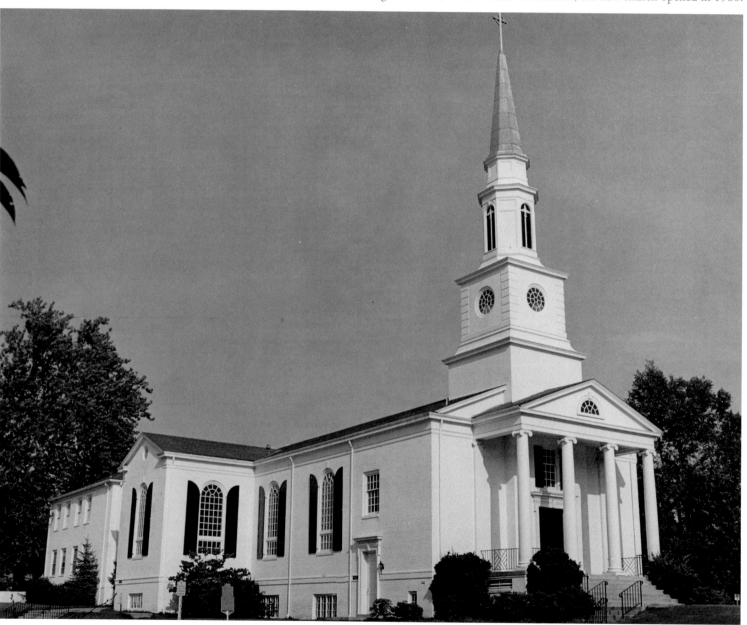

A view of Arlington Boulevard to the west. This is the long-delayed linkage
of the Lee Memorial Boulevard to Arlington Memorial Bridge. The Iwo Jima
Motel is visible right center (now replaced by a Quality Inn).

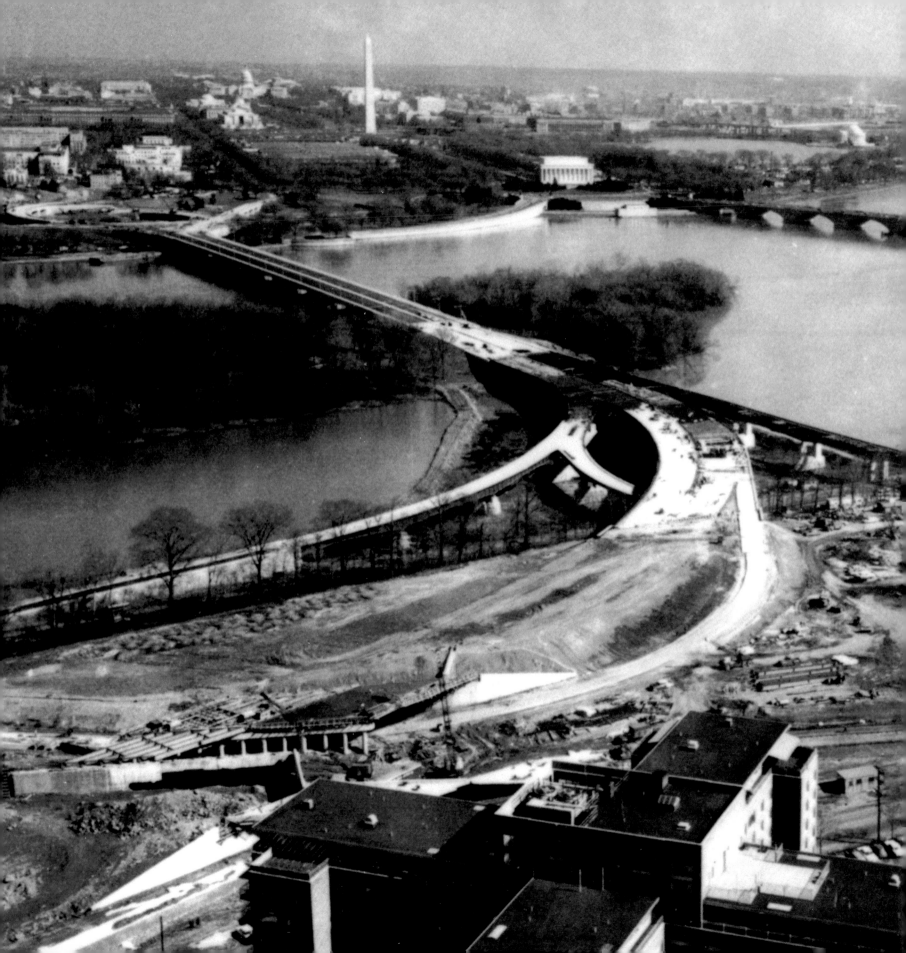

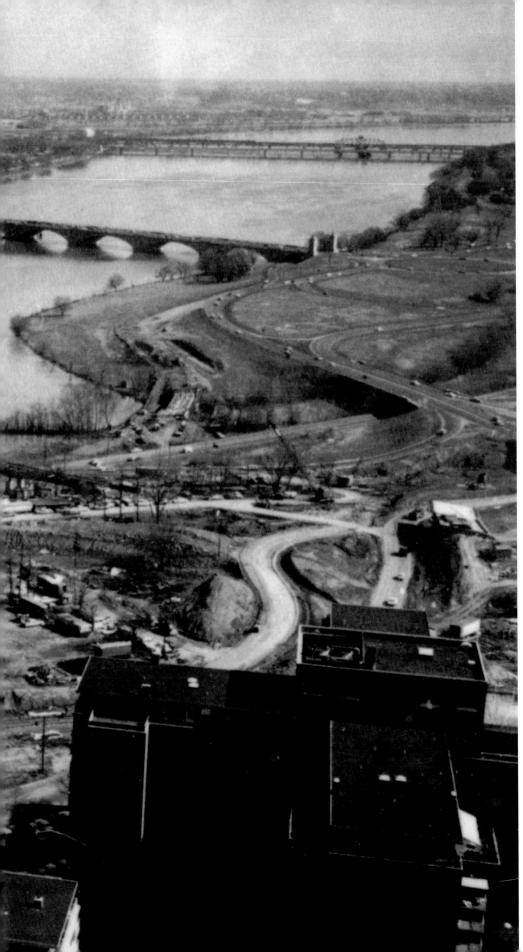

Theodore Roosevelt Bridge under construction in April 1964, not long before its opening on June 23. Mooted as early as 1948, the bridge was designed as part of a complex web of freeways for the national capital region. Those for the District of Columbia were mostly blocked; Arlington did get Interstate 66, of which this bridge was a part. Routing of the bridge across the southern end of Theodore Roosevelt Island faced fierce opposition. In the foreground are two of the four towers of Arlington Towers (now known as River Place). At the time of construction, this was the world's largest air-conditioned project of its type.

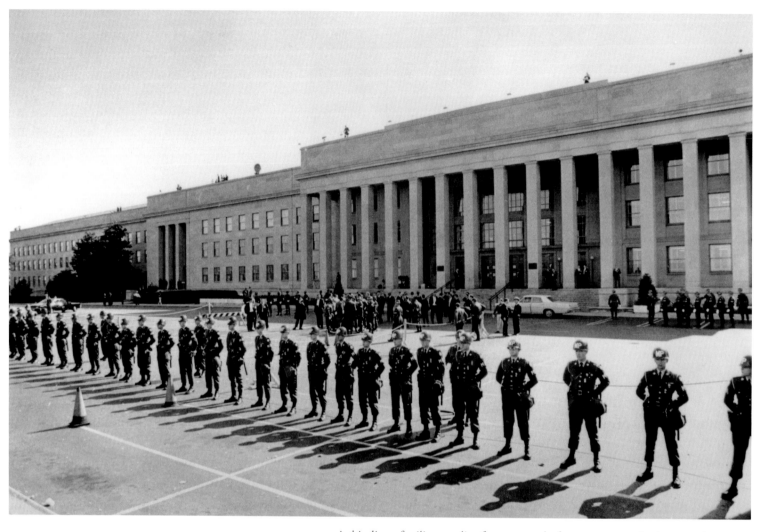

A thin line of military police faces a crowd of protestors numbering over 50,000 on October 21, 1967. The demonstration was supposed to be confined to the north parking lot, some distance away from the Pentagon itself. Eventually the obstacles and defenses were overcome, and thirty protestors actually burst into the Pentagon. Norman Mailer and David Dellinger were among those protesting.

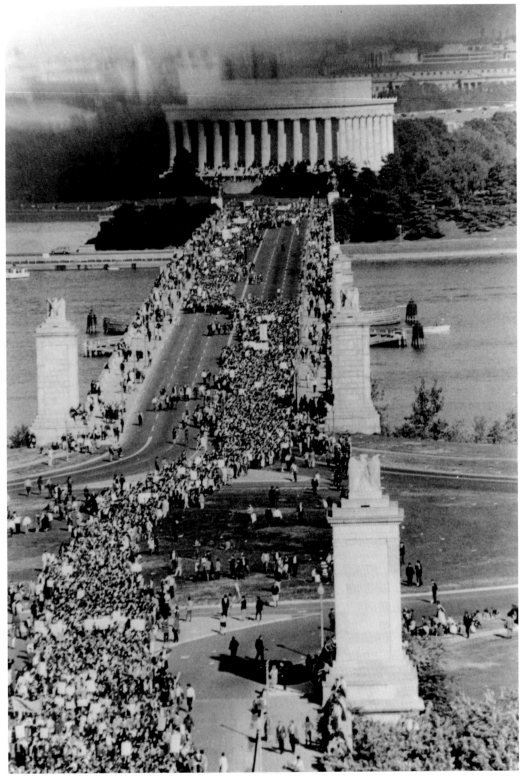

Here is some part of the crowd which faced that spare defensive line of military police on October 21, 1967. The protest began with a rally at the Lincoln Memorial. Here, protestors cross Arlington Memorial Bridge to reach the Pentagon. Included in the crowd was Abbie Hoffman, who had plans to use psychic energy to levitate the Pentagon—one of the world's largest buildings!

The county widens Washington Boulevard from Arlington
Boulevard to 3rd Street, March 27, 1966.

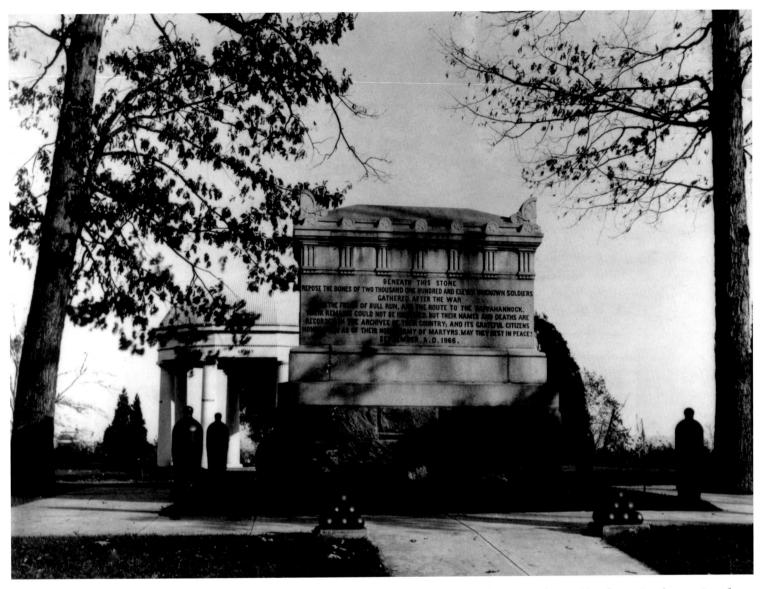

The memorial to Civil War unknown soldiers was dedicated in September 1866 and contains the remains of over 2,100 men from many battlefields. This is a merest fraction of the over 150,000 unknowns buried at eighty-three national cemeteries across the nation, as reported in 1903. The 1921 dedication of the Tomb of the Unknown Soldier has taken much of the attention from this memorial. Reputedly, this memorial was placed in the Lee family rose garden to spite the family and prevent them from ever enjoying it again. For many years the Temple of Fame lay to the south in the center of the rose garden, but it was removed in 1966.

The house of Vera Koehler, almost hidden by dense vegetation in 1972. Koehler's house and many others were sacrificed for Interstate 66. Koehler was party to a lawsuit to prevent the construction of I-66. Area residents fought a long (and in Arlington, unsuccessful) battle against a massive interstate freeway plan, preferring rapid transit. Arlington ended up with a combination, Interstate 66 and Metro rail, some stations of which were located along I-66.

A charming reminder of days gone by—a frame house still standing in a commercial strip in 1973.

Thomas Jefferson Junior High School opened in 1938. In 1966, Thomas Jefferson was merged with the all-black Hoffman-Boston Junior High, and a report on school facilities urgently pressed for its expansion or replacement. The current building was built in 1971.

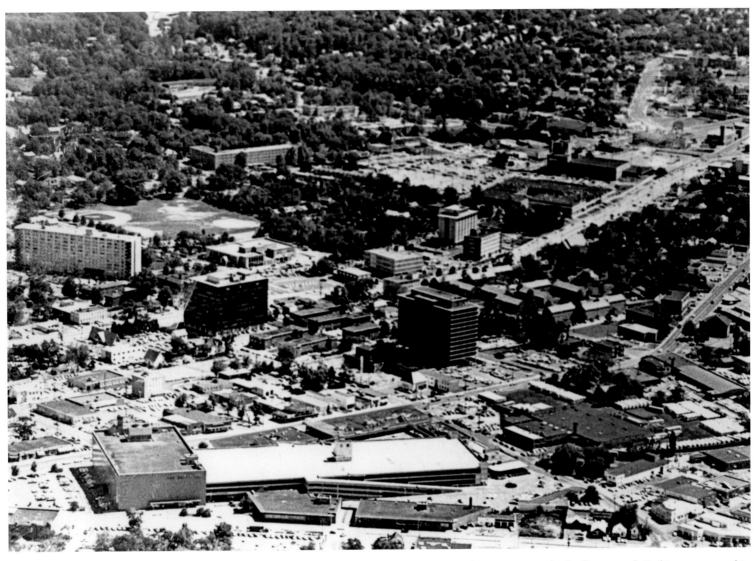

A 1971 image of Ballston showing the Parkington shopping center in the foreground. Parkington opened in November 1951 and featured the Hecht's department store, thirty other stores, and parking for a nickel in any of 2,000 parking spots. Down-at-the-heels after thirty years, Parkington was replaced by Ballston Common Mall in the 1980s, although total refurbishment of Hecht's had to wait until 2006 with its conversion to Macy's. The few tall buildings seen here along Fairfax Drive have since been joined by many others.

Notes on the Photographs

These notes, listed by page number, attempt to include all aspects known of the photographs. Each of the photographs is identified by the page number, photograph's title or description, photographer and collection, archive, and call or box number when applicable. Although every attempt was made to collect all available data, in some cases complete data was unavailable due to the age and condition of some of the photographs and records.

II **1878 Alexandria County Map**
Library of Congress
ct000165g

VI **Aerial of Fairfax Drive**
Courtesy of Washingtoniana Division, D.C. Public Library

X **George Washington Parke Custis**
Library of Congress
3c10010u

3 **Long Bridge**
Alexandria Library, Local History/Special Collections
008

4 **Boundary Stone**
Virginia Room, Arlington County Public Library
230-0462

5 **Mary Custis Lee**
Library of Congress
85378

6 **"Quaker Guns"**
Virginia Room, Arlington County Public Library
230-1149

7 **Octagonal House**
Alexandria Library, Local History/Special Collections
William Smith Collection_ 1392

8 **General Irwin McDowell's Headquarters**
Library of Congress
01487u

9 **Long Bridge Damage**
Virginia Room, Arlington County Public Library
230-1769

10 **Fort Marcy**
Library of Congress
01549u

11 **Stables at Arlington House**
Library of Congress
07323u

12 **Fort Haggerty**
Library of Congress
01439u

13 **Fort Corcoran**
Library of Congress
03582u

15 **Arlington House Portico**
Library of Congress
08246u

16 **Soldiers Relaxing**
Library of Congress
07322u

17 **Fort Whipple**
Library of Congress
03813u

18 **Band of the 107th U.S. Colored Infantry**
Library of Congress
02479u

20 **Fort C. F. Smith**
Library of Congress
04124u

21 **Home of Mary Carlin**
Virginia Room, Arlington County Public Library
208-0243

22 **Wellhouse**
Courtesy of Washingtoniana Division, D.C. Public Library
392

23 **Curtis (Now Carlin) Hall**
Virginia Room, Arlington County Public Library
208-0003

24 **Chain Bridge**
Virginia Room, Arlington County Public Library
208-0006

25 **Courthouse**
Virginia Room, Arlington County Public Library
100-0402

26 **Honoring the USS "Maine"**
Library of Congress
57110

27 **Al Thompson and Bash**
Virginia Room, Arlington County Public Library
12-5035

28 **USS "Maine" Memorial**
Courtesy of Washingtoniana Division, D.C. Public Library
319

30 CEREMONY
Courtesy of Washingtoniana
Division, D.C. Public Library

31 OSCAR HARING'S
GENERAL STORE
Virginia Room, Arlington
County Public Library
230-1708

32 CHARLES KNOXVILLE'S
SUNDAY BAR
Virginia Room, Arlington
County Public Library
230-1235

33 TEMPLE OF FAME
Courtesy of Washingtoniana
Division, D.C. Public Library
314

34 BALLSTON SCHOOL
Virginia Room, Arlington
County Public Library
230-0724

35 BALLSTON POST OFFICE
AND DRUG STORE
Virginia Room, Arlington
County Public Library
230-1693

36 TROLLEY STOP
Virginia Room, Arlington
County Public Library
230-1790

37 GAZEBO AT HUME
SPRING
Alexandria Library, Local
History/Special Collections
WilliamSmithCollection_530

38 ALEXANDRIA CANAL
Alexandria Library, Local
History/Special Collections
WilliamSmithCollection_521

39 AQUEDUCT BRIDGE
Virginia Room, Arlington
County Public Library
200-0813

40 BARCROFT STATION
Virginia Room, Arlington
County Public Library
230-1789

41 COLUMBIA SCHOOL
Virginia Room, Arlington
County Public Library
200-1227

42 FIRE-STARTING
COMPETITION
Virginia Room, Arlington
County Public Library
200-1179

43 WASHINGTON LUNA
PARK
Virginia Room, Arlington
County Public Library
200-0102

44 LUNA PARK'S CAROUSEL
Virginia Room, Arlington
County Public Library
230-0453

45 LUNA PARK
Virginia Room, Arlington
County Public Library
230-0454

46 TROLLEY STATION
Virginia Room, Arlington
County Public Library
230-1322

47 ROSSLYN STATION
Virginia Room, Arlington
County Public Library
230-0749

48 MENOKIN
Alexandria Library, Local
History/Special Collections
WilliamSmithCollection_
543

49 ABINGDON
Alexandria Library, Local
History/Special Collections
SommersvilleCollection_403

50 BALLSTON STATION
Virginia Room, Arlington
County Public Library
200-1270

51 BUGGY
Virginia Room, Arlington
County Public Library
12-5036

52 CLARENDON CIRCLE
Virginia Room, Arlington
County Public Library
200-1271

53 MOUNT OLIVET
METHODIST CHURCH
CROWD
Virginia Room, Arlington
County Public Library
230-0609

54 ROCK SPRING ROAD
Virginia Room, Arlington
County Public Library
230-1204

55 BENNET H. YOUNG
Library of Congress
91975

56 CONFEDERATE
MEMORIAL
Library of Congress
91974

58 CLARENDON FIRE
DEPARTMENT
Virginia Room, Arlington
County Public Library
230-1144

59 BALTIMORE AND
POTOMAC RAILROAD
Virginia Room, Arlington
County Public Library
208-3998

60 ARLINGTON TRUST
COMPANY
Virginia Room, Arlington
County Public Library
230-1232

61 ROSSLYN
Virginia Room, Arlington
County Public Library
230-1818

62 AEROPLANE
Virginia Room, Arlington
County Public Library
230-1582

63 GREAT FALLS & OLD
DOMINION RAILWAY
COMPANY
Virginia Room, Arlington
County Public Library
230-3819

64 INDEPENDENT ORDER OF
ODD FELLOWS
Virginia Room, Arlington
County Public Library
12-5012

65 WASHINGTON & OLD
DOMINION RAILROAD
Virginia Room, Arlington
County Public Library
200-1282

103 **GREAT ATLANTIC AND**
PACIFIC TEA COMPANY
Virginia Room, Arlington
County Public Library
200-0819

104 **PITCHING HORSESHOES**
Virginia Room, Arlington
County Public Library
12-5025

107 **CRANDAL MACKEY**
Virginia Room, Arlington
County Public Library
200-1171

108 **CRASH**
Virginia Room, Arlington
County Public Library
230-1583

110 **FORT MYER DRIVE**
Virginia Room, Arlington
County Public Library
230-1815

111 **POTOMAC RIVER AND**
ARLINGTON MEMORIAL
BRIDGE
Virginia Room, Arlington
County Public Library
230-0981

112 **LEE MEMORIAL**
BOULEVARD
Virginia Room, Arlington
County Public Library
230-1858

113 **LOW PLANE**
Virginia Room, Arlington
County Public Library
13-5048

114 **ALCOVA MOTOR**
COMPANY
Virginia Room, Arlington
County Public Library
200-0817

115 **DREW HOUSE**
Virginia Room, Arlington
County Public Library
200-0025

116 **ARLINGTON**
EXPERIMENTAL FARM
Virginia Room, Arlington
County Public Library
230-0464

117 **GEORGETOWN AND**
ALEXANDRIA ROAD
Virginia Room, Arlington
County Public Library
230-1834

118 **TAKING OFF**
Virginia Room, Arlington
County Public Library
13-5109

119 **WASHINGTON AIRPORT,**
1935
Virginia Room, Arlington
County Public Library
200-0726

120 **CARRIE SUTHERLIN AND**
FRANCES JENNINGS
Virginia Room, Arlington
County Public Library
03-0028

121 **MAIN BUILDING AT**
ARLINGTON HALL
Virginia Room, Arlington
County Public Library
03-0050

122 **BUCKINGHAM VILLAGE**
Library of Congress
368667pu

123 **STRINGENT MILK**
QUALITY STANDARD
Virginia Room, Arlington
County Public Library
21-5419

124 **GENERAL STORE**
Virginia Room, Arlington
County Public Library
200-1122

125 **MECHANICS**
Library of Congress
82575

126 **FLEET OF TRUCKS**
Virginia Room, Arlington
County Public Library
21-5245

127 **CLEAN-UP**
Virginia Room, Arlington
County Public Library
21-5185

128 **DAIRY PRODUCTION**
Virginia Room, Arlington
County Public Library
21-5373

129 **MARCEY BROTHERS**
Virginia Room, Arlington
County Public Library
21-5374

130 **HEALTH DEPARTMENT**
OFFICIALS
Virginia Room, Arlington
County Public Library
21-5418

131 **ARLINGTON HEALTH**
DEPARTMENT
Virginia Room, Arlington
County Public Library
21-5225

132 **STUDENTS**
Virginia Room, Arlington
County Public Library
03-0037

133 **EQUESTRIENNES**
Virginia Room, Arlington
County Public Library
03-0014

134 **COMPANY M BAYONET**
PRACTICE
Library of Congress
731

136 **"TRACKLESS" TANK**
Library of Congress
574

137 **BANTAM TRUCK**
Library of Congress
580

138 **KAY DOWD**
Library of Congress
5926

139 **TENT COLONY**
Washingtonia Division, D.C.
Public Library
135

140 **MIKADO**
Virginia Room, Arlington
County Public Library
218-0042

141 **EDUCATIONAL PROGRAM**
Virginia Room, Arlington
County Public Library
03-0015

142 ROYAL CROWN
Virginia Room, Arlington
County Public Library
21-5435

**143 HARRISON-DOUGLAS
MACHINE SHOP**
Virginia Room, Arlington
County Public Library
230-1267

**144 PENTAGON
CONSTRUCTION**
Library of Congress
92757

**145 TOMB OF THE UNKNOWN
SOLDIER**
Library of Congress
25741

146 PENTAGON
Library of Congress
H814-T01-W02-005

148 WAR BONDS NOW
Virginia Room, Arlington
County Public Library
230-4051

149 VOTERS
Library of Congress
55810

150 POSTWAR SHOPPERS
Virginia Room, Arlington
County Public Library
230-1698

**151 "DOWNTOWN"
ARLINGTON**
Virginia Room, Arlington
County Public Library
200-0749

152 NATIONAL AIRPORT
Virginia Room, Arlington
County Public Library
230-1579

153 PARADE
Virginia Room, Arlington
County Public Library
230-1273

154 ARLINGTON FIREMEN
Virginia Room, Arlington
County Public Library
230-1274

155 SCHOOL PAGEANT
Virginia Room, Arlington
County Public Library
230-0557

156 NEW PATROL CARS
Virginia Room, Arlington
County Public Library
230-0572

**158 CLARENDON CIRCLE AND
WILSON BOULEVARD**
Virginia Room, Arlington
County Public Library
230-1120

159 BASEBALL
Virginia Room, Arlington
County Public Library
04-0036

160 SOAP BOX RACING
Virginia Room, Arlington
County Public Library
32-0124

162 RECREATION
Virginia Room, Arlington
County Public Library
218-0032

**163 ARLINGTON'S
COURTHOUSE**
Virginia Room, Arlington
County Public Library
100-0001

**164 FUNERAL OF GENERAL
JOHN J. PERSHING**
Library of Congress
92812

**165 ARLINGTON COUNTY
COURTHOUSE**
Virginia Room, Arlington
County Public Library
100-0420

166 THE HOT SHOPPE
Virginia Room, Arlington
County Public Library
200-0056

167 CLARENDON CIRCLE
Virginia Room, Arlington
County Public Library
200-0092

168 COLONIAL RESTAURANT
Virginia Room, Arlington
County Public Library
04-0032

169 FIRE
Virginia Room, Arlington
County Public Library
04-0031

**170 RECONFIGURATION OF
PARKINGTON**
Virginia Room, Arlington
County Public Library
200-2928

**172 TRAVELING FROM
VIRGINIA**
Courtesy of Washingtoniana
Division, D.C. Public Library

173 GROUP FISHING
Virginia Room, Arlington
County Public Library
230-2044

174 BOATS
Virginia Room, Arlington
County Public Library
230-2033

175 PRESTON'S
Virginia Room, Arlington
County Public Library
200-8740

176 MOTORCYCLE POLICE
Virginia Room, Arlington
County Public Library
200-0100

177 BIRD'S-EYE VIEW
Virginia Room, Arlington
County Public Library
200-0055

178 BIRD'S-EYE VIEW
Virginia Room, Arlington
County Public Library
200-0054

179 PARADE, LEE HEIGHTS
Virginia Room, Arlington
County Public Library
218-0062

**180 MOTORCYCLE POLICE
FORCE**
Virginia Room, Arlington
County Public Library
200-0101

**181 BASCULE OF ARLINGTON
MEMORIAL BRIDGE**
Library of Congress
113773